KT-571-676

049129

THE HENLEY COLLEGE LIBRARY

JIM DINE, some drawings

Text by Stephanie Wiles, Jim Dine and Vincent Katz

Allen Memorial Art Museum, Oberlin College / Steidl

TOUR SCHEDULE

Allen Memorial Art Museum
Oberlin College
April 8–July 17, 2005

Neuberger Museum of Art
Purchase College, State University of New York
September 18–January 6, 2006

Mary and Leigh Block Museum of Art
Northwestern University
April 7–June 18, 2006

This exhibition and catalogue were made possible through special funding
from the Allen Memorial Art Museum Friends of Art Fund, Oberlin College

Jim Dine, some drawings

CONTENTS

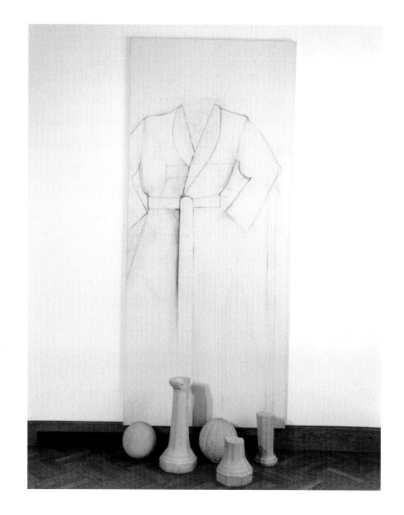

PREFACE

It is an honor for the Allen Memorial Art Museum to host this exhibition of drawings by Jim Dine, which marks the 40th anniversary of his first visit to Oberlin. In 1965, Oberlin College's legendary professor of art history Ellen Johnson invited the young Ohio-born artist to participate in the College's artist-in-residence program. During Dine's residency, a selection of his work was shown at the Allen, his first solo museum show. That same year the Allen acquired Dine's *Charcoal Self-Portrait in a Cement Garden,* 1964 (see figure), which remains one of the icons of the permanent collection today. At her death, Johnson bequeathed a number of works by Dine to the Allen, and over the next four decades the museum continued to acquire his works both through purchase and gift.

The variety and breadth of Dine's drawings show the intense way he observes the world around him and the excitement with which he records it on paper. In all of the drawings on view, Dine captivates us with the way he sees and the way he makes images his own. The restlessness of his vision, the erasures and continual reworking of line, his facility with whatever media comes to hand—all point to the artist's great pleasure in the act of drawing. Dine has said that his ability to draw is both a privilege and the result of hard physical training, compelling him to move inexorably forward to capture the next idea or the next psychological insight in drawings that are, in the end, extraordinarily human.

Following a five-year stay in London, Dine returned to the United States in the early 1970s. He has often described how he moved to Putney, Vermont and "taught [him]self to draw." Among the drawings shown are finely rendered pencil portraits of a neighbor and favorite model Jessie and equally sensitive and objective drawings of plants, such as begonias and tulips, one which he named *Careful Pencil Drawing* (1978). These lyrical drawings show a technical virtuosity in line and form. They appear alongside unselfconsciously private expressions such as *A Study from Blake* (1976) and a group of self-portraits that hint at powerful human stories that don't need to be read, only experienced.

Drawings such as the tour de force of *Patsy Orlofsky, Pregnant* (1976-1977) or the much later *Portrait of Chuck Close* (1993), show Dine's sureness and concentration as he places pencil or chalk to paper and begins to create a living presence. The Close portrait had a seemingly modest beginning in a head and shoulder view focused on the sitter's face. This exploded into a full-length seated portrait as Dine added several large sheets of paper to the original. Dine deftly drew Close's body with powerful strokes and an economy of form that recall Renaissance and Baroque painters' cartoons. Dine concentrated fiercely on Close's physical presence and responded to both his own impressive powers of drawing and the unspoken, but clearly present, artistic status of his subject.

The self-portraits, perhaps more than any other drawings, show how intensely preoccupied Dine is with studying himself, from varying viewpoints, at different times and in a variety of settings. Dine often employs the bust-length portrait format, such as in an unprepossesing 1978 self-portrait in an artist's smock. The series *Looking in the Dark* (1984)—drawn without wearing his glasses—experiments with a different set of physical criteria. These portraits demand another kind of participation, pushing both artist and viewer to consider how one perceives reality. They illustrate the nature of seeing,

Jim Dine, *Charcoal Self-Portrait in a Cement Garden*, 1964
Charcoal and oil on canvas with five cement objects
Ruth Roush Fund for Contemporary Art, Allen Memorial Art
Museum, Oberlin College
Acc. No. 1965.47

showing how a world can be transformed by varying physical circumstances. Works like these raise questions about the objective/subjective nature of drawing. They also compel us to consider what is actually seen and what might be imagined.

Scale is crucial to Dine's drawings. The small size and relatively delicate handling of his early tool images gives way to a great expansion in the late 1970s and beyond. Dine's 1978 *Large Drawing of a Small Statue*, measuring 45 1/2 x 31 3/4 inches, makes a conscious statement about changing the physical nature of an object and thereby altering its status. A similar approach can be seen in Dine's drawings after Van Gogh. Dine has described how, after seeing an exhibition of Van Gogh's work in London in the mid-1970s, he was inspired by the artist's single images often culled from popular media. After encountering a book on Van Gogh's work, Dine made a series of big drawings after Van Gogh in Los Angeles in 1983. These large-scale, gestural drawings stand as an homage to an artist whom Dine admires.

Autobiographical references in his work are well known. Two drawings from 1983, *Tool Drawing I* and *Tool Drawing II*, show Dine's familiar tools suspended in a kind of brilliant night sky as if they were constellations positioned within a personal universe of autobiography and abstraction. These mixed media works, executed on an impressive new scale of 70 x 70 inches, exist somewhere between painting and drawing. They remind us that Dine sees his paintings and drawings as essentially conceived and developed in the same way—requiring the same amount of time, emotion and physicality of medium. The only difference, in the end, is that the drawings are on paper.

Stephanie Wiles
John G.W. Cowles Director
Allen Memorial Art Museum
Oberlin College

MAKING DRAWINGS

by Jim Dine

I had spoken to "The Emperor" many times before I saw Untersberg.
Untersberg seemed to me
To be the body waiting to be opened to reveal the self
(Hopefully).
"Are you courageous?" asked The Emperor.
"No," I said, "but I am dazzled by beauty."
1. Nature gives me the courage to persist in my quest
2. The fabulous treasure is inside
3. Barbarossa asks me to sing for him
4. The mountain opens, his long beard encircles me
5. I have turned to silver
6. I touch the red stone.

When I am making a drawing, words are coming up in me. They are not spoken but are part of what I'm doing. It's my method of "allowing." When I say in the poem that I spoke to The Emperor, I'm speaking about a *personal,* mythological figure who came into my psyche many years ago. I'm not talking about a fortune teller or, God, I'm talking about (for lack of a better word) The Emperor, but what I'm really saying is, "Dine, what are you doing? Ask The Emperor. Go on your nerve."

It is really very simple. I'm not an emperor, but The Emperor exists within me. I call him "The Emperor" because that's what my unconscious called him years ago. When I start a drawing, I start a drawing. I choose paper. I tack something on the wall. I put out flowers to draw. I look at tools on the floor. I'll then bring a piece of detritus from something else or a piece of paper that has been stained because I spilled something on it. Chalk. Paint. A mark. A splash. An accident. A footprint. That's just me gathering my forces. The battle and the campaign start when I'm surrounded by all or some of these familiar objects. With the Untersberg drawings, I was not trying to reproduce what the mountian looked like. I had looked at the mountain a million times in passing, but when I decided I wanted to draw it, I wanted to take its essence. For me, because I was lucky and The Emperor helped me, the mountain became metaphorical. In the end, it is an imaginative landscape. The combination of The Emperor and my hands; pretty strong stuff!

All day, every day, I'm looking and spotting things. I'm seeing if I can draw this, if I'd like to draw that; seeing what I can collect. My life is really a history of observing forms and taking in imagery. I don't mean in a photographic way, I mean in a way of feeling them structurally. In a drawing, I dig into

the paper with marks for the ultimate emotional impact, and coupled with my innate love of beauty, I'm always thinking about making the whole image. I often add on to the paper, pasting on a sheet or pieces of paper to make the drawing bigger. It's a Procrustean idea, making the thing fit the bed, I guess. I saw that method first with Degas. He did that. There are no rules as far as I'm concerned. My drawings grow as I work on them, that's a physical fact. For instance, the drawing of Chuck Close at first was on one piece of paper, and then, his shoulders emerged and his bulky body took over. When I started to draw him, I thought I'll just do his head, but then I could not ignore his body which is pretty much inanimate, so I had to allow the *drawing* to move and grow.

The drawings of my ex-wife, Nancy, are drawings from drawings. As I remember, she sat sometimes. I made some marks. I put down stuff. Then I went back and worked on them a lot. I just kept on layering them. They were pinned up in my studio in New York for a long time. When I look at them now, I am shocked at the ability of the artist to unconsciously depict the electricity going through the sitter. I think the sureness of portraiture is big in them. They are fresh and they are incendiary. They remind me of a plant growing before your eyes.

The drawing called *Hair* is all about drawing. It's all about moving my pencil. That's what that work is about—moving the pencil and building and weaving the graphite strokes. Without depicting the navel or hips, or the thighs, I created the female triangle. By just making marks, I added literature. It is not an abstraction. It's poetry. It was very exciting when the black and silver lay next to each other and like a torch, heated each other up.

When I was working on a drawing show in 1989, I pinned six pieces of red paper to the wall, and I made the work called *Childhood*. I used a lot of paint, a lot of charcoal, a lot of everything. But as Rauschenberg said, if you drive through the mud with a tire and then go across a sheet of paper, that's a drawing. And he's right, it could be a drawing. But what if you drove your tire through cadmium yellow across the paper, is that a painting? There is a kind of fragile quality that the paper gives to the work that canvas doesn't have. Canvas is a workaday tough support mechanism for the artist's hand with a brush. Paper is a fragile support. Albeit tough at times, depending on what is done with it or to it. The red paper gave me a specific ground of color. Red is the color I care most about anyway.

What I did in the drawing, *Childhood,* is what I do in all my drawings. I go to my childhood and look into that dark place. That excites me. I can express what I find with my hands if I am not afraid. I must speak clearly on the paper. Drawing has an erotic quality to it. The way I use pencil and the way I use chalk and charcoal; there is a black and white sensuality to this material. Of course, there is no question of the erotic pleasure of drawing from the female nude for me, I mean you've got to be crazy if you're not thinking of sex.

My hands (my left hand) can express what I am capable of feeling. There was a moment when I knew I could draw anything but I tried to staunch it, tried to stop it. I tied my hands behind my back so to speak, so I would force myself to look harder and honor realism. It took me a long time to allow my-

self to add the painterliness and exuberance I have for making marks into the work. I can start carefully. I have it in me to begin carefully. I sometimes don't, (I don't on purpose sometimes), or if my mood is that I'm pissed off, particularly, I won't be careful. I try to work the pissed offness, the anger, into the *beginning*. As I often have said, anger is part of my medium. I like to walk alongside of it. Once when I was making a drawing, and getting so angry at it, I soaked it with a sponge, then just balled it up, and threw it against the wall. Then, my anger was over and I carefully peeled it open, I put it on the wall to dry and went at it again calmly. I have anger and impatience, and I use them both. When I use the sander, and if I become impatient, the sander can almost take the skin off my hand, or the skin off the drawing. I'm willing to risk that for something good. I like to honor any accident or destruction of the marks that will enhance a new beginning.

Drawing makes invention more accessible for me. Faster. Immediate. I start a drawing and I start to invent. I am always destroying the drawing's status quo. I guess you could say I practice my own form of larceny. I sabotage reality, otherwise it's like kissing without using your tongue. I can't even cook a hamburger without messing with it. I have to fuck with it to make it mine. I need to claim it, the way a dog pisses on a fire hydrant. I was born with that feeling. I express what I feel about the objects I draw, and I imbue them with myself. I don't abstract from something (i.e. object, figure).

Before, often I lay down everything in a realistic way, but now, I have less patience for realism. My heart is too full. I need to release more emotion. I want more emotion and that gets in the way of realism. I want it to cut the realism. Now, I'm letting off a lot of firecrackers, and I'm putting down a lot of ideas as though I was building with ideas. Things are coming up. Things are coming up *and* I have no way to speak about what the things are, but things are coming up that wouldn't ordinarily grow next to each other. The depiction of physical energy on the paper and the disturbing of the paper's surface are other ways to bring the drawing to life. In the drawings, *Jessie with the Scarf* and *Jade Plant,* the paper surface wasn't disturbed, it was added to. Previously in depictions of plants, I usually took one plant. One single thing. That was enough then.

I am making landscapes, now. I say landscapes because it's natural forms that I'm using. But if instead of natural forms, I used tools, I still might say it was a landscape, or I could say it is a landscape of tools. But really it's an arrangement in space. It's an arrangement of marks and objects that I can make in space on the paper, and I've done it enough times to know what I want. Often I don't get it for a long time. It doesn't happen right away. I have to noodle around and find it on the paper or in my hand or when I use the grinder and it runs crazily off the page. To find that, that's a gift. That comes from outside of me; from The Emperor.

I am an old guy now. 69 is not summer. I feel fortunate to want to continue this journey of drawing. To harvest what I was born with. I'm still full of desire and I love to work. The determination to *see* pushes me onward. The world, as we knew it, is gone. We and they have seen to that, but still I have the great urge to speak by drawing. It makes me "stay" a little longer out here, in the ether.

Greek and Roman Musings: Jim Dine's Drawings of Ancient Sculpture

by Vincent Katz

Munich's Glyptothek is a cherished site of pilgrimage for art-lovers, a treasure-trove of early Western sculptural masterpieces spanning nearly a millennium of Greek and Roman endeavor. King Ludwig I (1786-1868), who acquired many of the museum's works during a trip to Italy in 1804 and in succeeding years through emissaries, commissioned architect Leo von Klenze to build a palace for them. It opened in 1830, with a name coined by the King himself—Glyptothek, or museum of carving.

Jim Dine made his first visit to the museum on the Königsplatz in 1985 more or less by accident. "I had been meaning to go to the Alte Pinakothek, to see the old paintings, when I saw it," Dine recalls. "I couldn't believe it, because they'd done such a great job of re-modeling the Glyptothek, of re-building it after the War. It had been completely demolished, the roof and everything."[1]

Dine's first Glyptothek drawings were done during regular visiting hours, by sitting on a canvas chair provided by the museum and drawing directly from the works on view. Finding himself unable to work under public scrutiny, Dine withdrew to Venice, where, armed with photographs and newspaper clippings, he created in 1987 and 1988 *The Glyptothek Drawings*, a single work composed of 40 small drawings on drafting paper, tissue paper and Mylar, from which he made an artist's book of 40 intaglio prints of the images. "They were then shown at the Albertina in Vienna," Dine recounts, "and a dealer from Munich saw them and told Klaus Vierneisel, the director of the Glyptothek. He invited me back, saying, 'You can do whatever you want in the museum!'" Vierneisel already had a sophisticated program of showing contemporary art at the Glyptothek in relation to its collection of ancient works, including a show of drawings by Joseph Beuys and an intervention by Roni Horn in the museum's courtyard.

"Vierneisel said, 'You can come in any time,'" Dine continues. "So, I said, 'Okay, I'll come in about four in the morning.' I'd set my alarm clock, come in at four. I had my easel and my stuff in a closet, I had a piece of plastic I'd put on the floor, and I'd work until about nine. There was one guard who played chess with himself, I never saw him. Otherwise, nothing. It was a little spooky, pitch black. This guy would put on one or two lights for me. Then, I would draw as intensely as I could, to get this thing down. Around nine, the guards would start to come in, and I didn't want them to see what I'd done. I didn't want to have to explain it. I'd stop. I'd take the drawing to the hotel, and the next day I'd bring another clean piece of paper. I did the same thing every day for a week, maybe eight days. It was such a pleasure to be able to meditate on the work of a colleague, who is nameless. Some guy with a chisel did these things."

Drawing has always been central to Dine's work, but the period in the mid 1970s, when he devoted himself to drawing the human figure, can be seen as a cardinal point in his career, a hinge which moved him from one plane of work into another, not necessarily higher, just at a different angle to the world. To move from the living figure to the figure in stone or metal is again a planar shift. Before going to the Glyptothek, Dine had said, "…there are two kinds of drawings, drawings of people and drawings from photographs. In those from photographs, I'm not interested in the likeness.

I'm interested in getting something... expressive. In the portraits of people, I'm interested in getting the portrait likeness."[2]

In drawing the sculptures at the Glyptothek, Dine put himself in the tradition of Western art that looks back to its masterpieces as models of composition and technique, but relying on his graphic mannerisms, Dine does not so much pay homage to the past as get beyond it. Beginning from these stationary, nameless models, created by artists unknown to us today, he gets a sense of a person and a work of art that is distinct from the model.

When you look for a long time at the drawings Dine did in the Glyptothek, interesting things start to happen. Closely examining the two drawings of the *Barberini Faun*, for example, you suddenly feel that you are looking at the body, which is what the sculptor was getting you to do, too, but here you are looking at the drawing through the sculpture to the body. Dine, ignoring the sculpture while looking straight at it, gets you closer to the body—through his constant modulations of tone and temperament, the rips and shreddings of paper, the variation of hard-edge line he uses on the right inside thigh, combined with loose, washy painting over the belly, delicate pencil marks, and the ever-present footprints, in this case in the upper left corner of the drawing with the whole torso and head visible. The other *Faun* drawing, with the upper torso cut off, is more of a straight-on shot of the crotch area, extensively worked in charcoal. Thickened areas of black charcoal take on lives of their own. The Faun of the original sculpture is sleeping naked, a probably drunken satyr, whose spread availability, complete nakedness, and rough countenance are calculated to trigger feelings of animal lust. There is no hint of the perfection of the human form here. The satyr's hanging arm is full of blood, its veins popping. It is a Hellenistic masterpiece, distinct from the lofty perfection of archaic *kouroi* and possessing a baroque excess distinguishing it from Roman sculpture. Dine's drawing, like his drawing of his former wife, Nancy, (*Portrait of Nancy (Nude)*, 1987), remains sexy, while drawing attention to its worked artistry.

One should be wary of over-emphasizing the role of subject matter in Dine's Glyptothek drawings. The modernity of his works distances them from particular stories of mythical or historical figures portrayed in the sculptures. The distancing factor is great between a contemporary viewer and an historical figure such as the Roman emperor Trajan. Add to that the complexities of imperial portraiture, in which it was incumbent on artists to create images that reflected the way supreme rulers wished to be depicted, and the real person is as removed as a mythological subject, such as the Trojan archer Paris from the classical Greek temple to Aphaia on the island of Aegina—or a type, such as the Hellenistic faun that came to light during the reign of Pope Urban VIII (Maffeo Barberini, 1623-1644).

Dine's drawings do have a lot to do, however, with the original artworks. Apart from facts of idealizing or genericizing, there are the more pressing questions of the artist's motivations and actions when faced with these ancient works of art. He speaks of his "dialogue" with the antique, a funny phrase, since it implies that he talks to the antique, as well as its talking to him. "While I'm drawing I don't ever think about where the sculptures were done... A lot of the things I draw from

are Roman copies of Greek sculptures... I don't want to draw these things as dead objects, as stone. I want to observe them carefully, and then I want to put life into them and make them vigorous and physical...."[3]

The scalar relations Dine creates between the subject and the paper edges are instructive. Dine has long been interested in what could be called "Colossalism." Among his early achievements in painting was a series of subjects painted large: a man's tie, a bathrobe, sections of hair and skin. Of the hundreds of objects in the Glyptothek, Dine chose certain ones to draw. He may have been attracted by the colossalism of the head of Titus, but he modulated this in his drawing, bringing the deified emperor back to human scale. Some of the figures in the sculptures are approximately life-size, but others are smaller; Dine's drawings play with our expectations or lack of them. The late 4th century BCE Tanagra figures are in reality quite small, as is the dancing figure that forms the subject for *Red Dancers on the Western Shore*, and yet the latter are some of the most imposing of Dine's Greek and Roman drawings.

The selection for the present exhibition allows us to observe a mini-history of Dine's treatments of classical subjects, and the different technical approaches he has employed, ranging from charcoal and pencil to thickly brushed acrylic, along with physical interventions of rubbing, scraping and sanding. The earliest in the group (*Large Drawing of a Small Statue*, 1978) is not Greek or Roman but Egyptian. The next (*Study for the Venus in Black and Gray*, 1983) comes from the archetypal Greek depiction of female beauty, the *Venus de Milo*. However, the drawing is not of the original or a picture of the original but of one of Dine's own sculptural permutations of the subject. In the drawing of the Venus, the dialogue between drawing and sculpture is stressed by scratches on the drawing's surface and a tear that traverses more than a third of the sheet.

With *Red Dancers on the Western Shore*, 1986, Dine is moving into Glyptothek territory. These four large drawings were made from a small figure in the collection of The Metropolitan Museum of Art in New York. Dine's vision of them is as someone who has seen them up close, has entered into the scale of the sculpture, and therefore sees it as life-size, not as a tiny object in a large vitrine. Once on the level of the sculpture, his imagination sees its motion and transcribes that, making a four-part image whose intense red ground matches the fast-paced gestures of the charcoal drawing. He sees the thrusting energy of the figure and takes it at face value, feeling no need to define it: it could be a dancer or a murder, or both. *Study for Europe*, 1987, is of a Neapolitan mosaic. These four pieces are pre-Glyptothek, but they show a desire for what the Glyptothek provides. As Dine said in 1979, "I'm looking more at ancient art now, because I'm trying to understand sculpture."[4]

In Der Glyptothek is a series of seventeen drawings produced by Dine in 1989.[5] He began several of them at the museum in Munich and continued to work on them at his studio in London, while others of the drawings were made wholly in London, using Glyptothek sculptures as subjects. Of the seventeen drawings, eleven are in the present exhibition:

Sleeping Satyr (Barberini Faun); Sleeping Satyr (Barberini Faun); Homer and Socrates; Panther; Colossal Portrait of the Emperor Titus; Portrait Bust of the Emperor Trajan; Palmette from the Parthenon; Trojan Archer (Paris); Twisted Torso of a Youth (Ilioneus); Tanagra Figures; and *Aged Silenus with Wineskin.*

The names and interpretations of many ancient sculptures are the products of conjecture. Portraits reflect the standards of the time and place in which they were made, and qualities adhere to a figure which may or may not have their basis in fact, or in how a person in a different time and place would observe them. Dine's drawing *Homer and Socrates* functions on several levels, partially as a drawing of bronze and marble sculptures, partially through the references those two historical figures bring up, and partially in the evocation of faces looking out from a mist of painted and smeared atmosphere.

Twisted Torso of a Youth (Ilioneus), a sculpture of youth whose now-missing arms were once raised to protect his now-missing head, is a case in which the symbolism inherent in the gesture is more significant than a positive identification. According to Henri Brunn, who wrote a guide to the Glyptothek in the late 19th century, this statue was identified with Ilioneus, the youngest child of Niobe, due to a superficial resemblance to a figure on a sarcophagus in the Vatican[6]. Niobe's seven sons and seven daughers were killed by Leto's children, Diana and Apollo, after Niobe claimed she was superior to Leto. In Ovid's words,

> Last of all, Ilioneus raised his arms in supplication, though it was to be of no avail. "O gods," he cried, "I pray you, one and all, spare me!" So he prayed, not knowing that there was no need to address them all. The archer Apollo was moved to sympathy, but already his shaft had gone beyond recall: still, the wound that killed the boy was only a slight one, and the arrow was not driven deep into his heart.[7]

Brunn points out that this statue is different from the other representations of the Niobids (as the children of Niobe are known) by its complete absence of clothing and its base, which, instead of evincing soil, is perfectly smooth. This leaves us with the certainty only that the statue shows a young, naked man lifting his arms over his head to protect himself from a blow. The smooth marble finish depicts young skin, and the youth seems in danger of imminent decapitation or other attack; he is a subject who arouses our sympathy. On another level, like the Faun, he too may arouse feelings of an erotic nature, in those for whom violence and sadism are stimuli.

One of the main attractions of the Glyptothek is the collection of figures from the pediments of a classical Greek temple on the island of Aegina, not far from Athens. A temple was built there around 560 BCE; after its roof burned out, a second temple was completed at the beginning of the 5th century. It is believed to have been a sanctuary to Aphaia, a goddess similar in nature to Artemis. One story has it that Britomartis, a Cretan goddess, was pursued by Minos. To escape him, she jumped off a cliff into

the ocean, there to be rescued in fishermen's nets. She fled to Aegina and was from that point on worshipped there as Aphaia. One scholar has written, "The Aegina figures are the best preserved of all such Greek temple groups, with the exception of those from the temple of Zeus at Olympia. It is the most comprehensive monument of Greek sculpture from the turn of 6th and 5th centuries, providing priceless evidence for the process of transition taking place in Greek art. The Aeginetan school of sculpture was much admired by the ancients."[8] The figure Dine has chosen to draw is the archer Paris, the lover whose rape of Helen led to the Trojan War, and whose arrow penetrated the one part of Achilles' body left vulnerable when his mother dipped him into the stream of immortality, holding him by the heel.

In 1991, still working with classical ideas, Dine made *Three Roman Heads*, based on photographs of sculptures in Copenhagen's Ny Carlsberg Glyptotek (named after the museum in Munich). These drawings possess a marked density of surface and palpable evidence that the artist has attacked that surface and broken through it in one case. Dine used ferric chloride and shellac to achieve a stone-like quality in the whole sheet. Watercolor drips heighten a feeling of painterliness, while a footprint on the back of the left-hand figure's neck draws attention to the piece's contemporary facture.

Dine returned to draw at the Munich Glyptothek in 1992, and in 1993, he made a series of 150 drawings, which, like the original set, stand as one work, entitled *Some Greeks, Some Romans*. Dine drew *Figure with Cupid* in 1994. Possibly depicting Venus with a Cupid, this drawing's careful modeling and angelic blue stain give it a Renaissance air, which is countered by being ripped through and wetted down.

The latest two works in the exhibition with classical hints are the two owl drawings from 2000. They are actually paintings over photo-silkscreens; the classical in these comes from the traces of Dine's Venus sculpture in the photo of his London studio (the same photoscreen is used as the ground for *Twisted Torso of a Youth (Ilioneus)*). In the smaller of the two, *Blind Owl*, one's attention is drawn to the forest of oil paint marks, as the owl, identified with Athena, takes the place of Aphrodite/Venus. In the larger piece, *Owl in Chelsea*, a series of footprints on the right side becomes patterning, and it overlays the patterning of the printing of the photoscreen. On the floor, this screen pattern pales next to the painted acrylic marks above, making up the bird, but in the base of the sculpture lends the drawing a modern subjectivity.

The Glyptothek work, in addition to being about looking at particular sculptures, is also about being in a particular space, the reaction that engenders in a particular viewer, enabling him better to feel the art on display. "I have never felt closer to the Ancient World than in the Glyptothek" Dine wrote. "In the big hall of Roman portrait heads there must be over one hundred heads. You feel like you're in a crowd of people, but there is nothing heroic about it. It's very much on a human scale, right at the viewer's eye level..."[9] The drawings also have to do with being in specific European places (Munich, Venice, London). "I sat in my studio that winter [1986-87 in Venice] and made drawings, all of a certain size, not too big. I wanted to make a portfolio, a book of my drawings. Then I started to draw

THE HENLEY COLLEGE LIBRARY

antiquities from books that weren't in the Glyptothek. In a sense, I was making my own Glyptothek. I did that over two and a half winters... [going between Venice and Munich] ..."[10]

These are not so much portraits of ancient sculptures, as they are, partially, attempts to re-depict what the sculptor originally attempted. In that sense, they are in a collegial competition with the nameless Greek and Roman creators of those pieces. On another level, they are part of Dine's evolutionary project of drawing, in which the subjects can be seen again as "symbols for the self," as were Dine's early moonlike face paintings.[11] As Dine puts it, "...my personal history is intertwined with this subject matter. These Greek and Roman citizens become my history. Each head is the voice of my unconscious."[12]

Part of the endeavor is about looking, something Dine has been attempting for a very long time. In 1966, before he moved to London, he had an exhibition at the Robert Fraser Gallery there, a section of which was confiscated by the police as pornography. John Russell, reviewing the exhibition in *ARTnews*, pointed out that the offending works were the result of Dine's practice of hard observation: "They were simply one more example of Dine's way of isolating elements in everyday life which usually come as part of an ensemble. The ensemble in question was London itself... Dine looked at a lot of things in London... and he worked reminiscences of one or another of them into a long series of mixed-medium pictures. Among the things he looked at were the phallic drawings, which embellish those unsung galleries of folk-art for which one penny is the usual price of admission. He took these straight, as the Venetian masters took the antiquities in the Museo Archeologico..."[13] In one sense, Dine's looking is the same, whether the gallery be of unsung folk-art or heralded masterpieces.

The previous issue of *ARTnews* had featured a Jim Dine cover and a "Test in Art," administered to Dine by his friend and collaborator, the poet Kenneth Koch. Finally, there is a sense in which the classical sculptures Dine drew are simply objects of a particular nature and as such have no claim on higher standing than any other objects. At certain moments, we need to be reminded that great works of art are merely things; otherwise we cannot go on with life. A similar attitude toward masterpieces may be gleaned from Koch's poem, "You Were Wearing":

> "We waited for a time and then joined her, only to be served tea in cups painted with pictures
> of Herman Melville

> As well as with illustrations from his book *Moby Dick* and from his novella, *Benito Cereno*."[14]

Jim Dine has re-invented his art at certain moments in his career—perhaps because he felt he had come to the end of the trajectory of a certain project or projects; perhaps because he simply felt nervous or bored. The mythological, historical, legendary, and semi-legendary figures he has chosen to depict, or to refer to—because each figure is a piece in a larger complex story—have given him opportunities to take his graphic meditations into areas even he does not know in advance. We can study the results of these meditations, and look forward to further explorations, for it seems Dine's passion for the classic is still in full swing.

1 Quotations of Jim Dine, unless otherwise noted, are from an interview with Vincent Katz, recorded on September 28, 2004.

2 Interview with Constance W. Glenn, in *Jim Dine Figure Drawings 1975-1979* (New York: Harper & Row, 1979).

3 Jim Dine, "In the Glyptothek" in *Jim Dine: Drawing From the Glyptothek*

(New York: Hudson Hills Press, in association with Madison Art Center, Wisconsin, 1993).

4 Interview in Glenn, 1979.

5 The pre-1993 work is documented in *Jim Dine: Drawing from the Glyptothek*

6 Henri Brunn, *Description de la Glyptothèque fondée par le Roi Louis I à Munich* (Munich: commissioned by Théodore Ackermann, 1879, second French edition)

7 Ovid, *Metamorphoses*, Book VI, 261 ff., translated by Mary M. Innes (Penguin Books, 1955).

8 Dieter Ohly, *The Munich Glyptothek: Greek and Roman Sculpture* (München: Verlag C. H. Beck, 2nd revised English ed. 1992).

9 Jim Dine "In the Glyptothek" in *Jim Dine: Drawing From the Glyptothek* (1993).

10 *ibid.*

11 See Vincent Katz, "Symbols for the Self," *Art in America*, Volume 87, Number 12, December 1999, pp. 100-105.

12 Jim Dine, "Notes on Some Greeks, Some Romans" in *Some Greeks, Some Romans: A Drawing By Jim Dine* (New York: PaceWildenstein, 1996).

13 John Russell, "Dine and the bobbies" in his column "London," *ARTnews*, Volume 65, Number 7, November 1966, p. 58 (continued on p. 87).

14 In Kenneth Koch, *On The Great Atlantic Rainway: Selected Poems 1950-1988* (New York: Alfred A. Knopf, 1994).

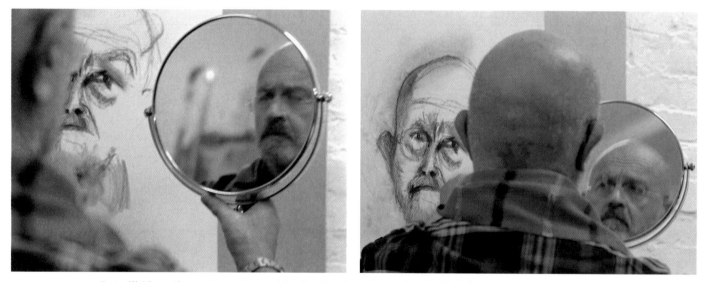

But still I have the great urge to speak by drawing. It makes me "stay" a little longer out here, in the ether.

PLATES

1

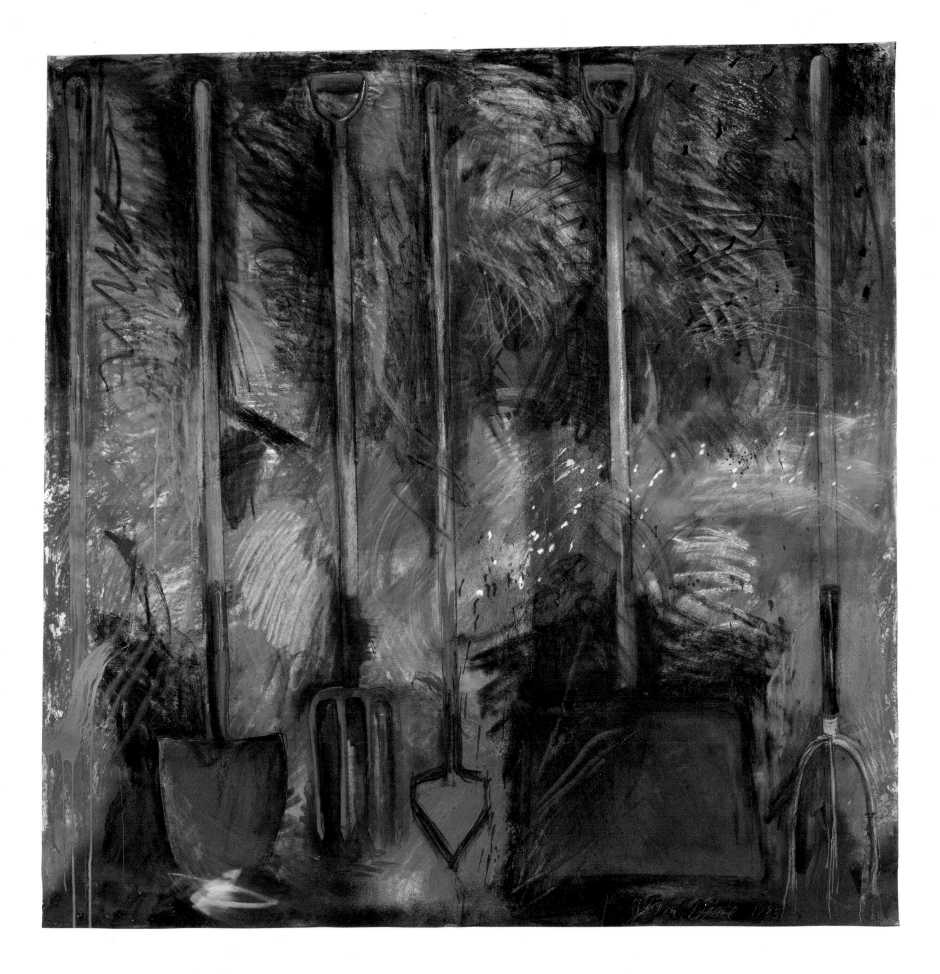

23

2

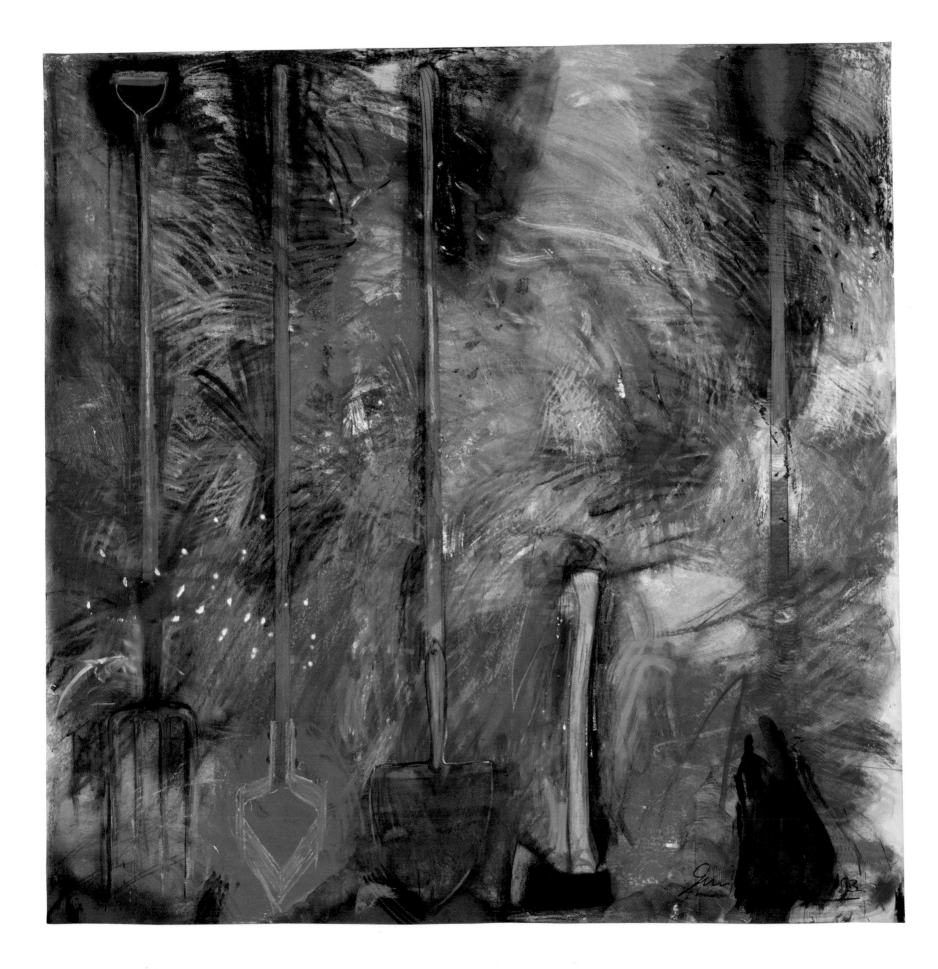

3

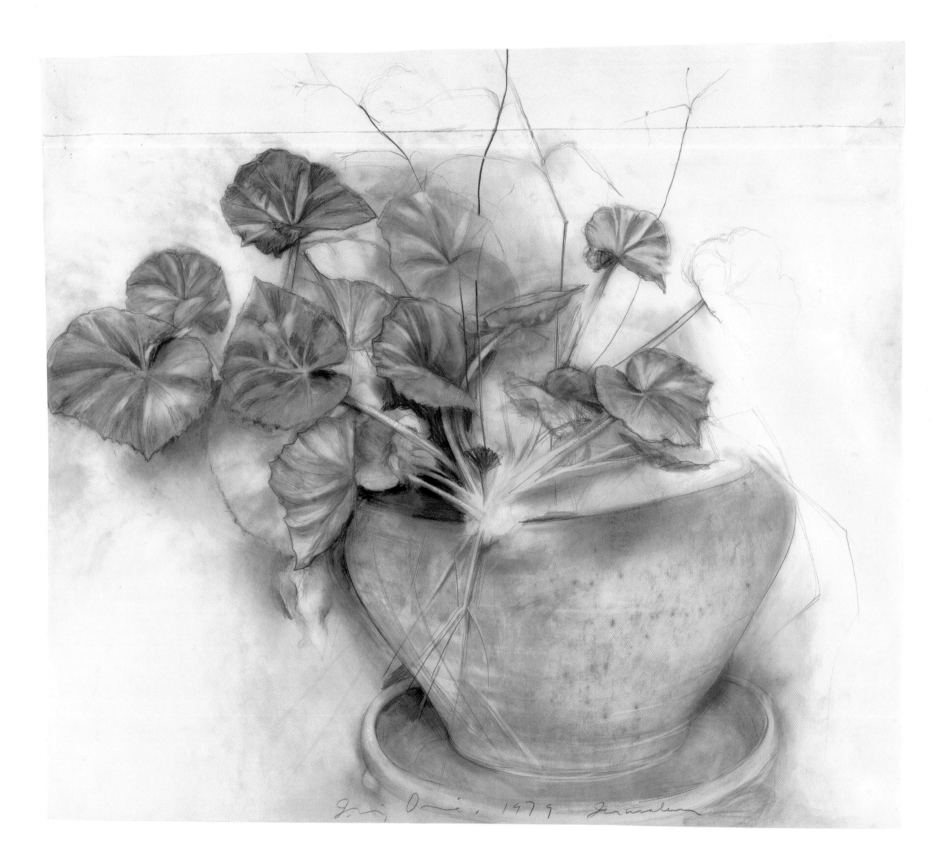

Irving Orrie, 1979 Jerusalem

4

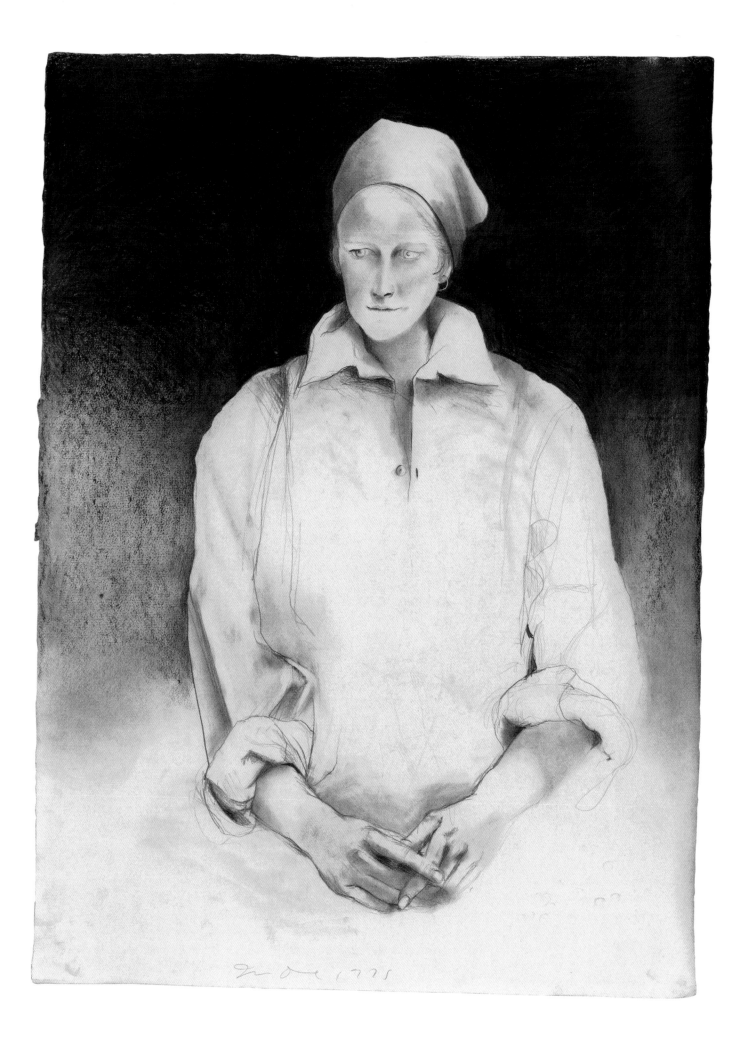

5

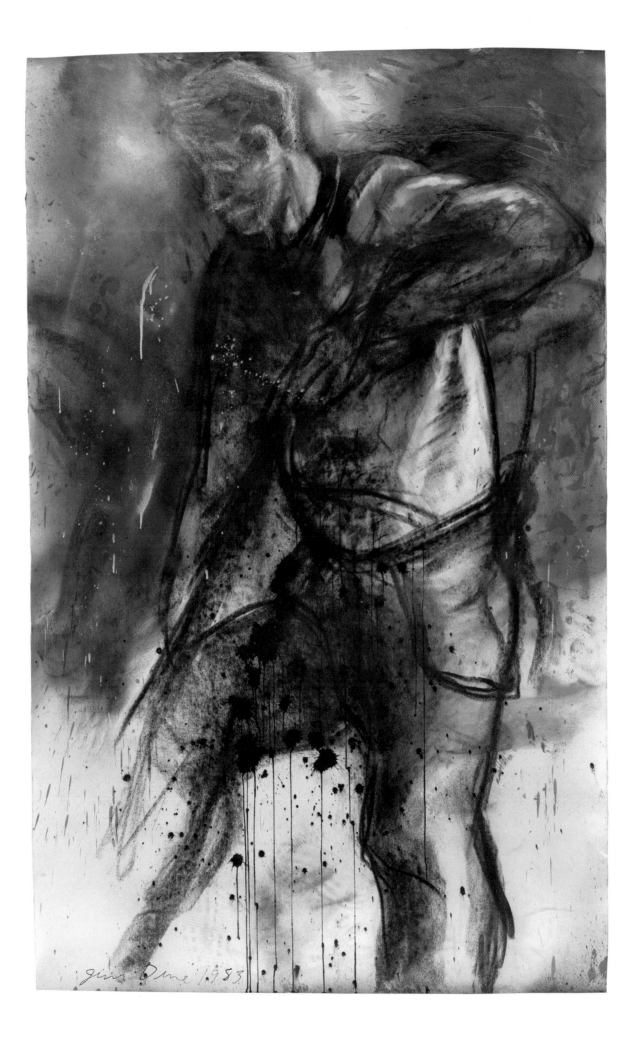

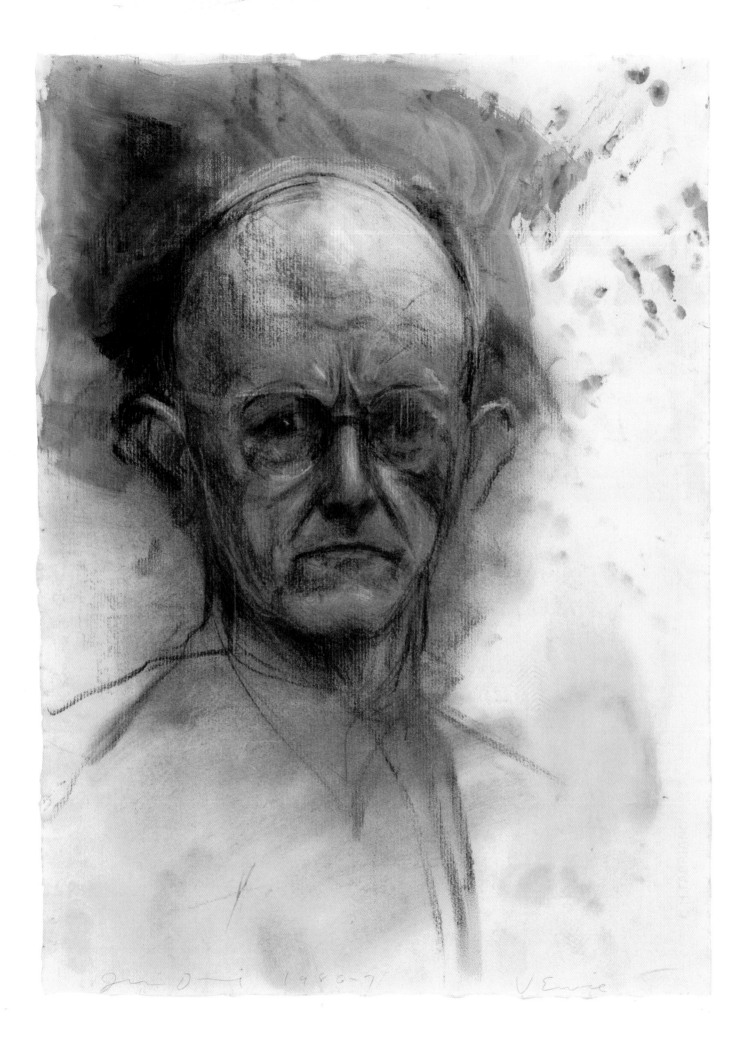

Jim Dine 1980–7 Venice

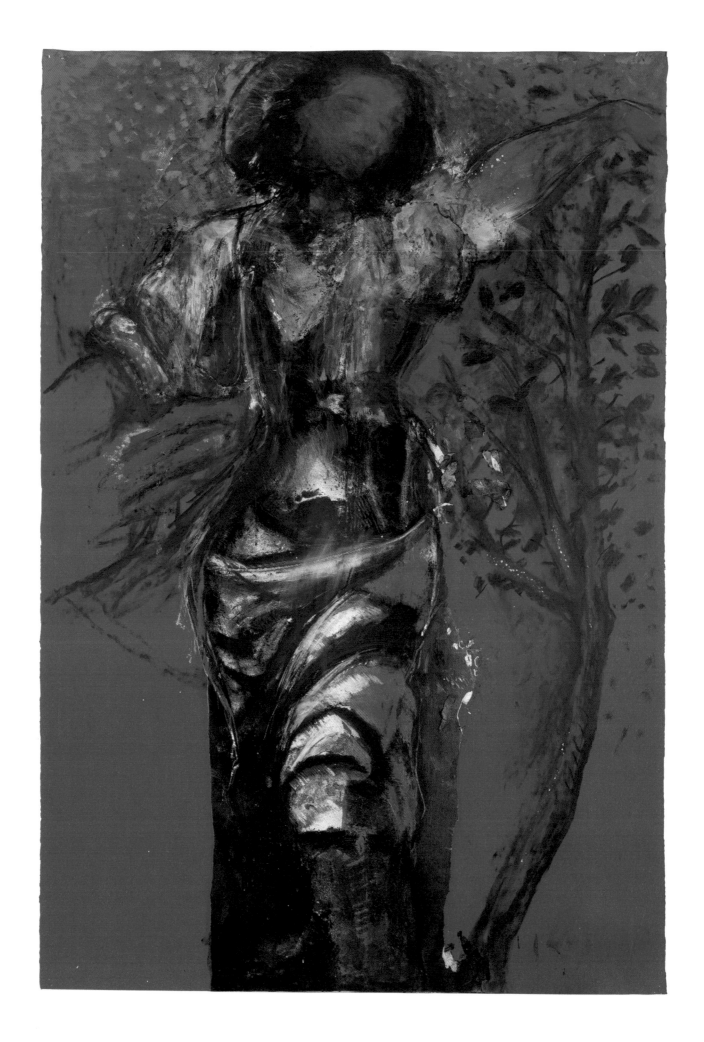

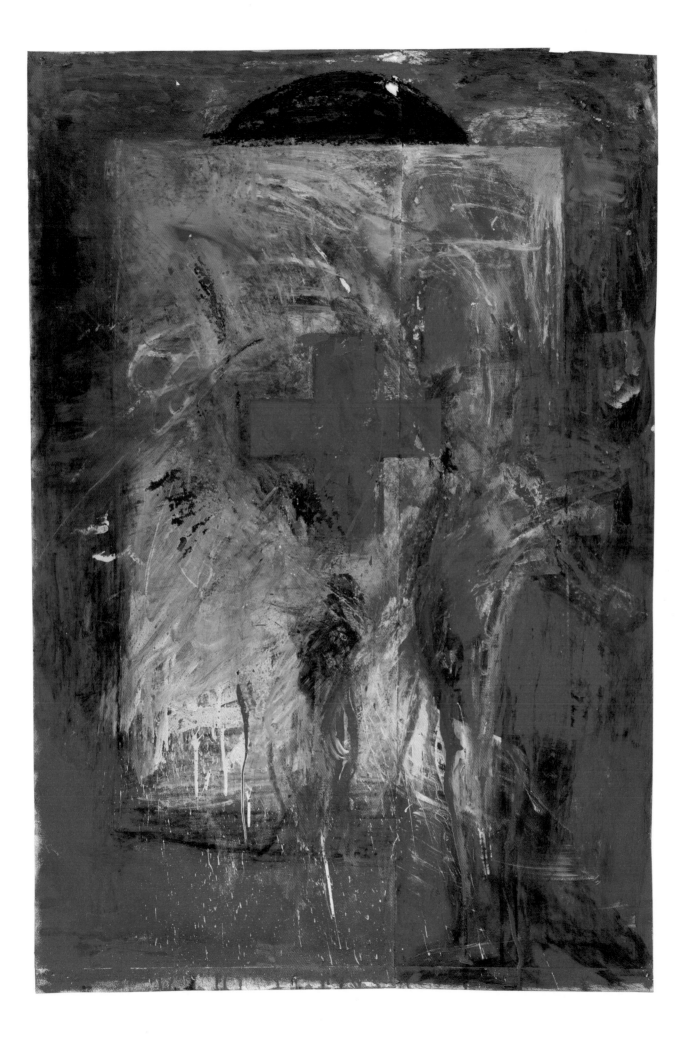

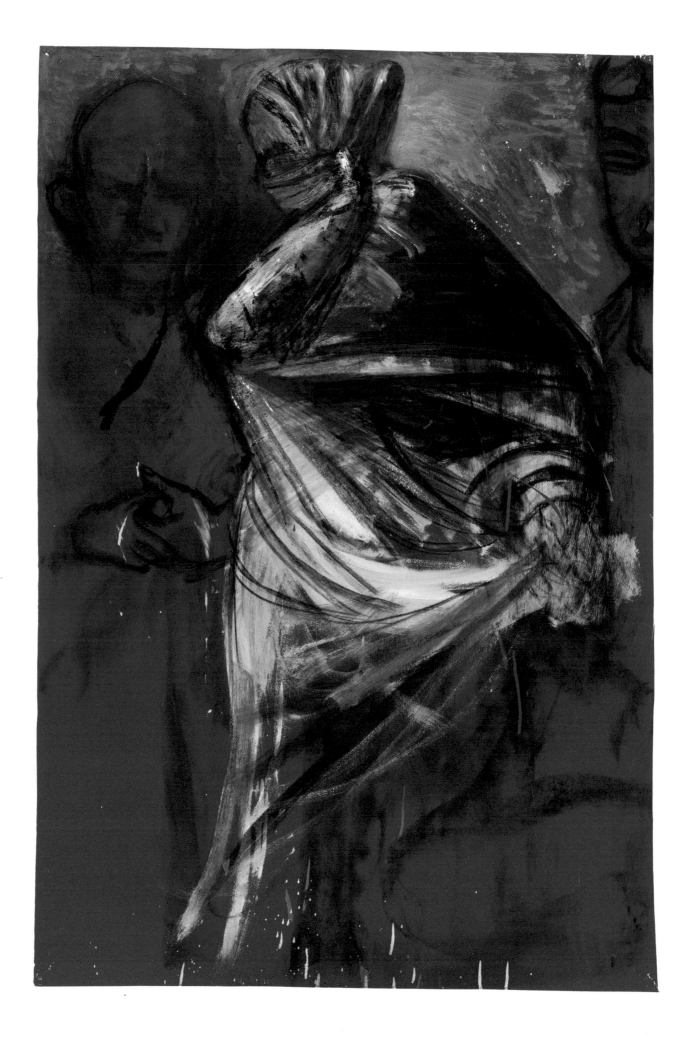

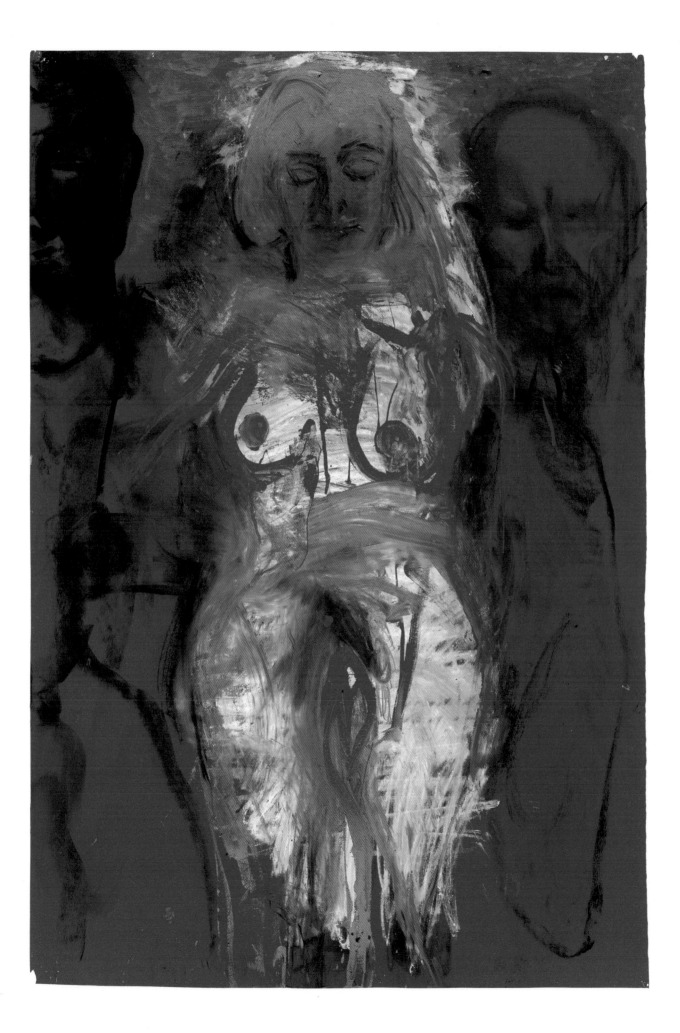

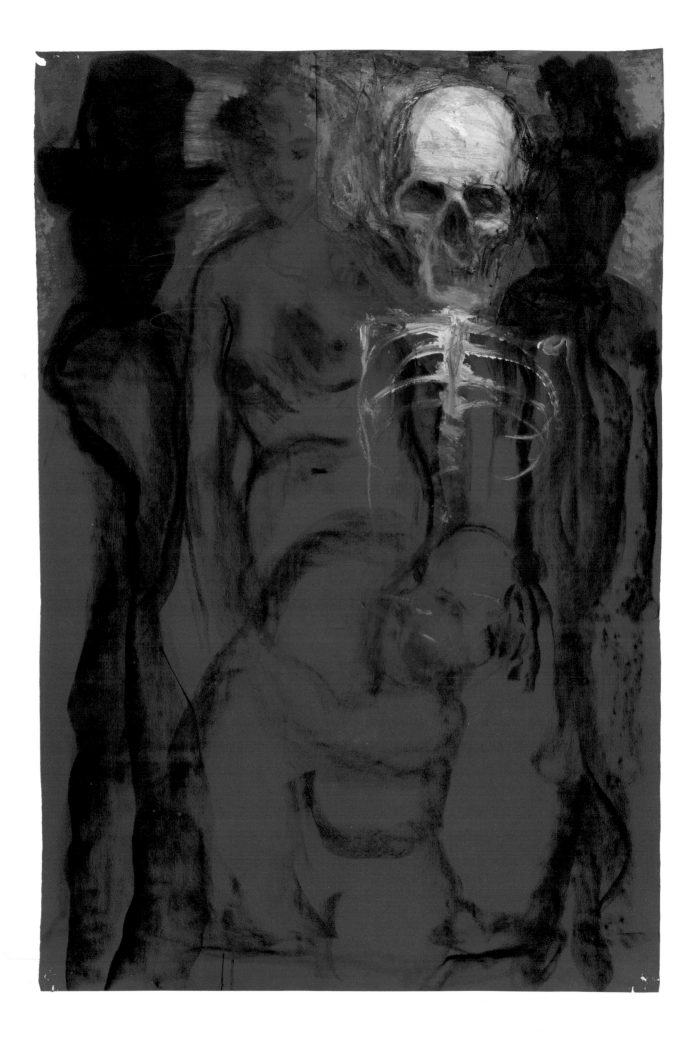

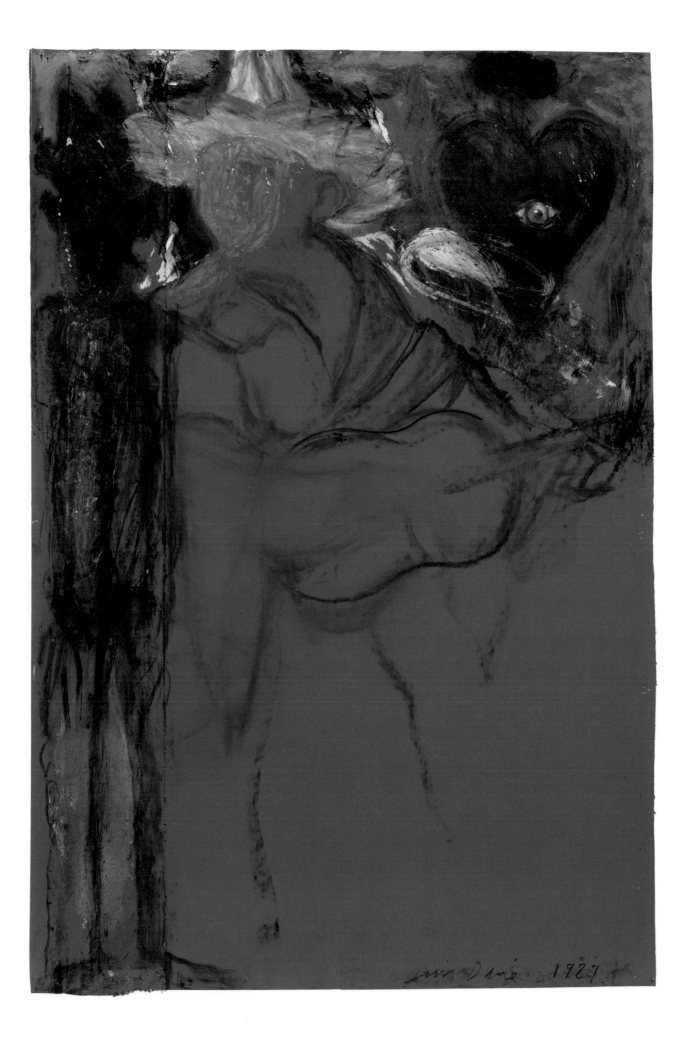

8

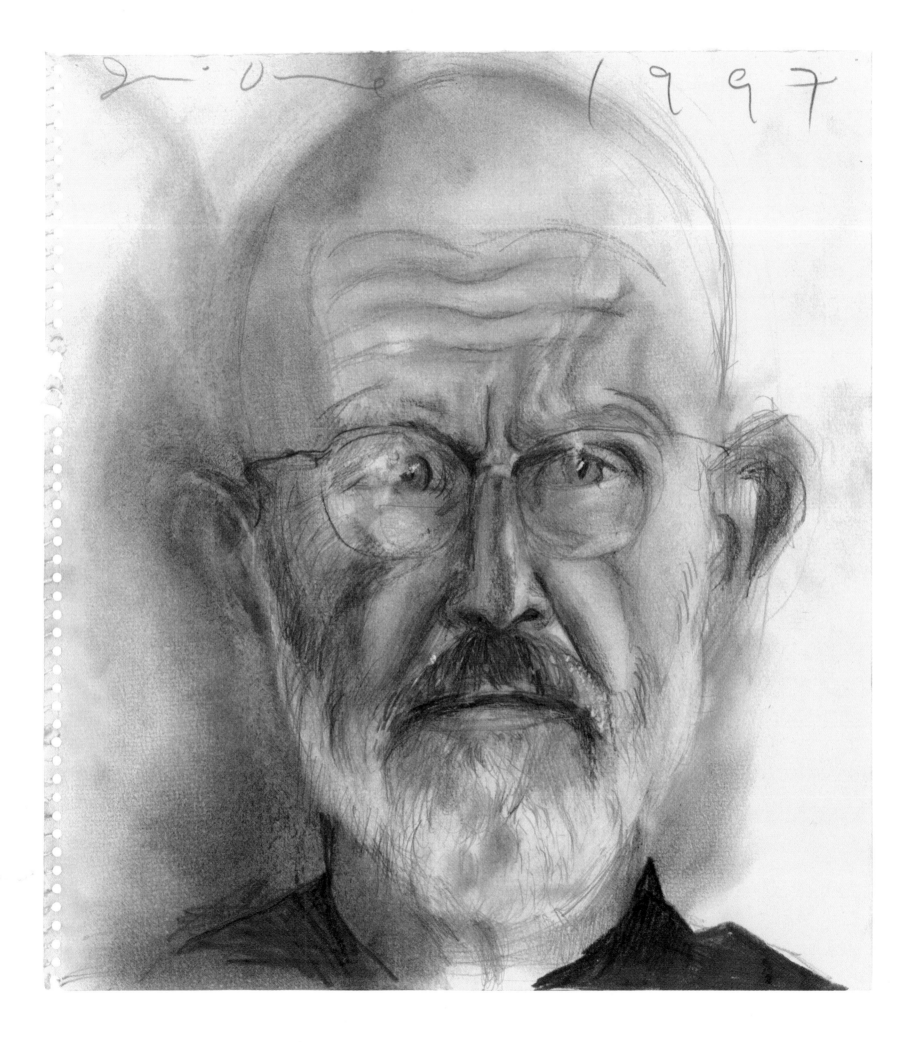

1997

41

9

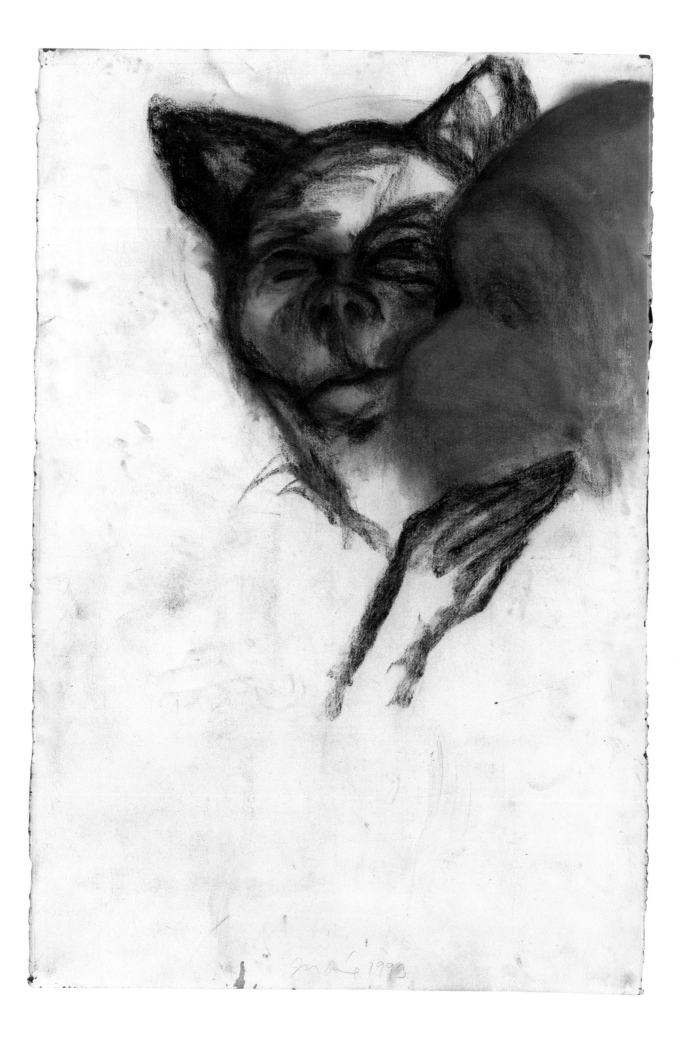

10

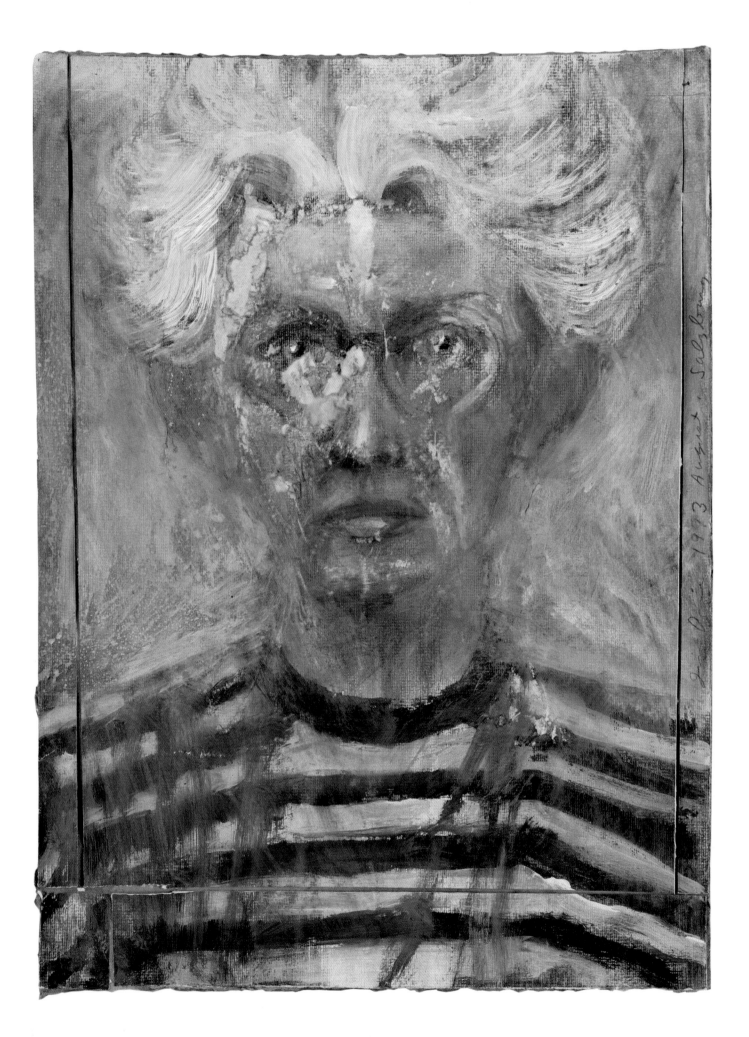

11

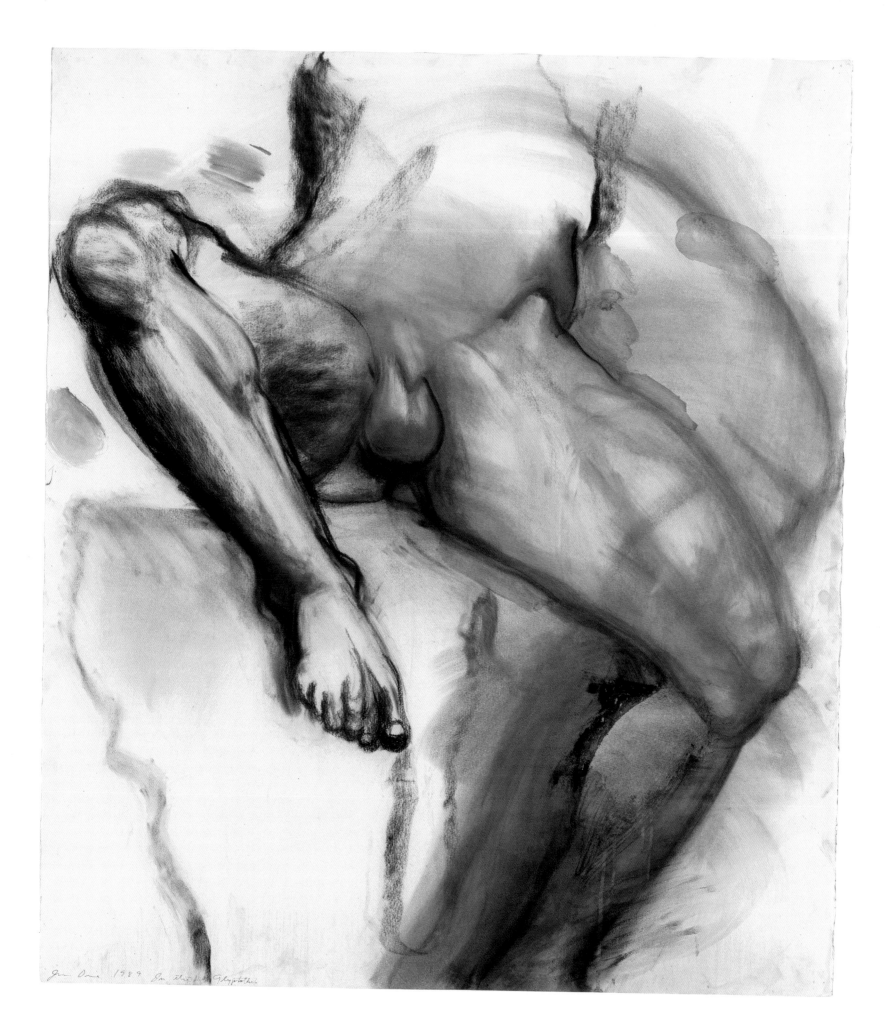

Jim Dine 1989 On the floor Glyptothek

12

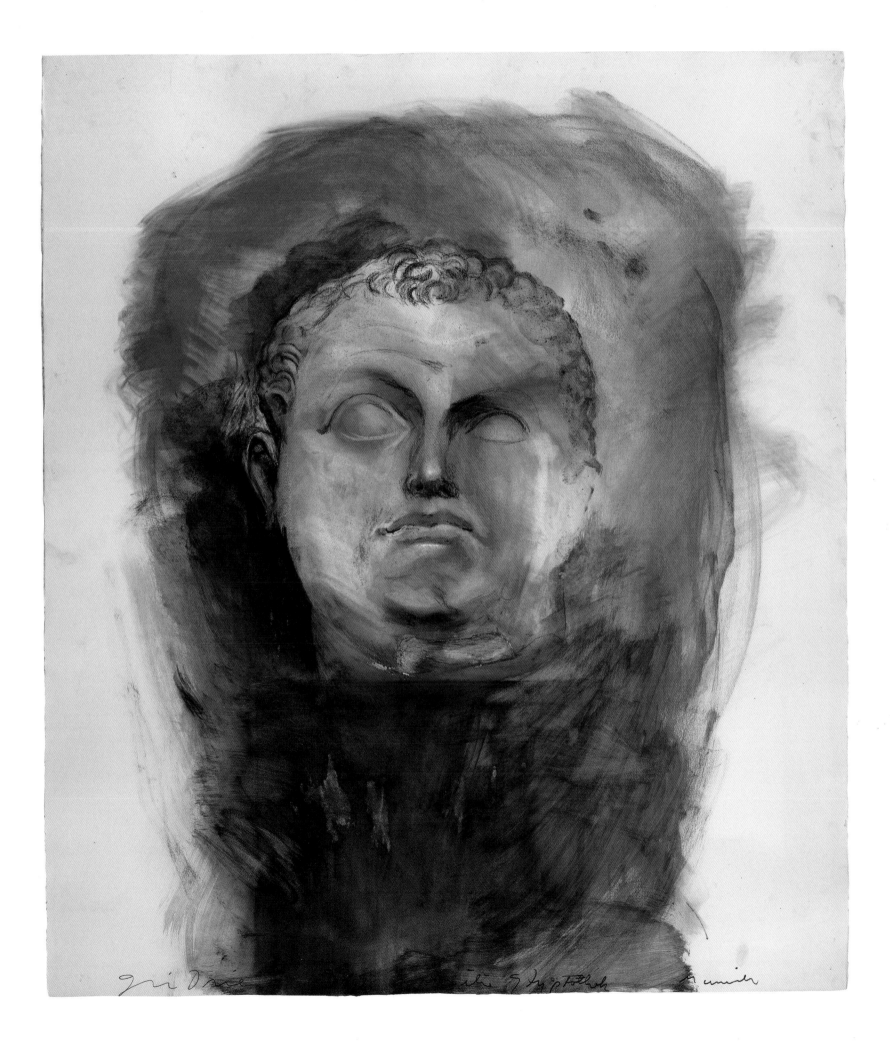

13

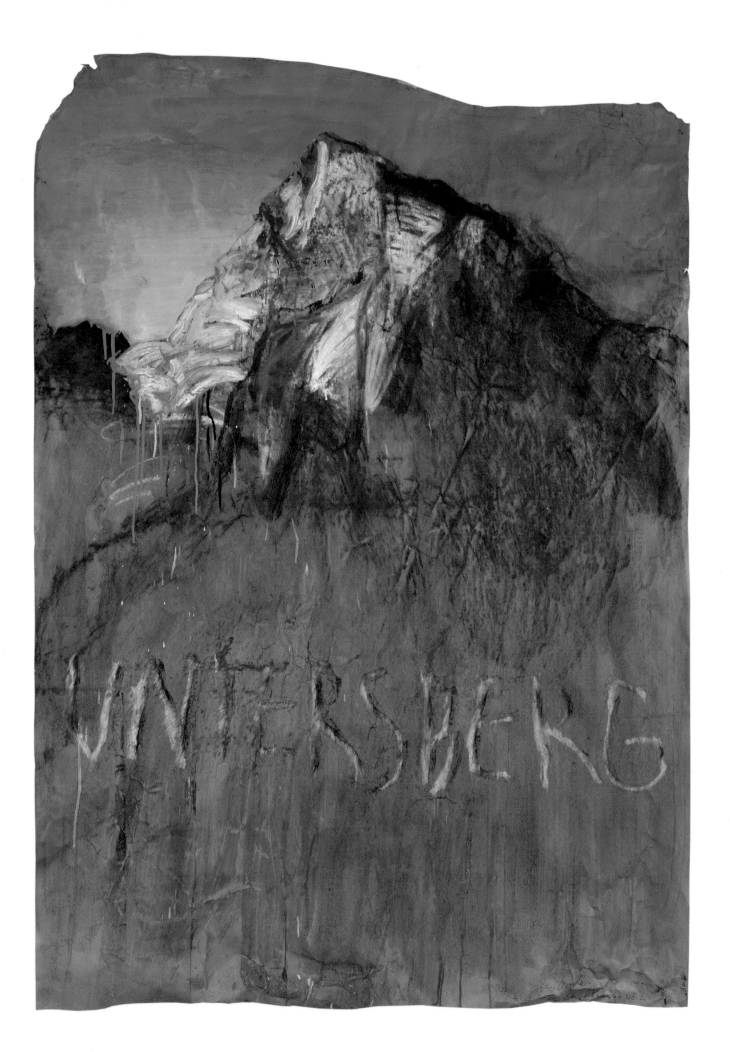

14

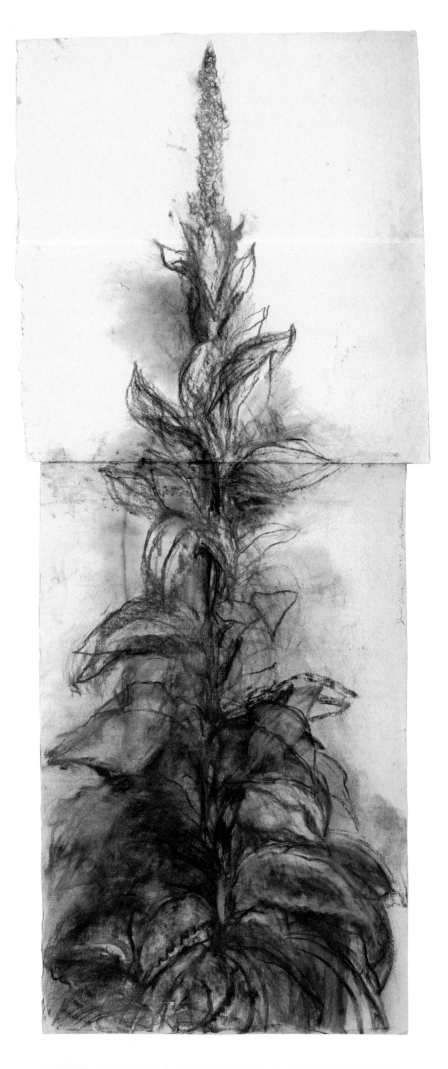

15

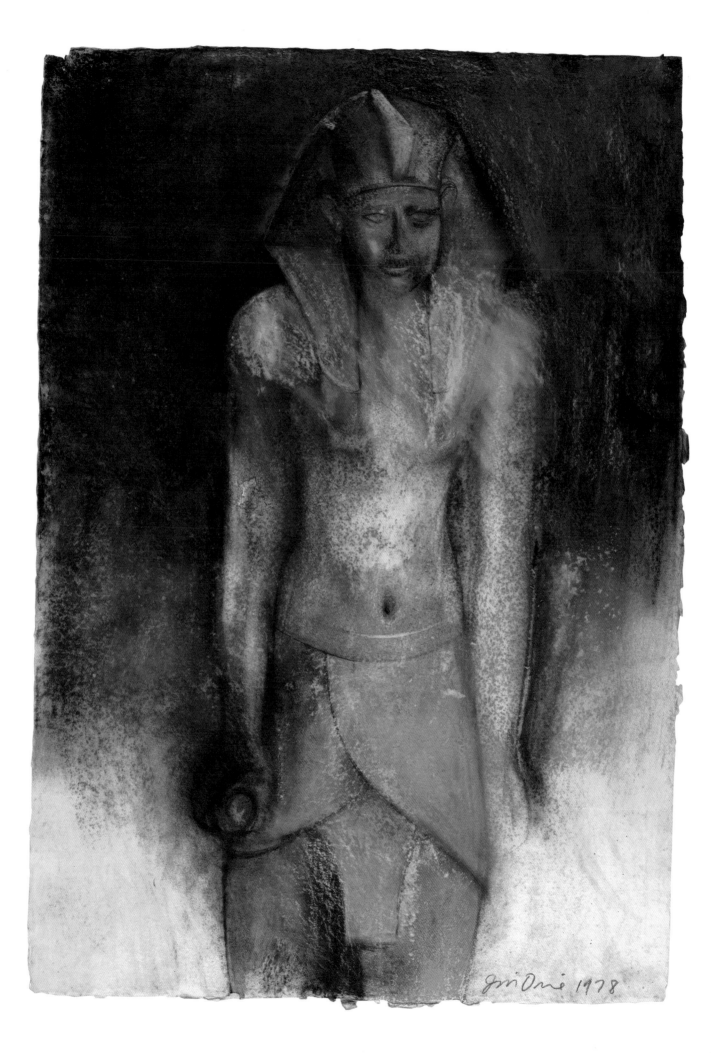

16

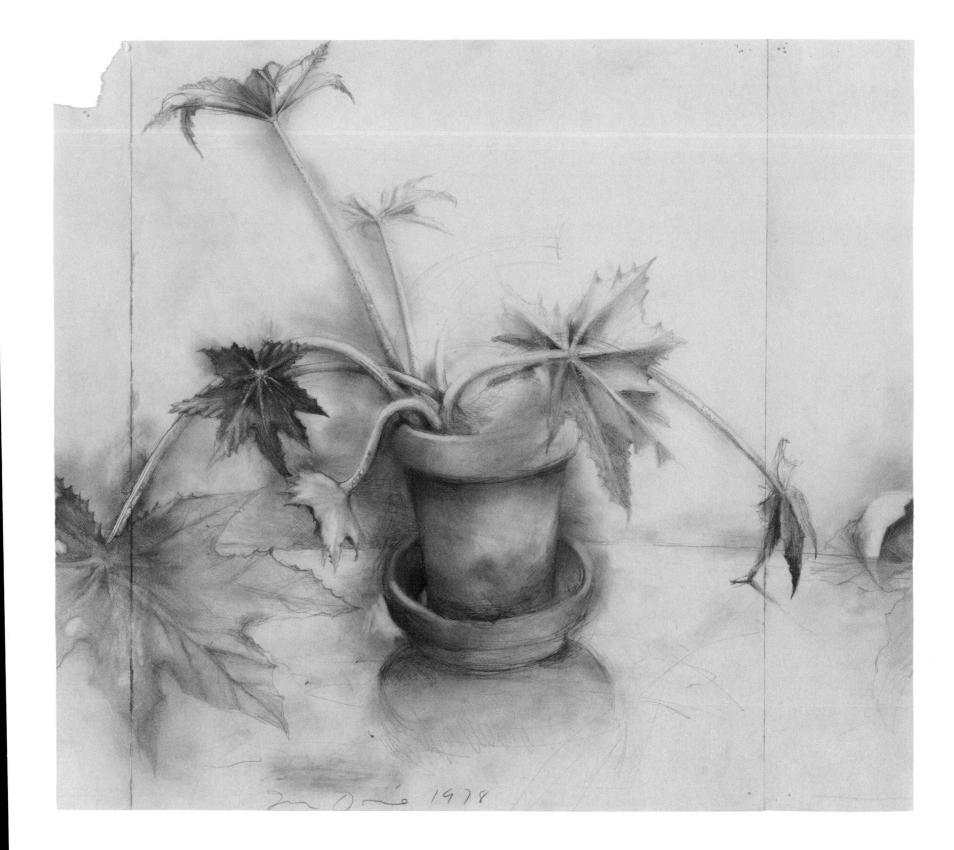

1978

17

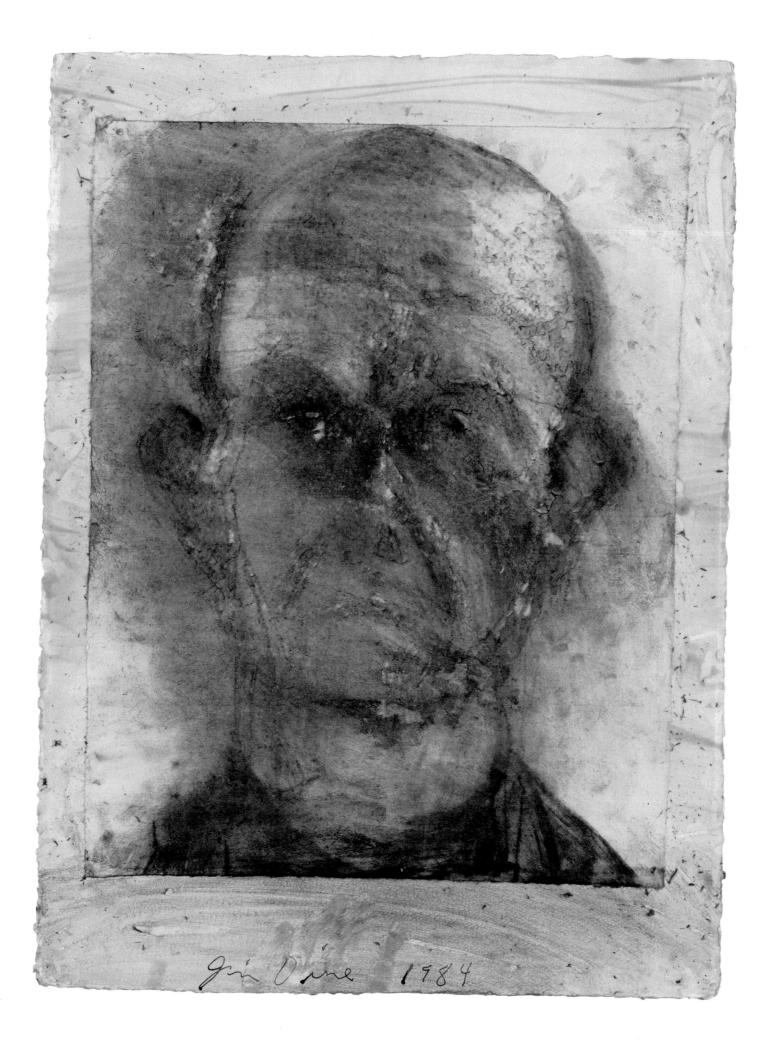

Jim Dine 1984

18

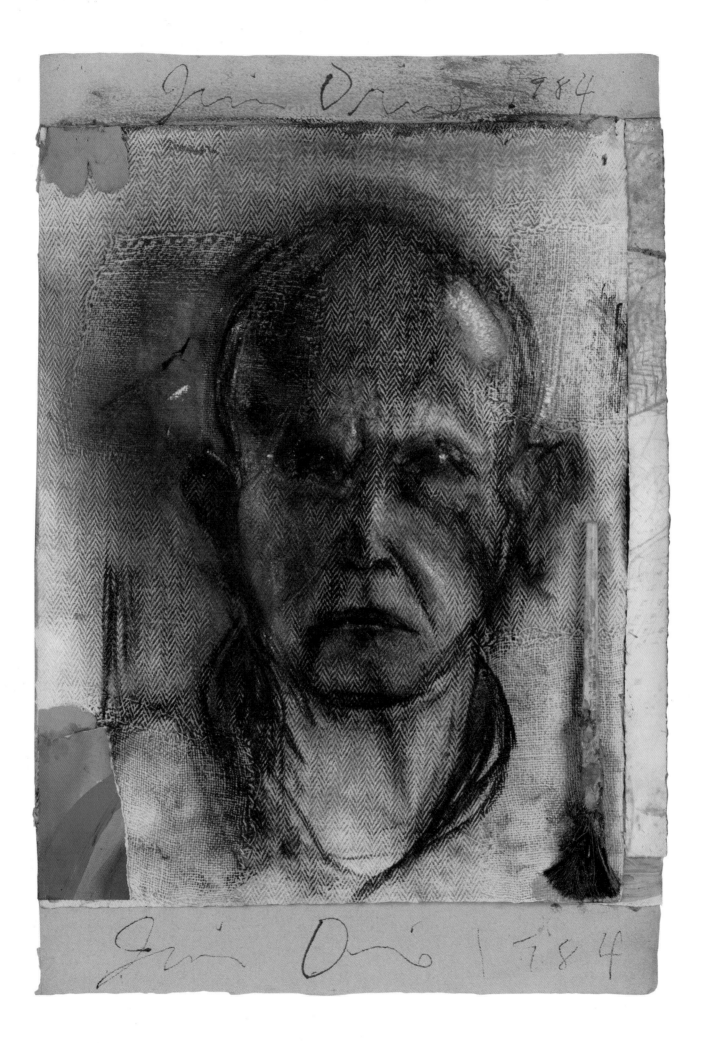

19

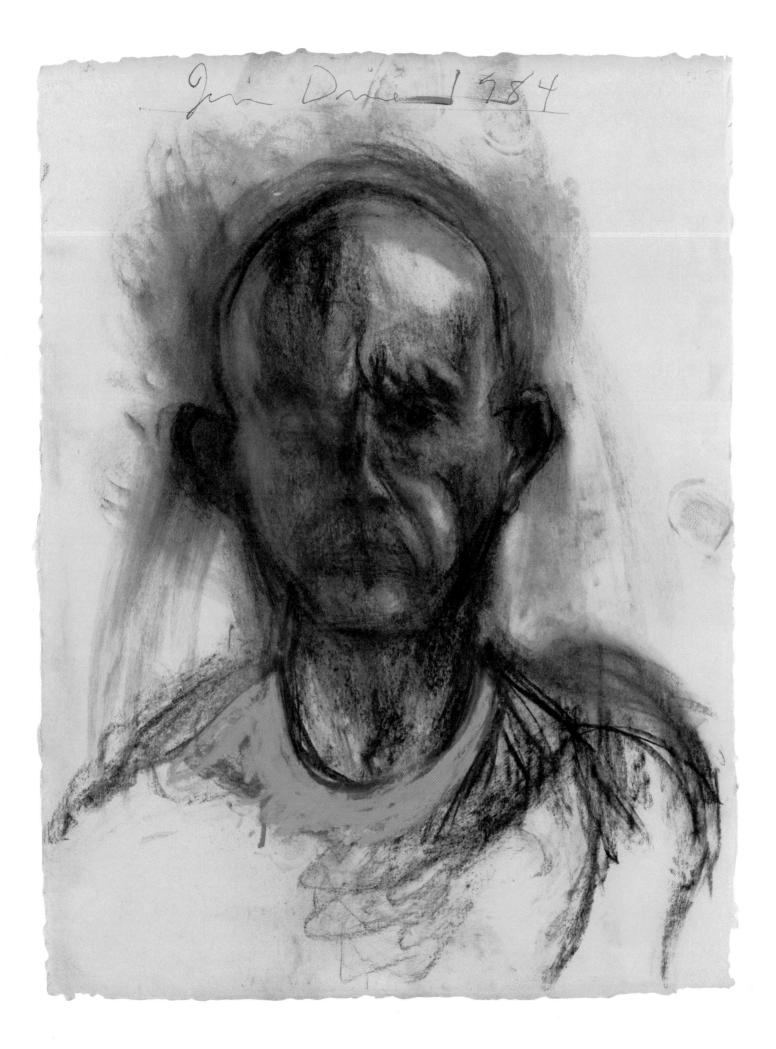

Jim Dine — 1984

20

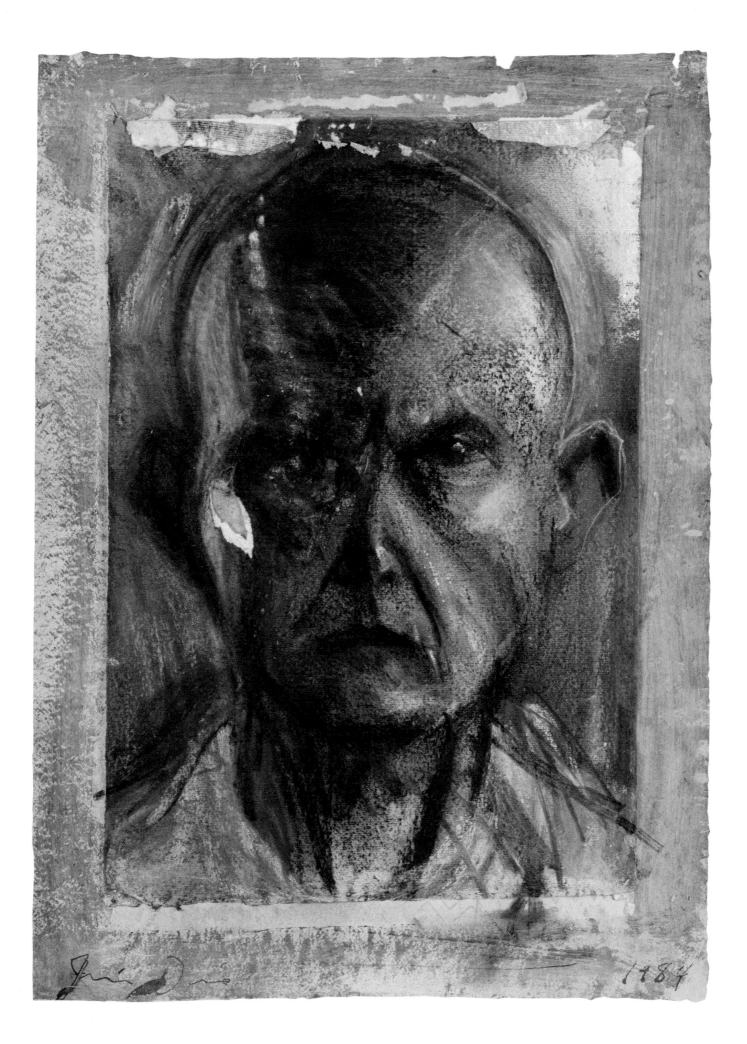

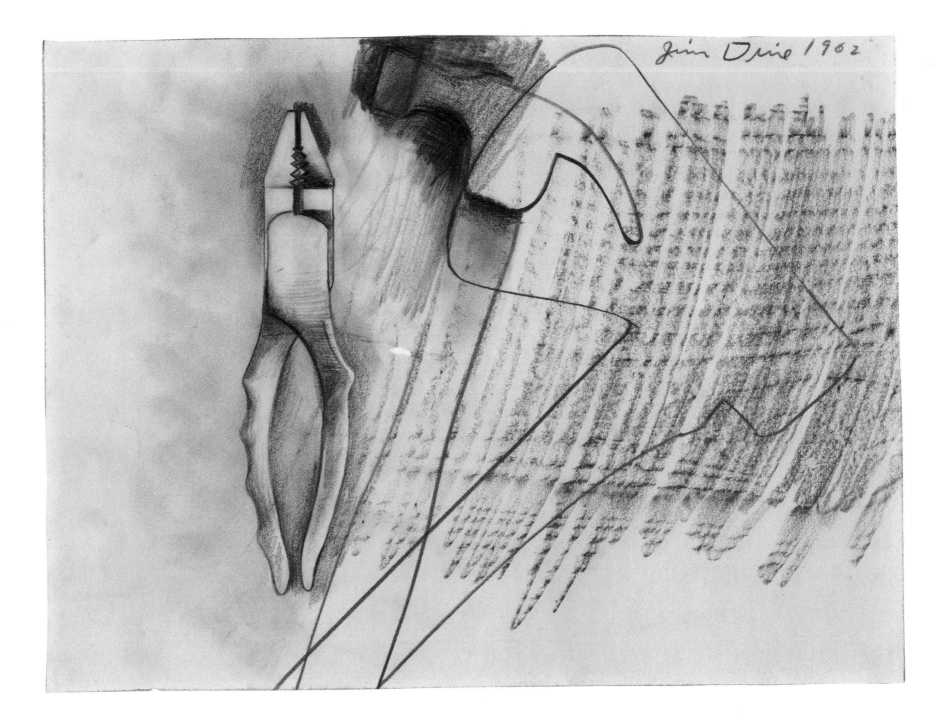

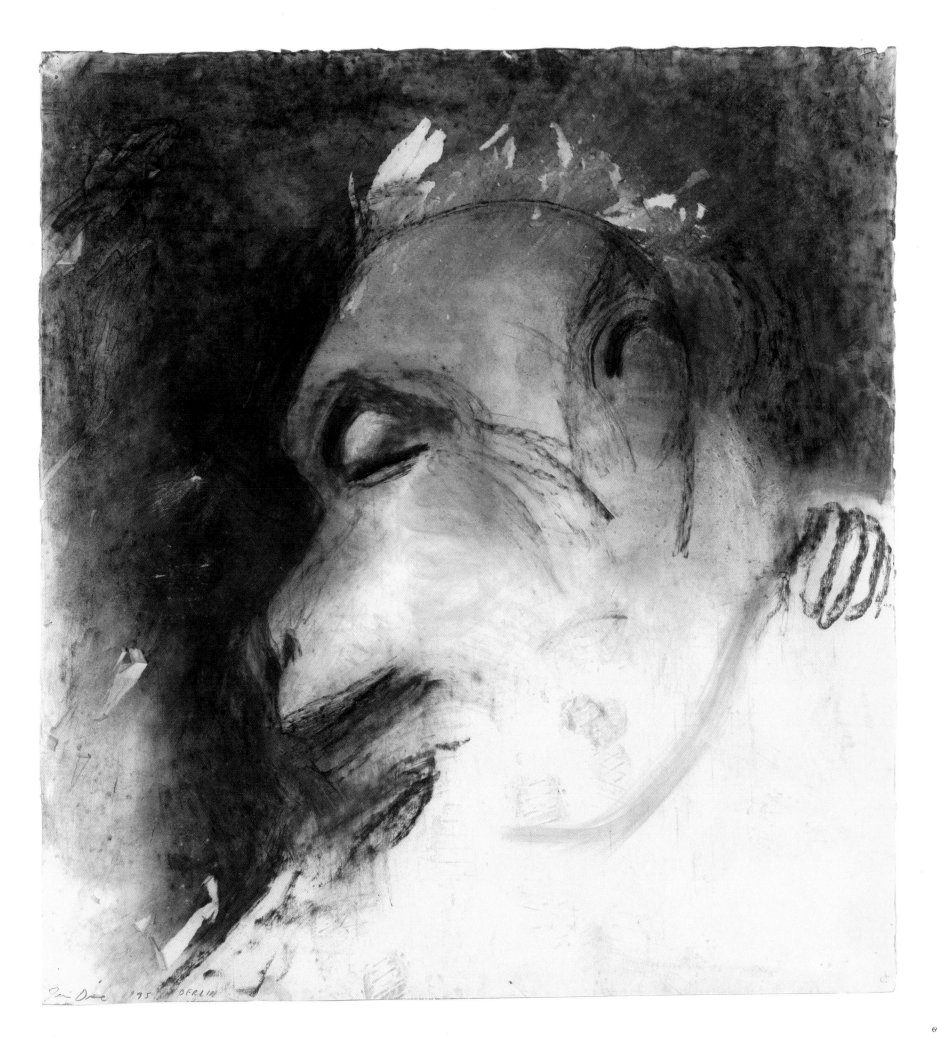

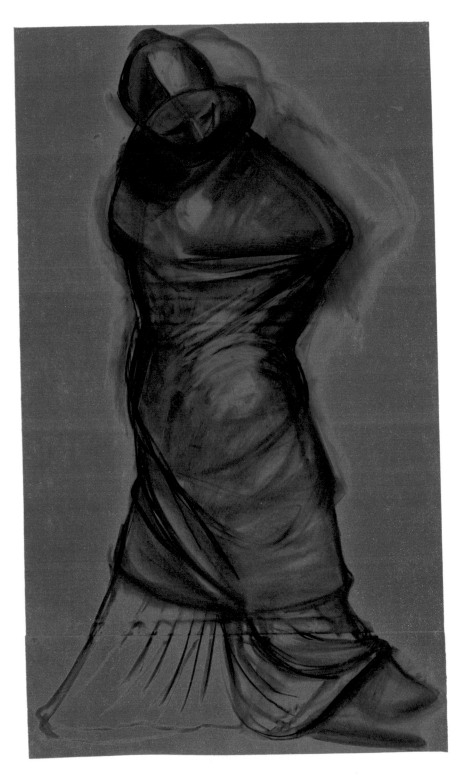
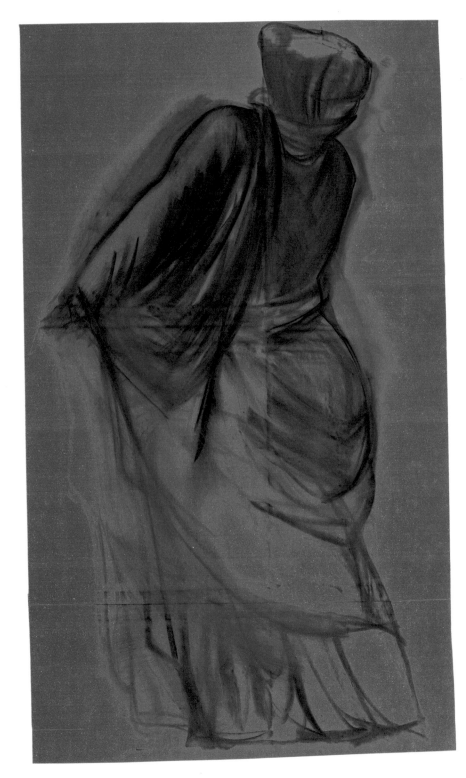

23

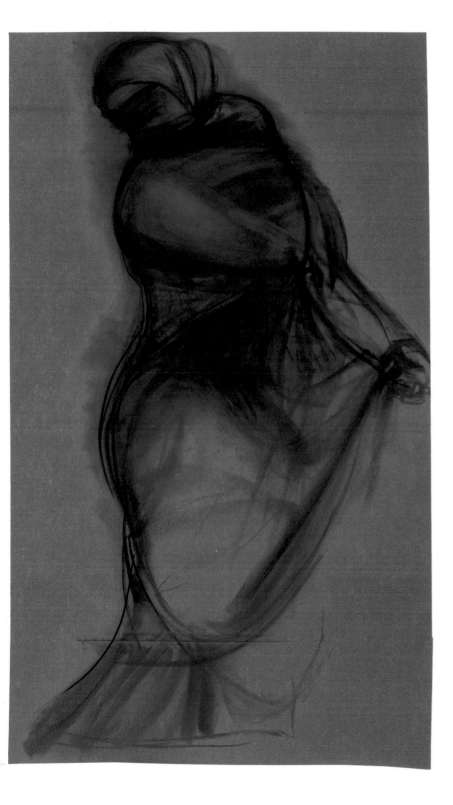
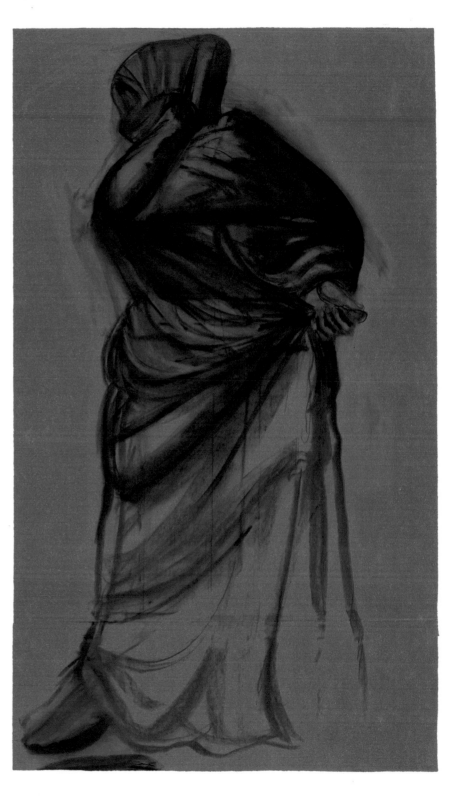

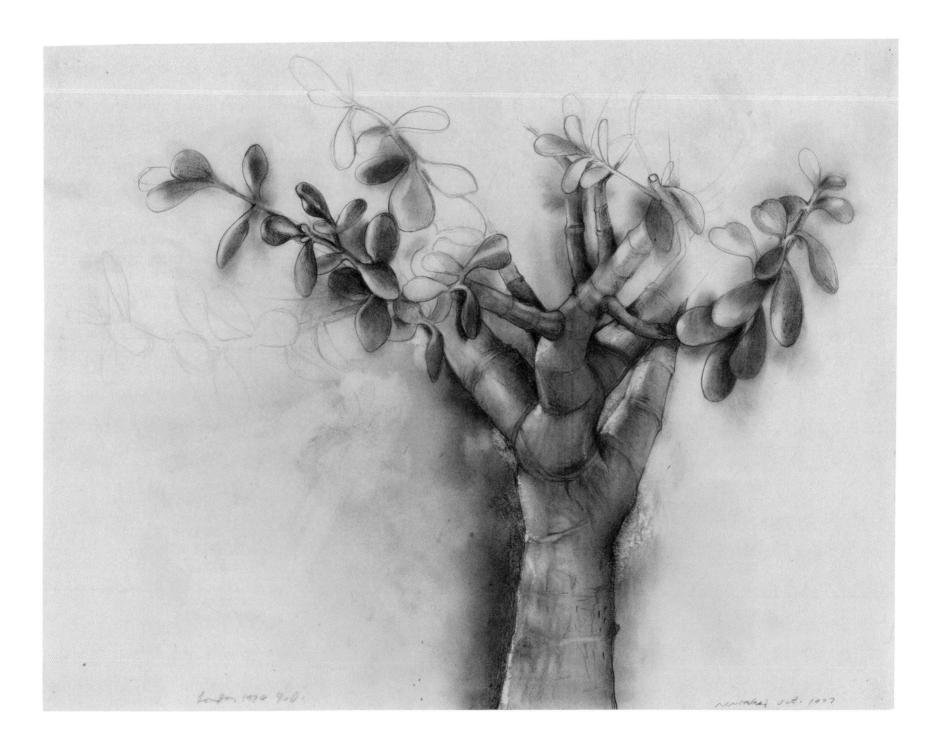

London 1976 9.0. reworked oct. 1977

25

THE HENLEY COLLEGE LIBRARY

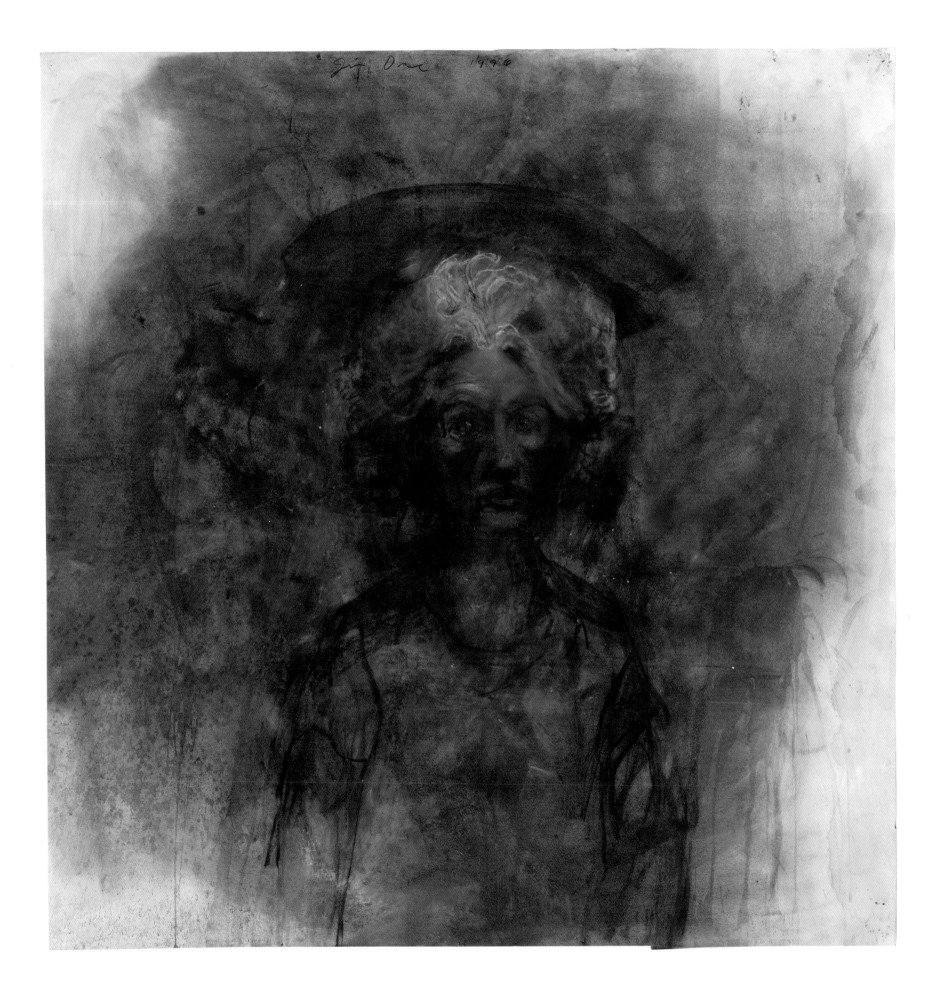

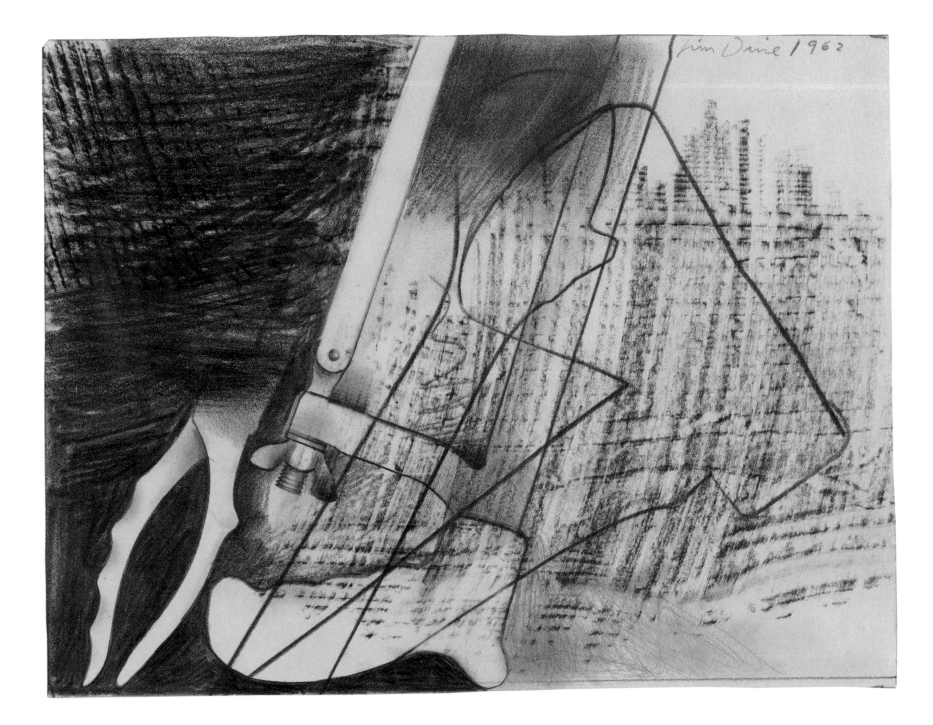

27

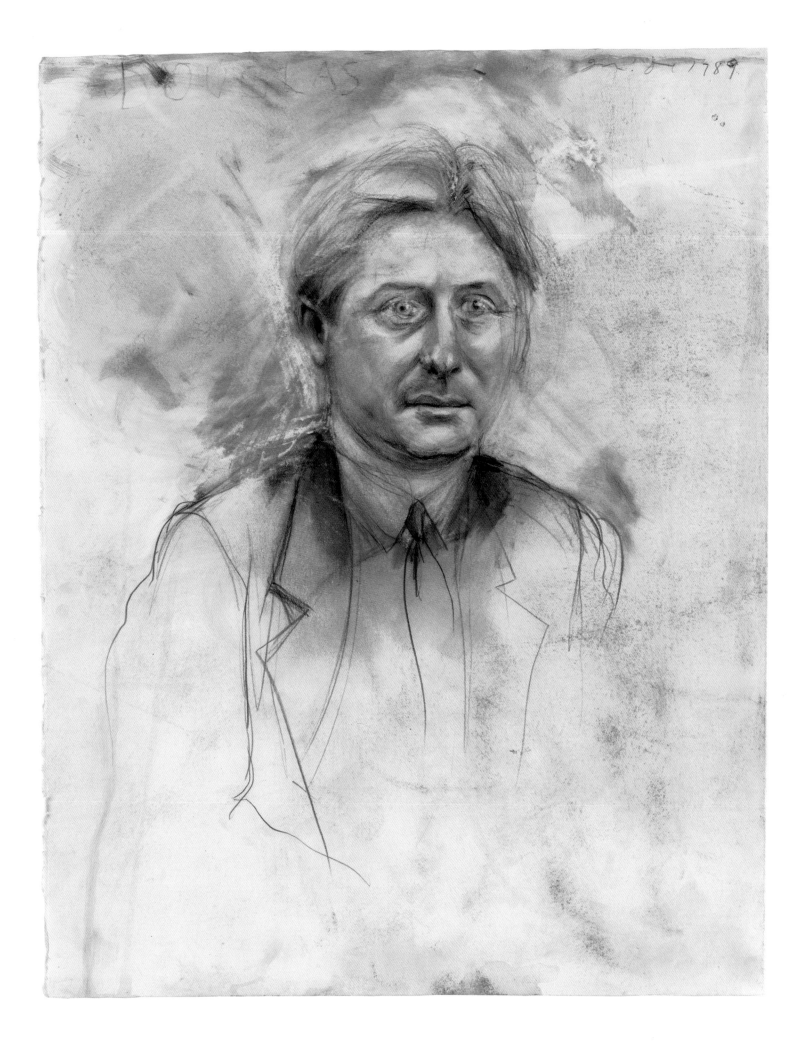

79

28

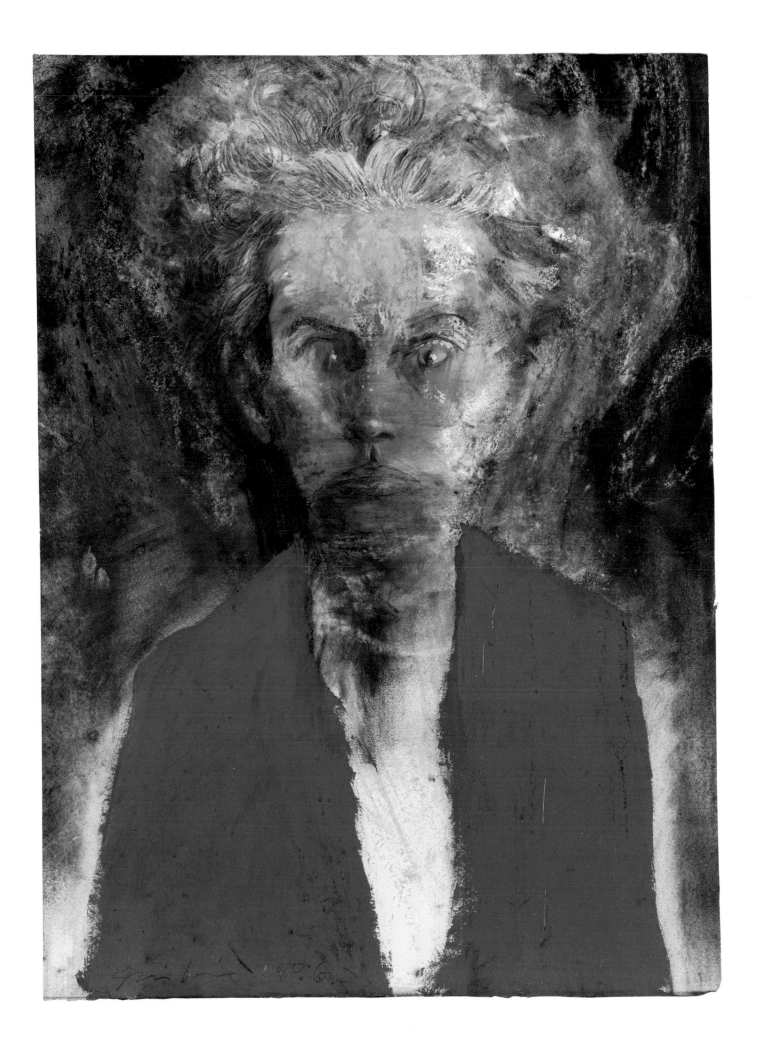

29

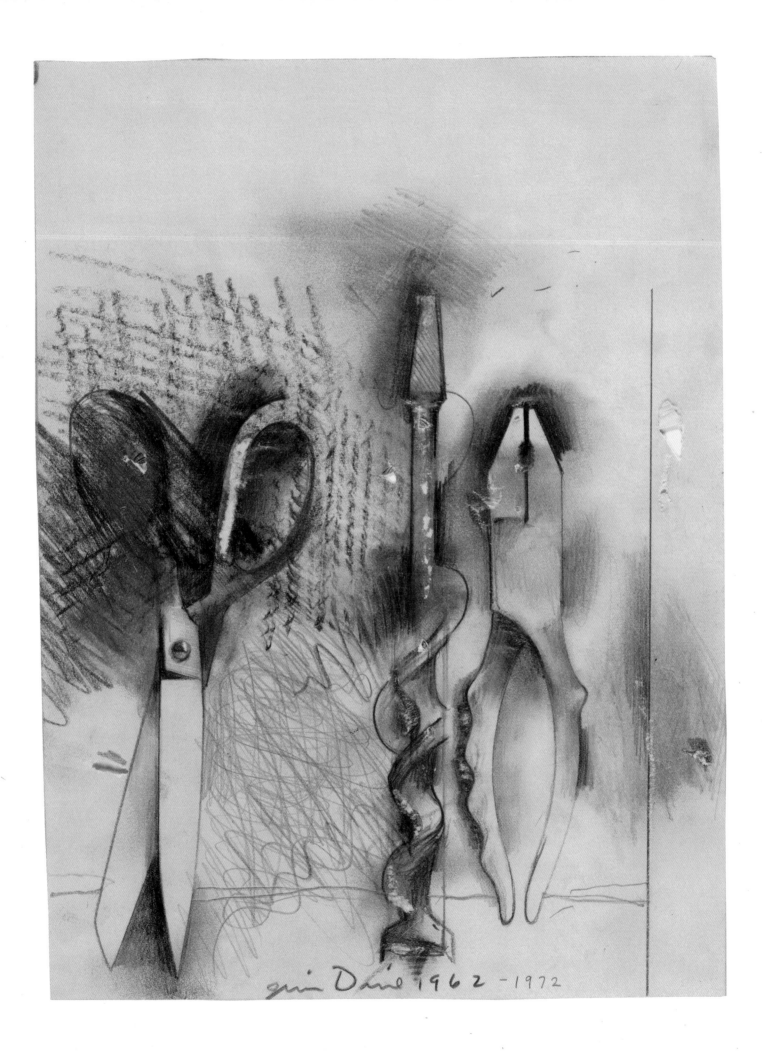

gin David 1962 – 1972

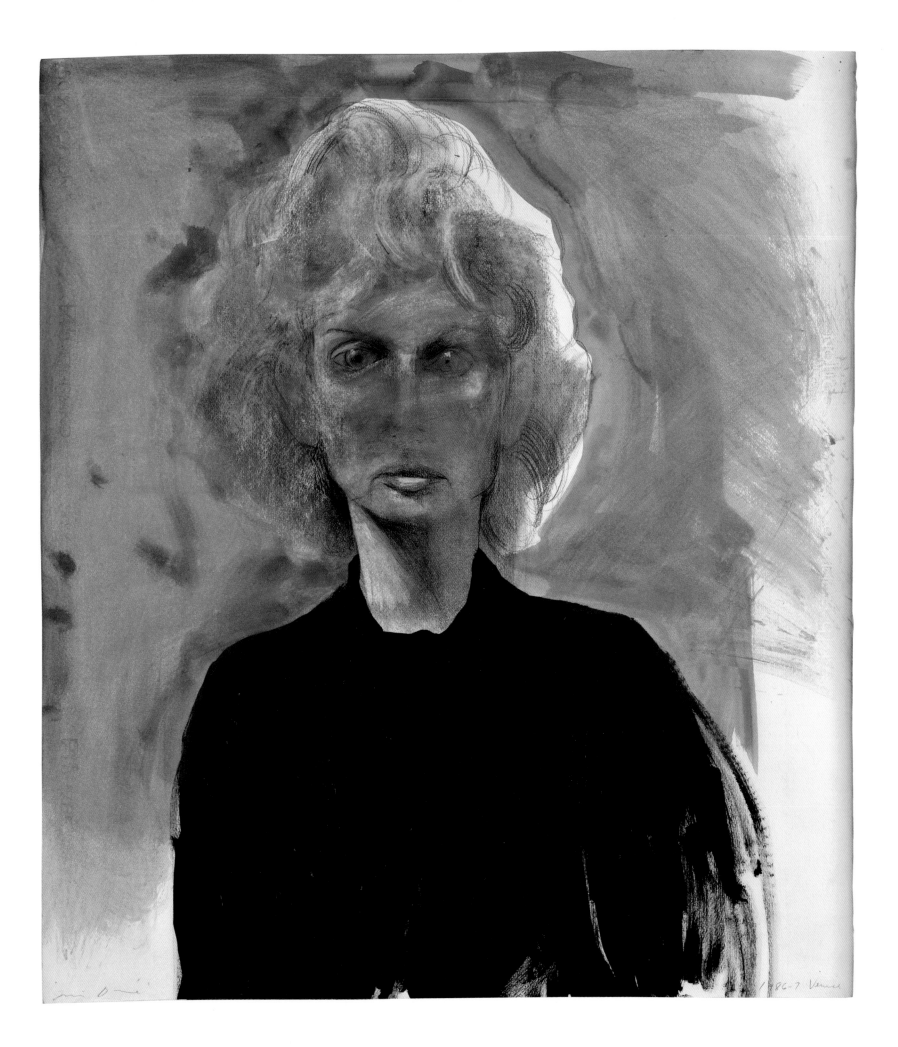

31

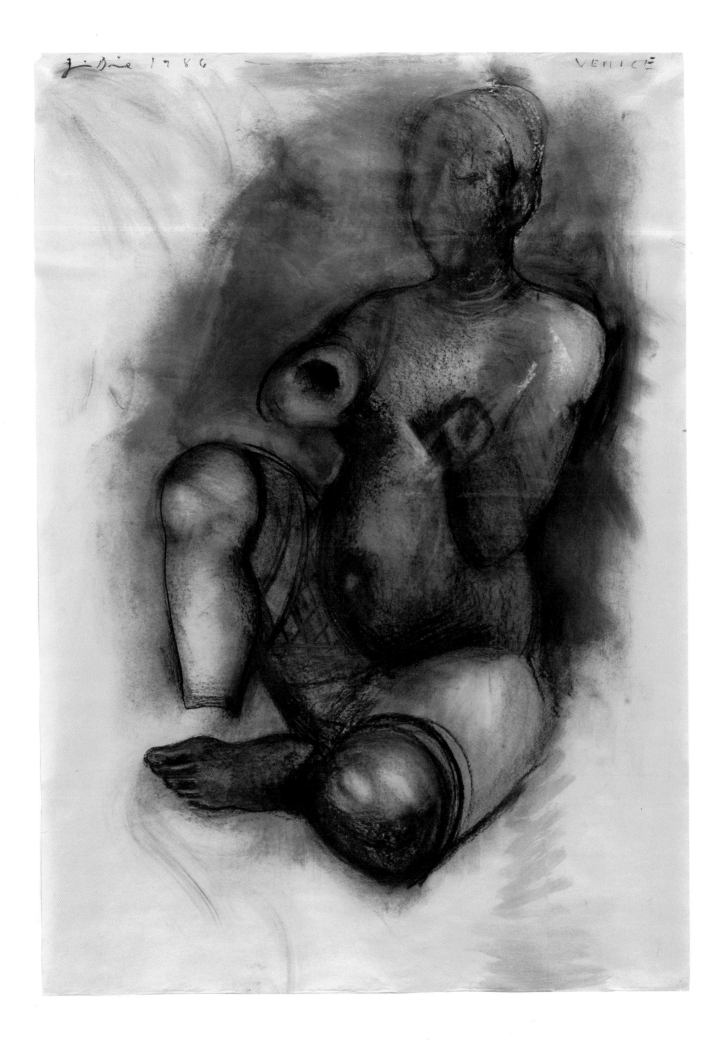

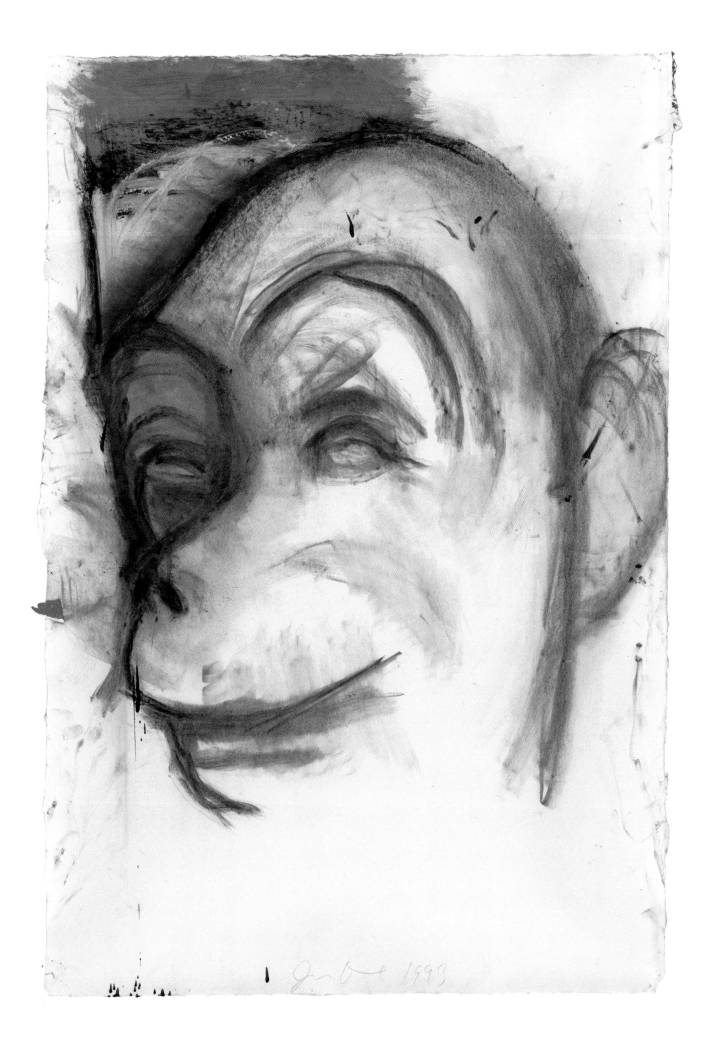

33

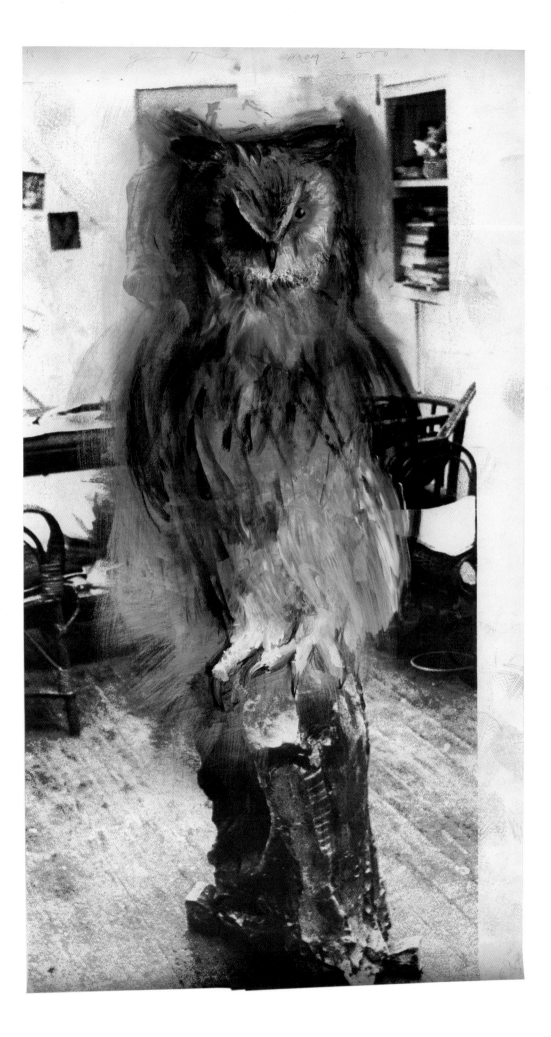

34

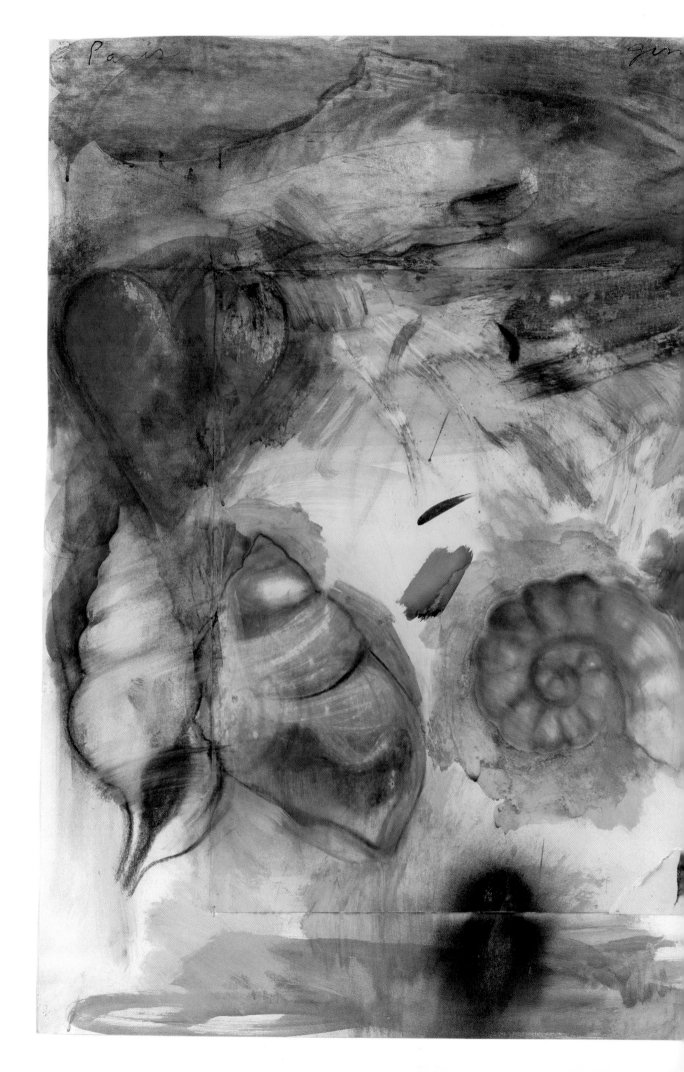

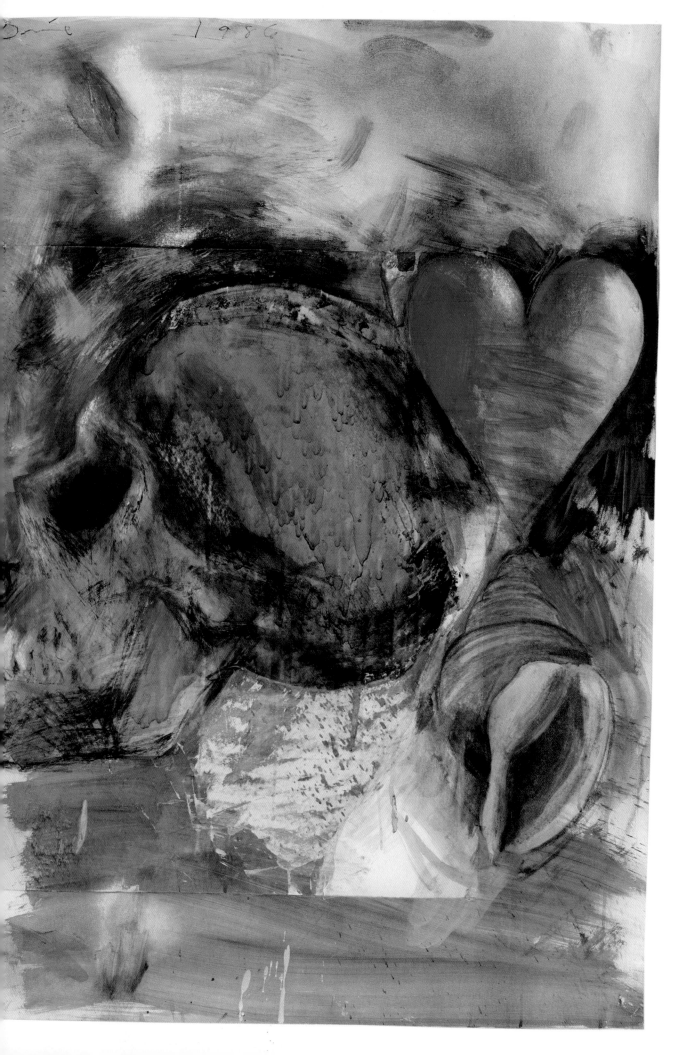

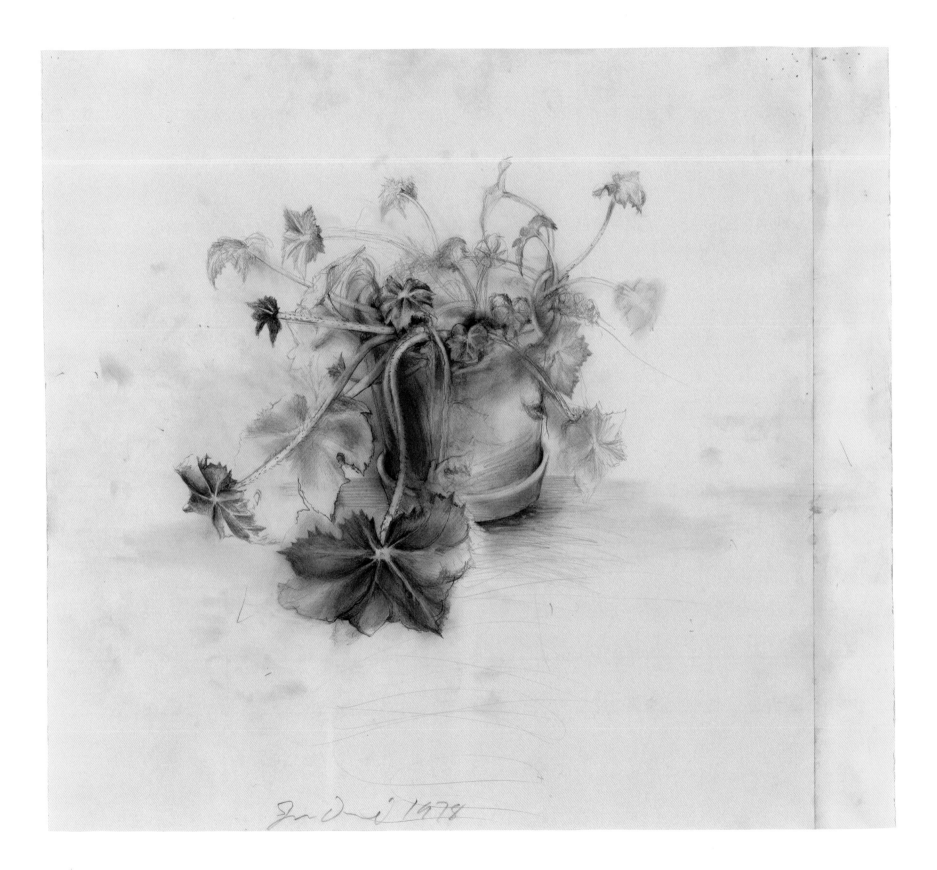

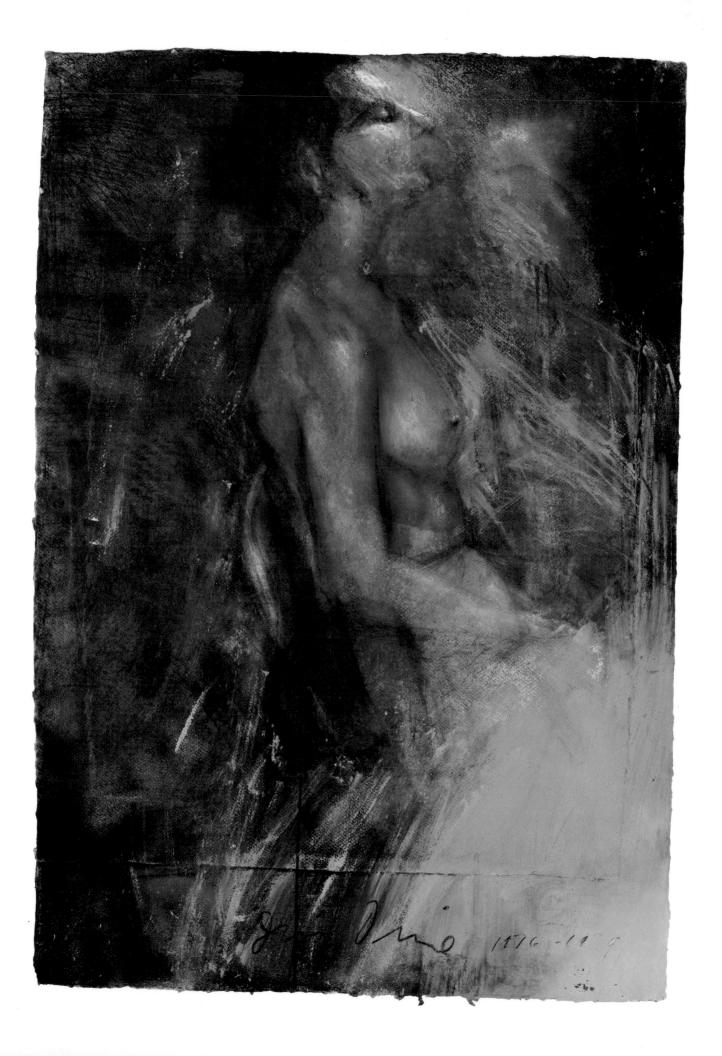

37

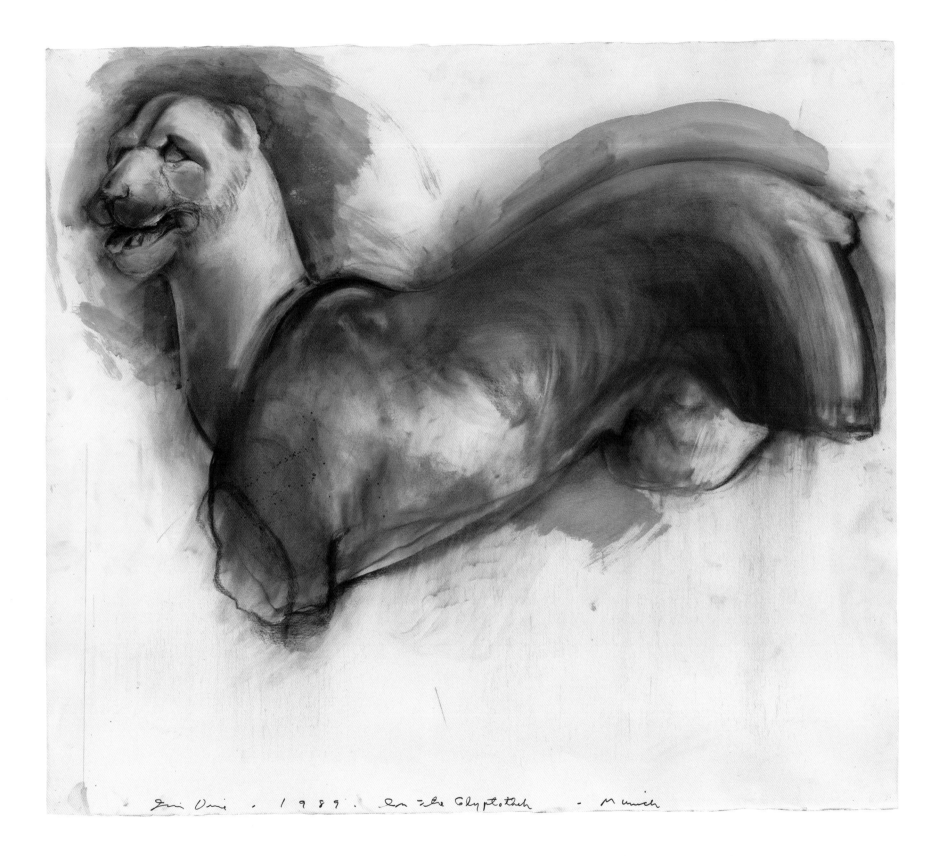

Erri Uni . 1 9 8 9 . On the Glyptothek - Munich

99

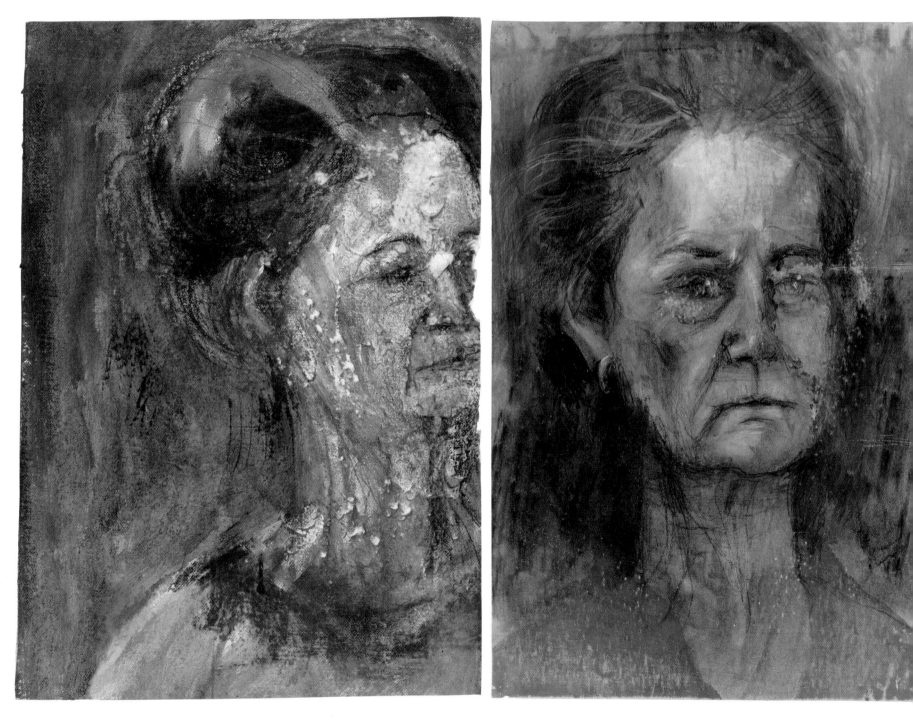

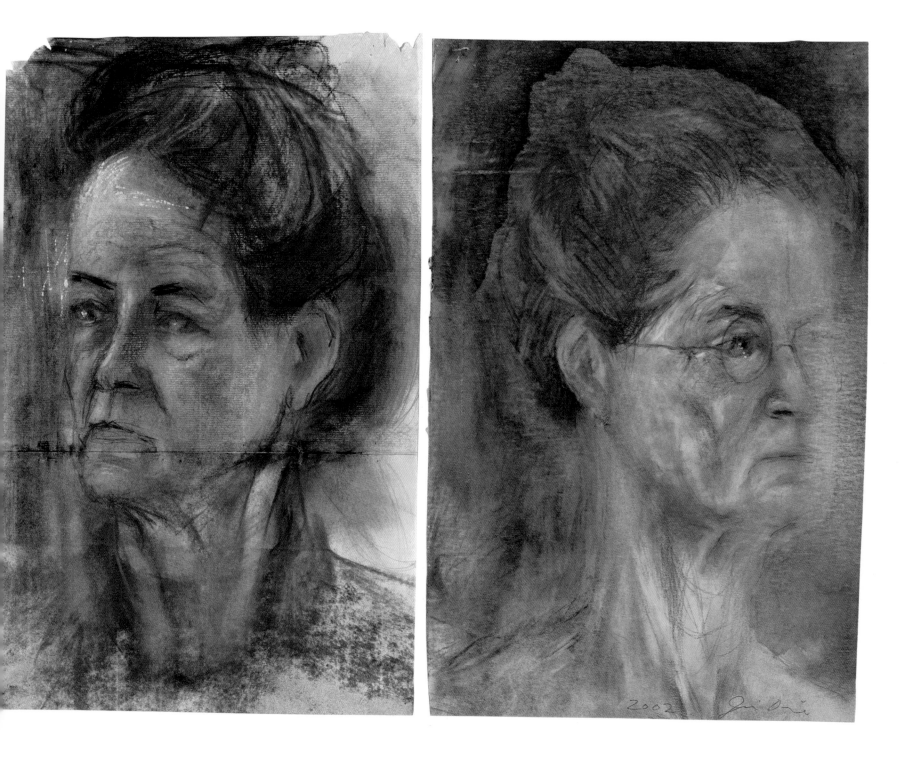

2002

39

THE HENLEY COLLEGE LIBRARY

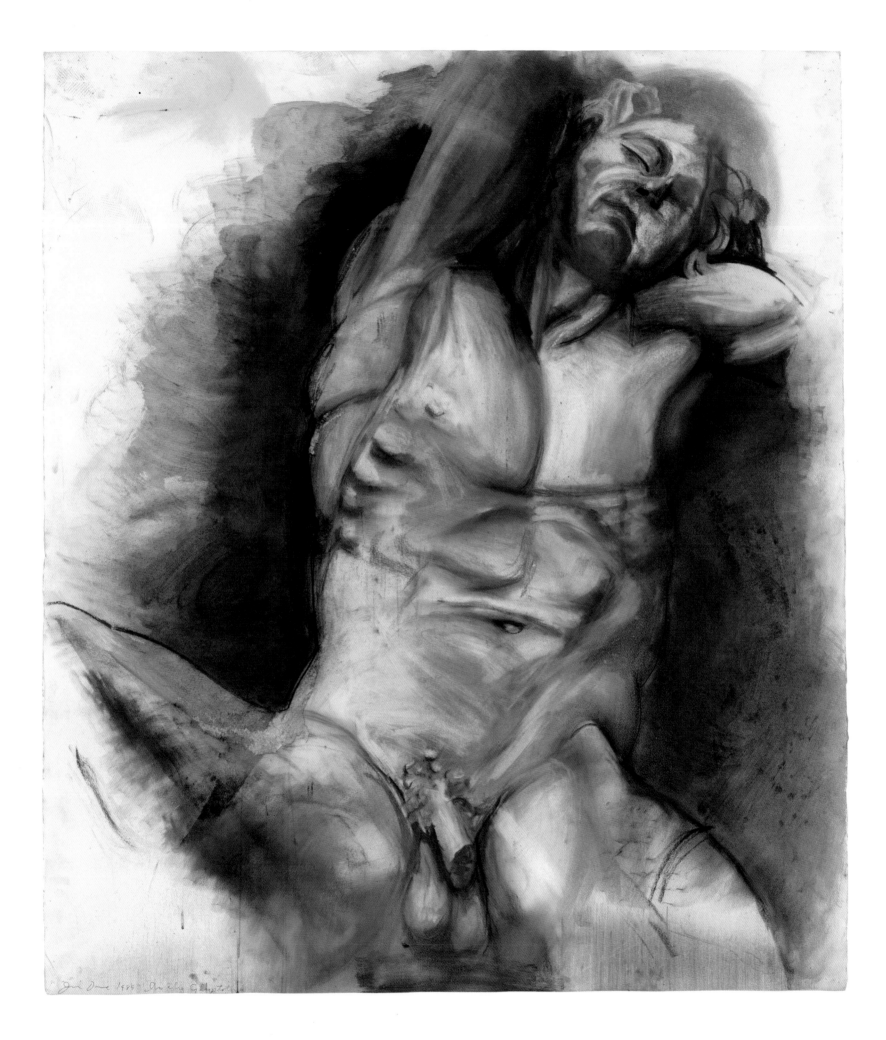

40

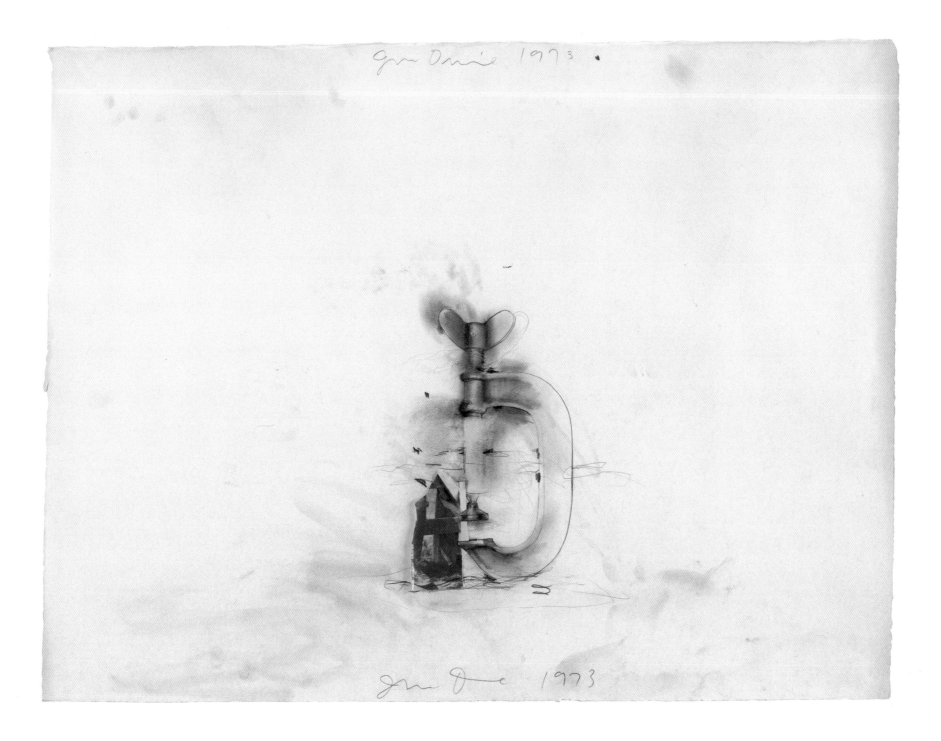

41

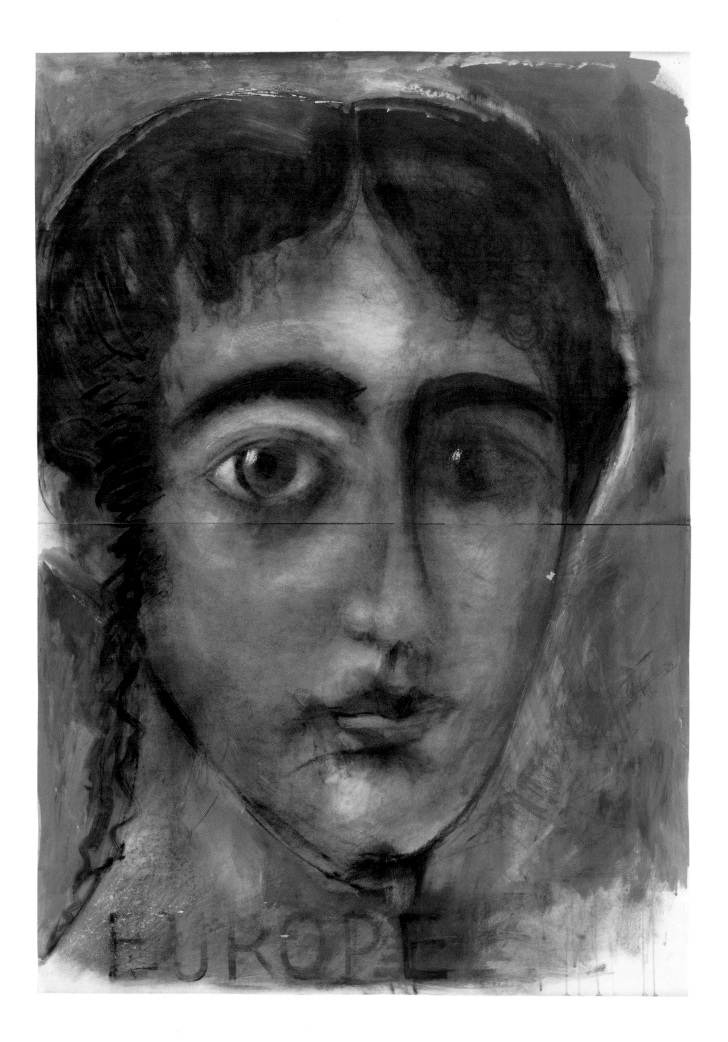

43

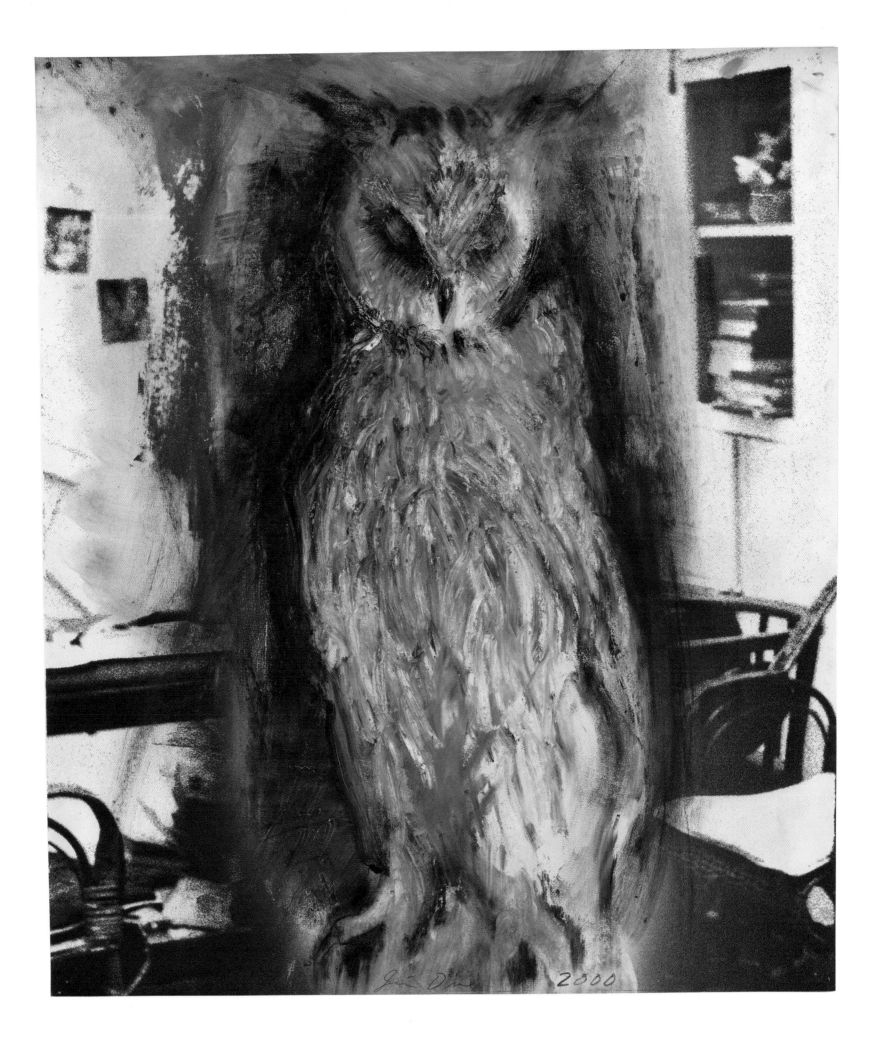

Jim Dine 2000

44

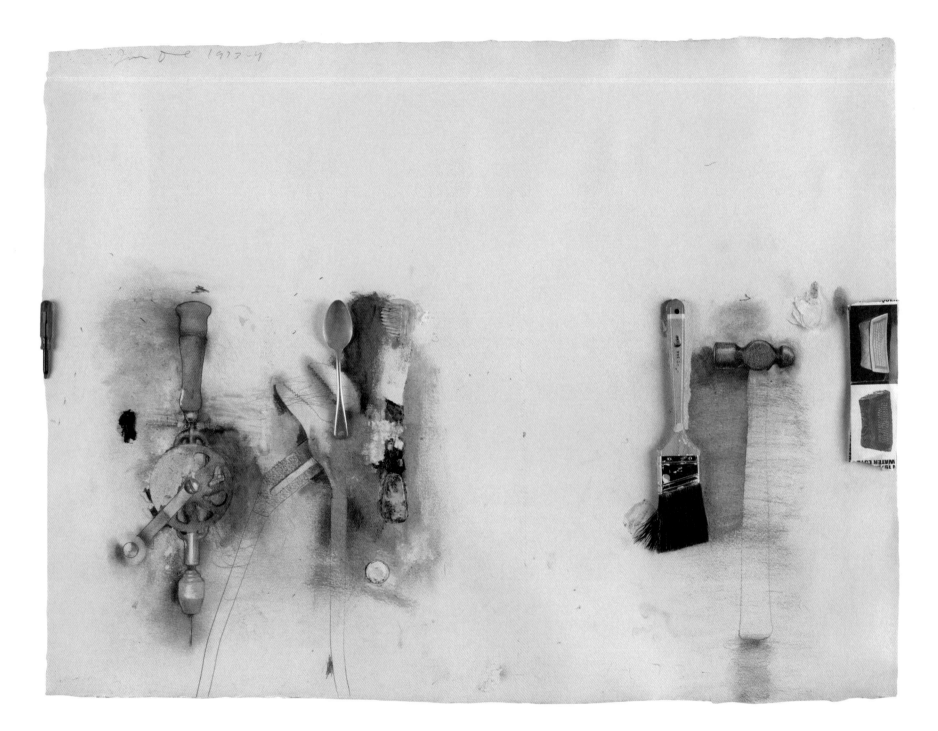

45

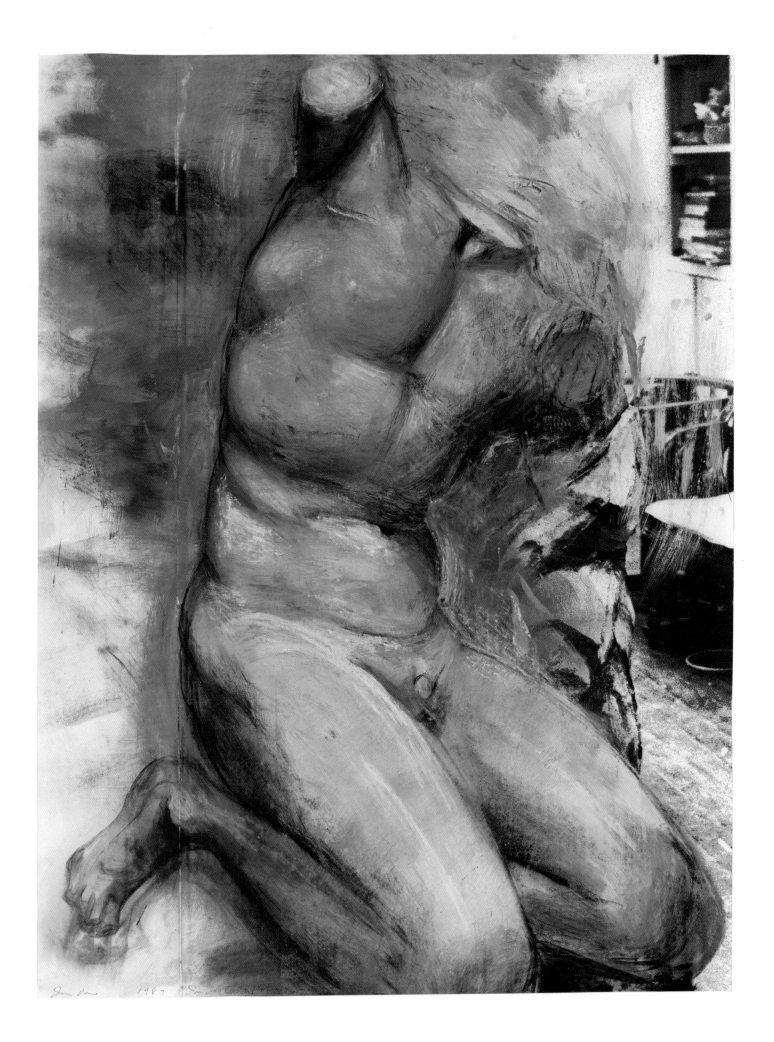

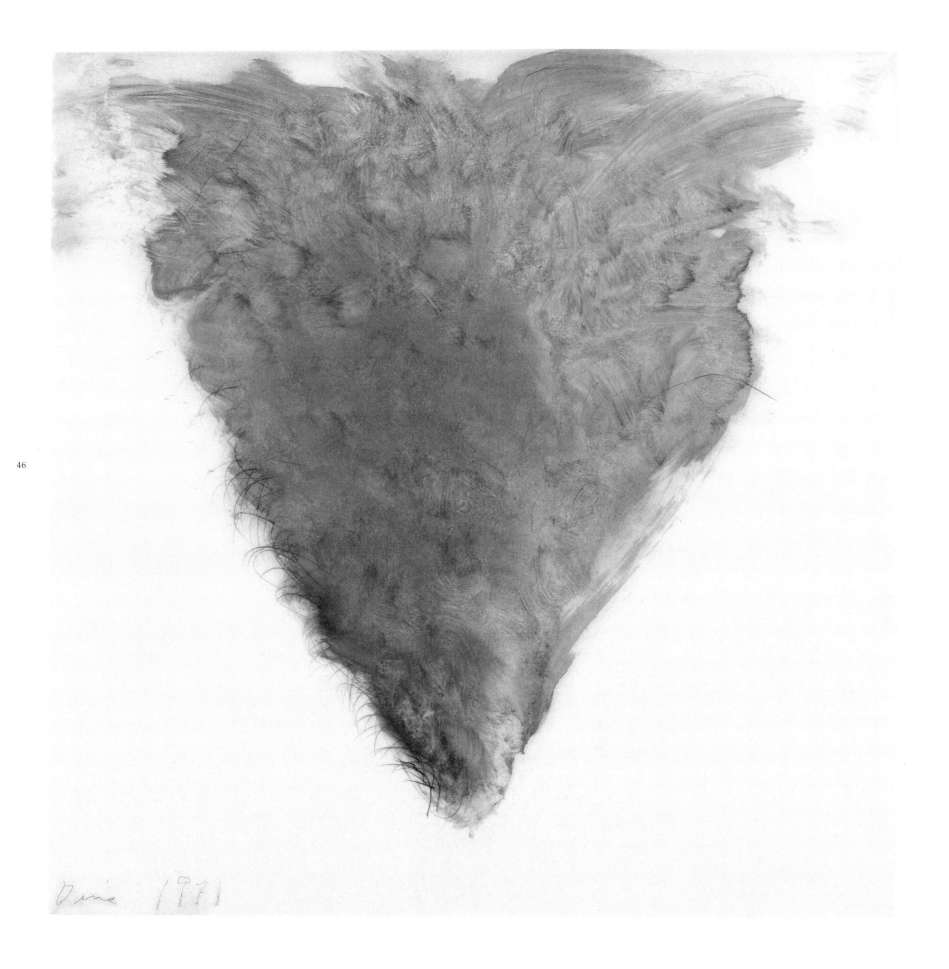

46

Dine 1971

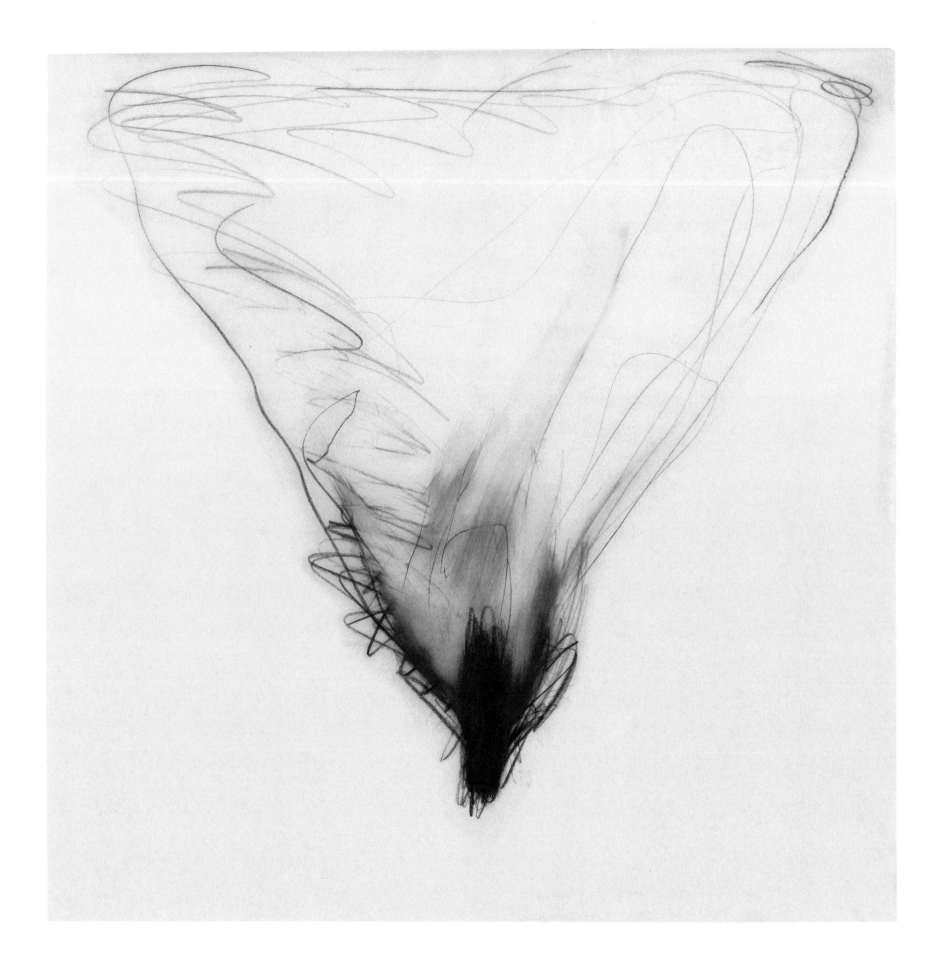

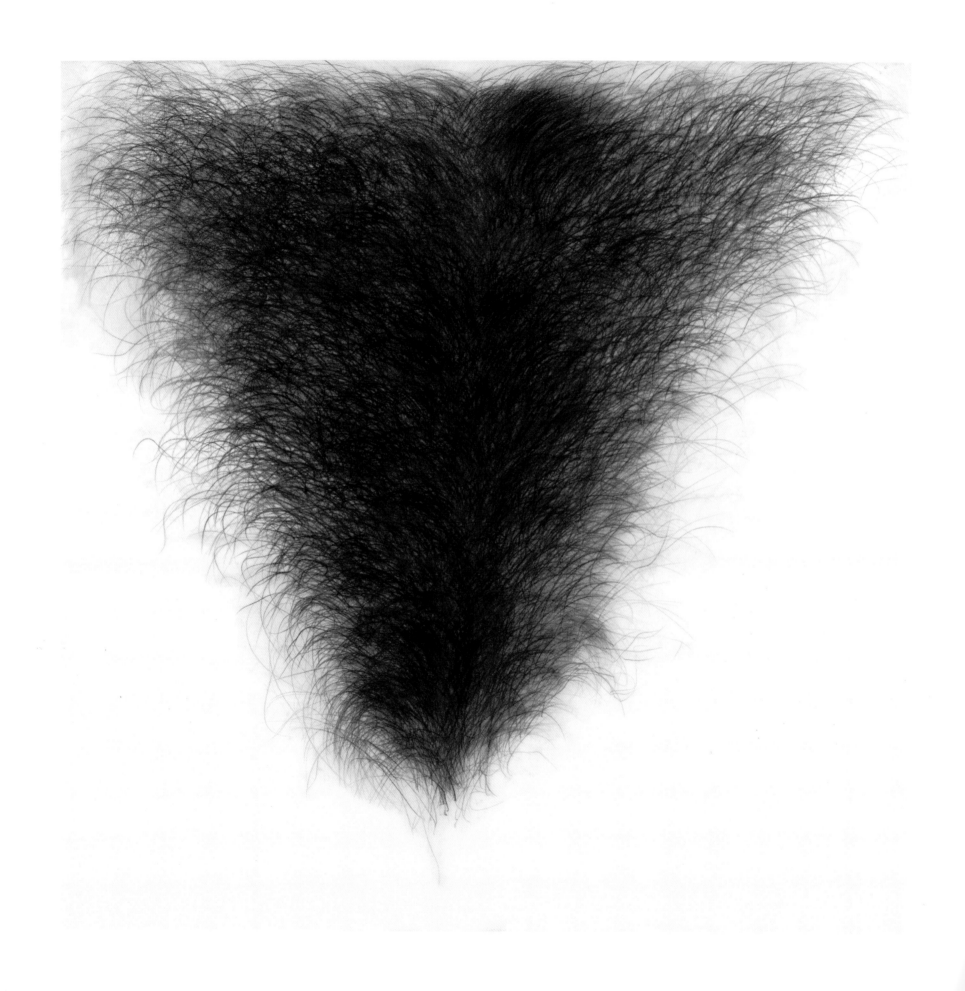

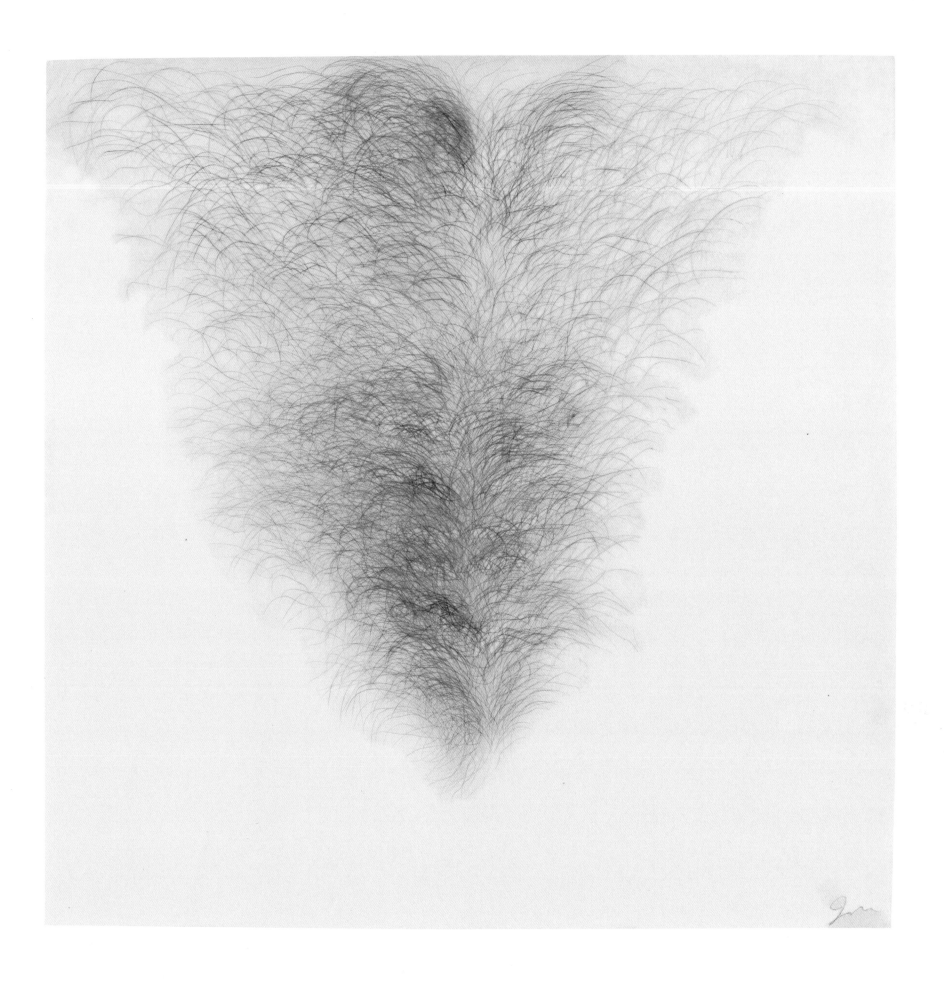

47

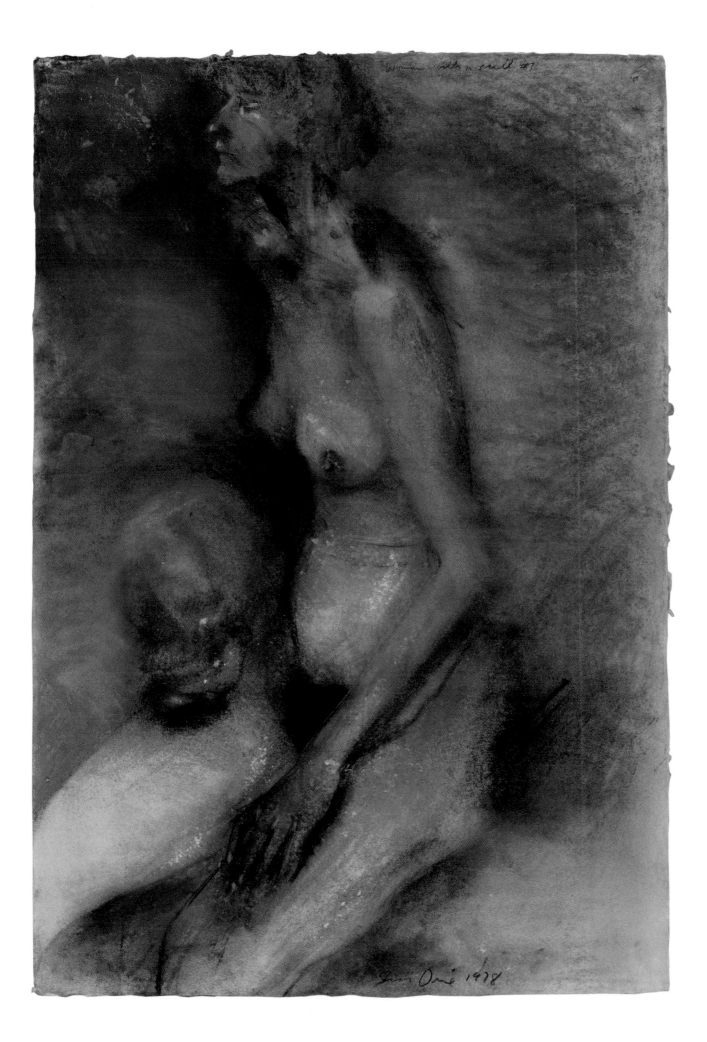

Woman with a skull #3

Don Orie 1978

48

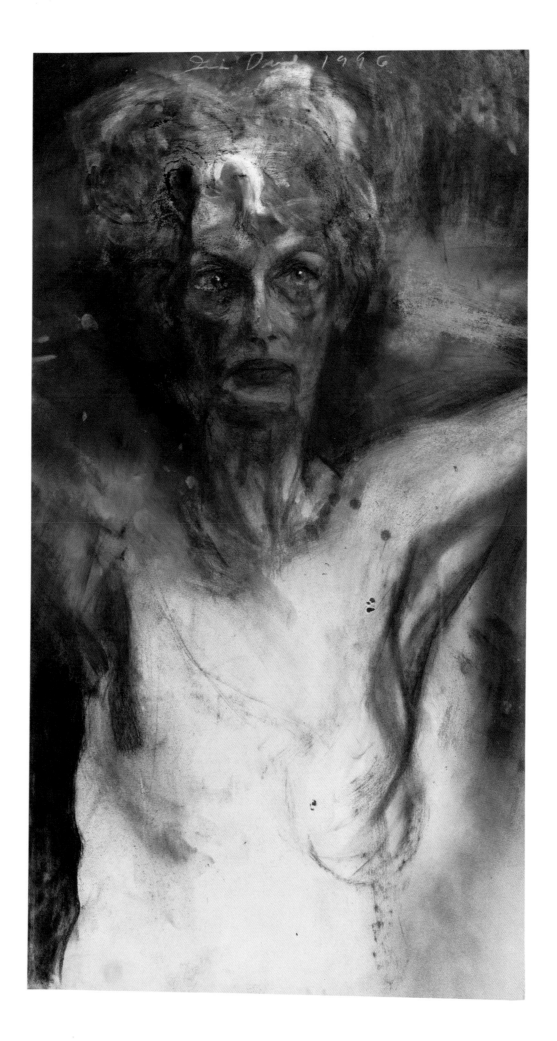

49

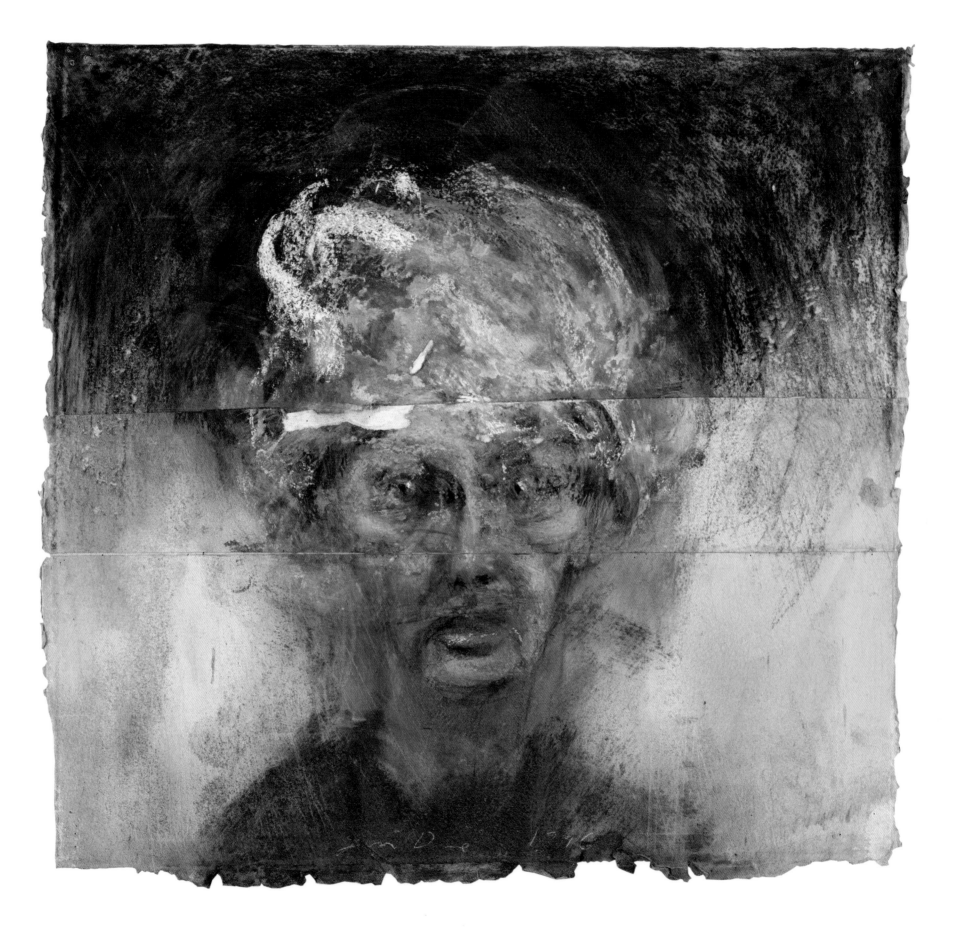

50

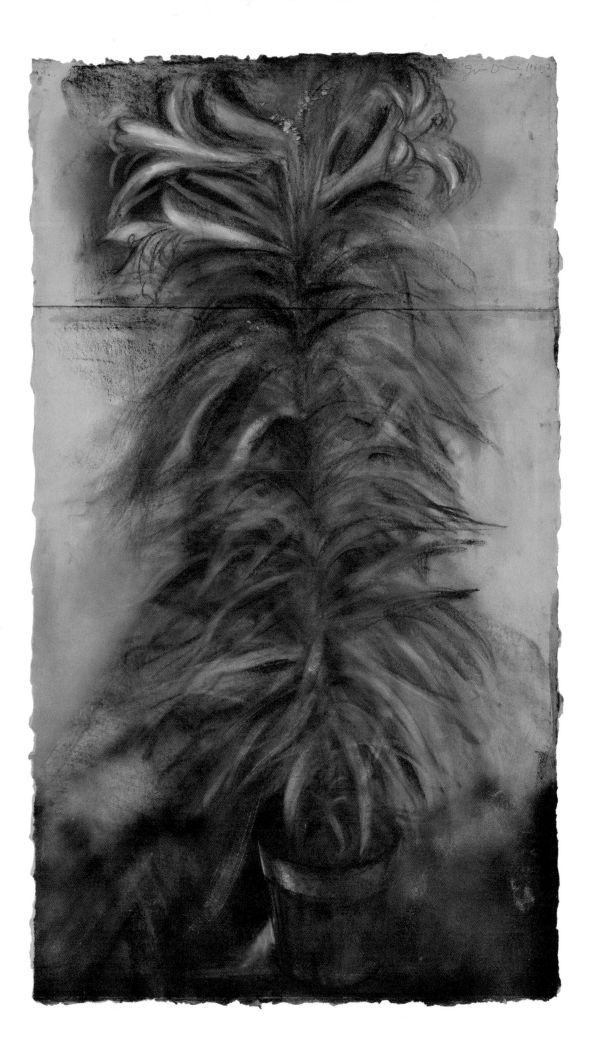

51

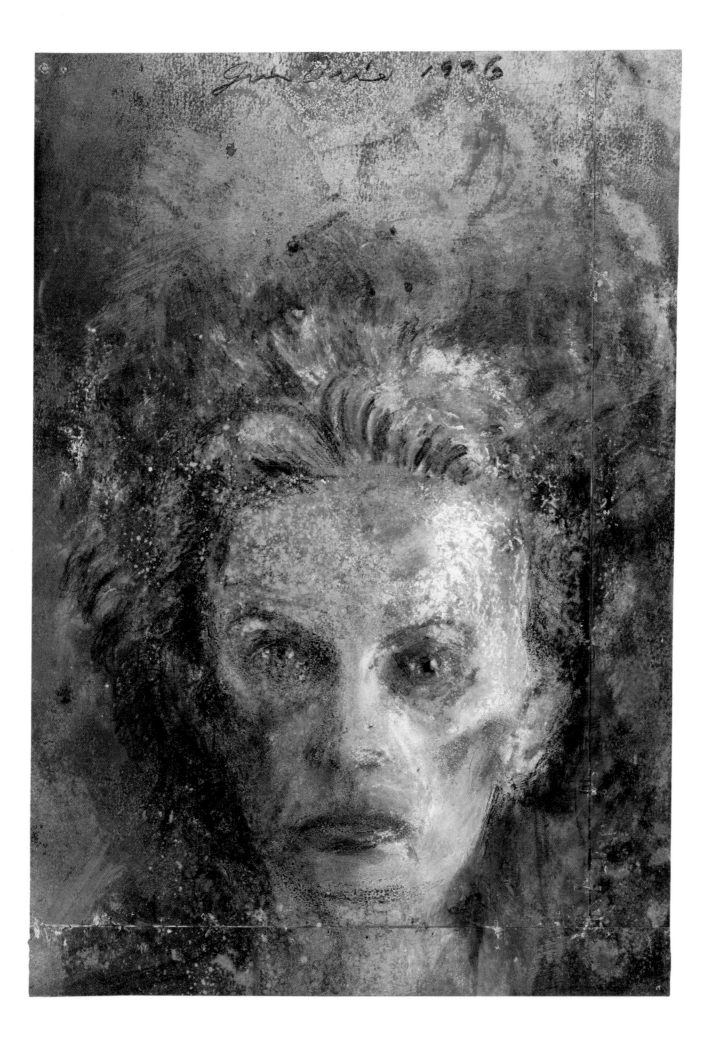

52

THE HENLEY COLLEGE LIBRARY

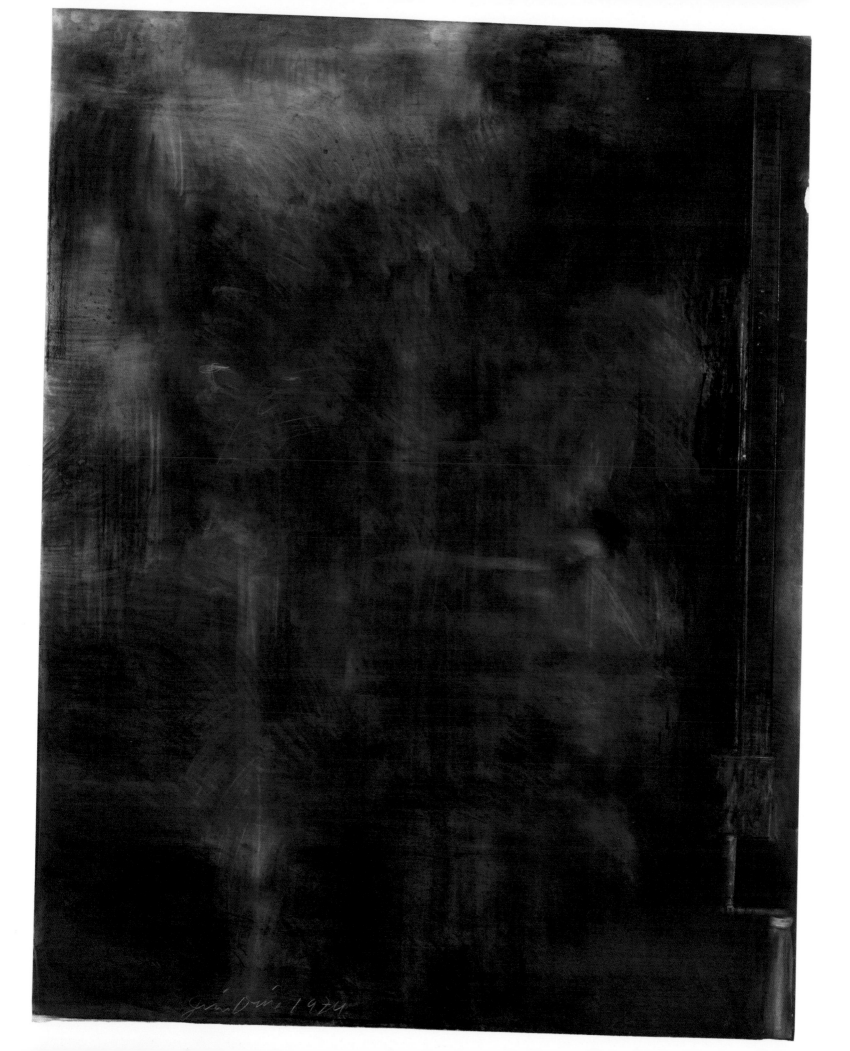

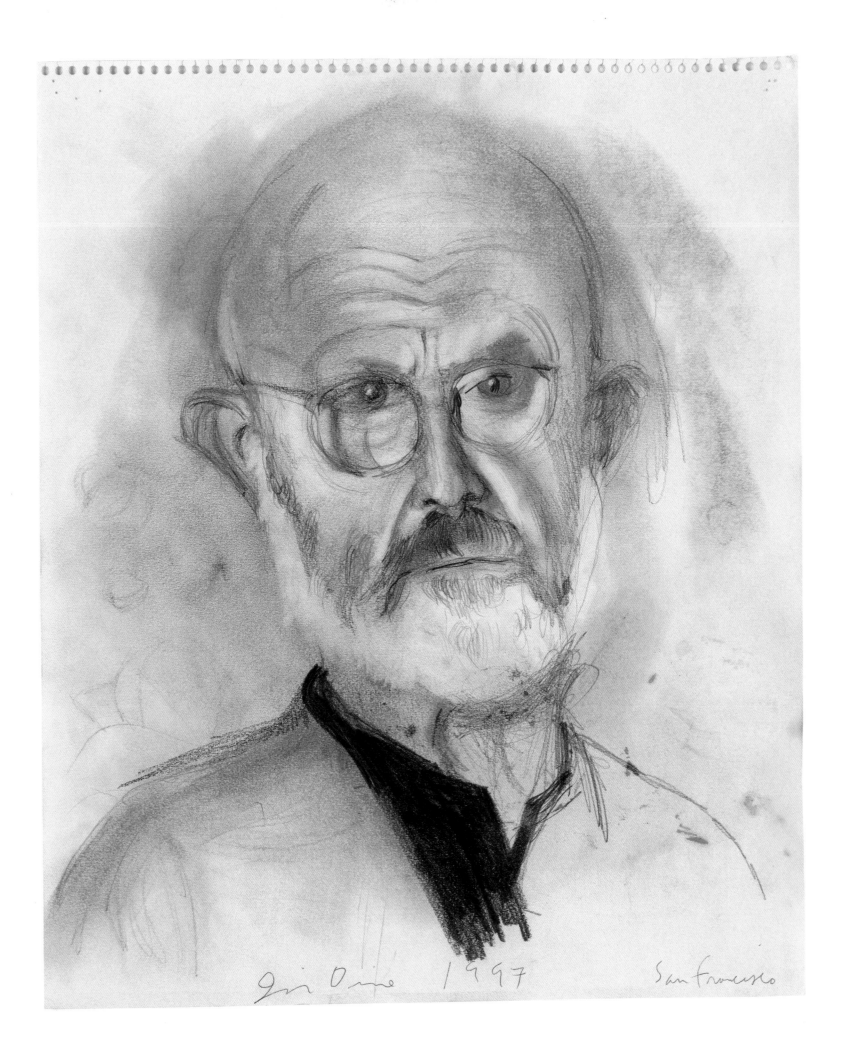

Jim Dine 1997 San Francisco

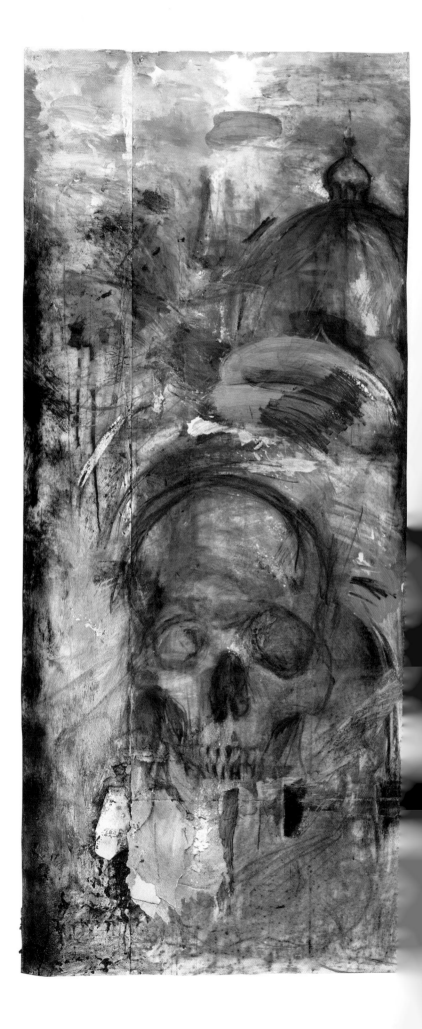

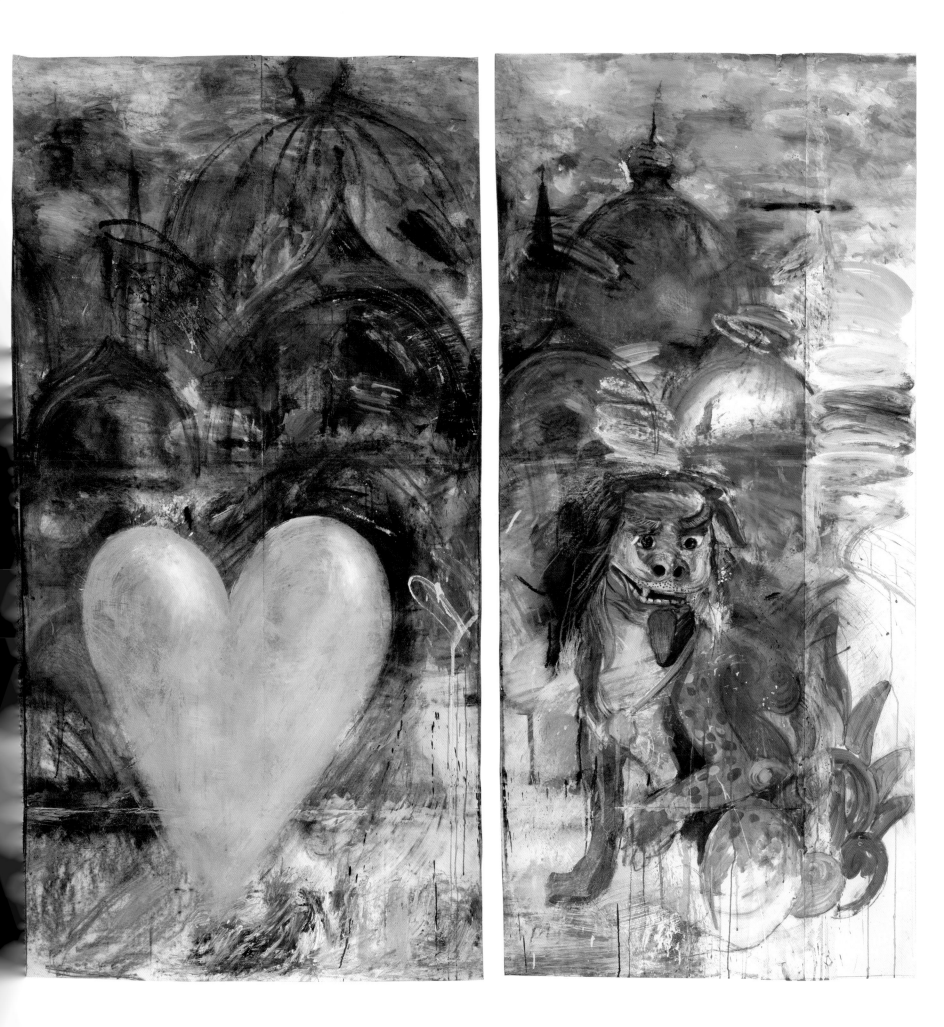

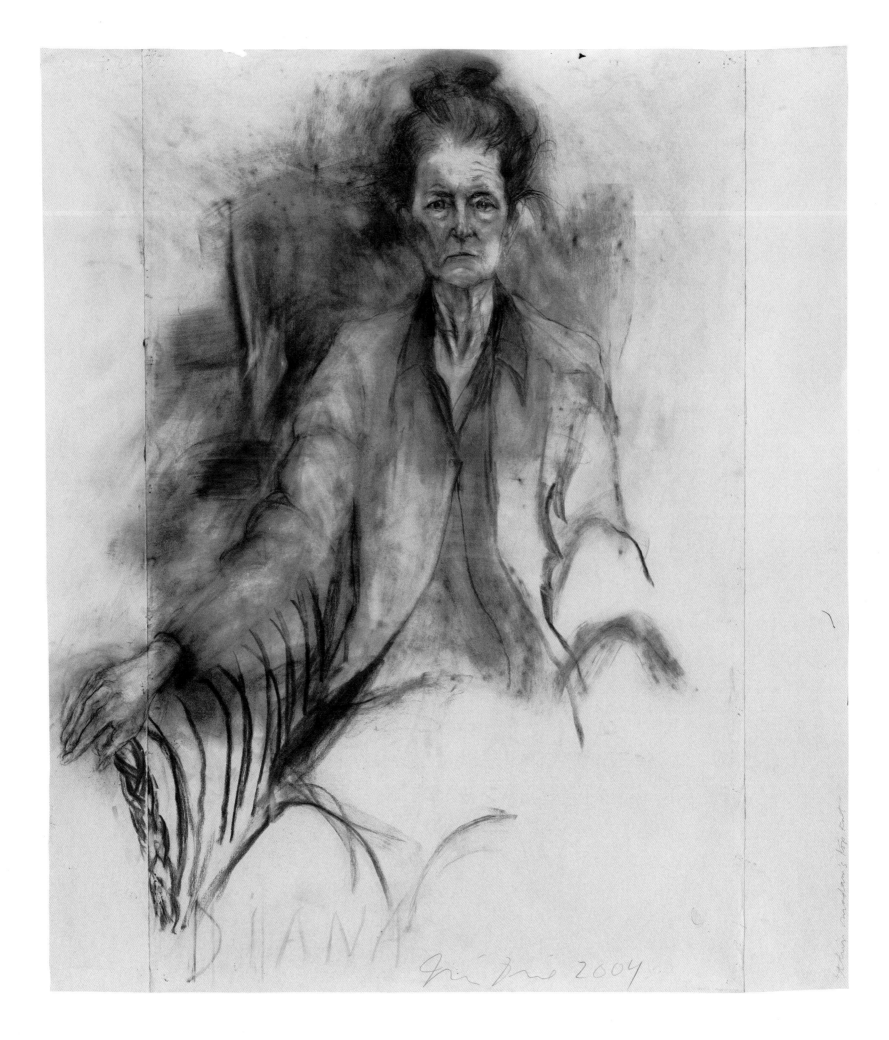

DIANA

2004

56

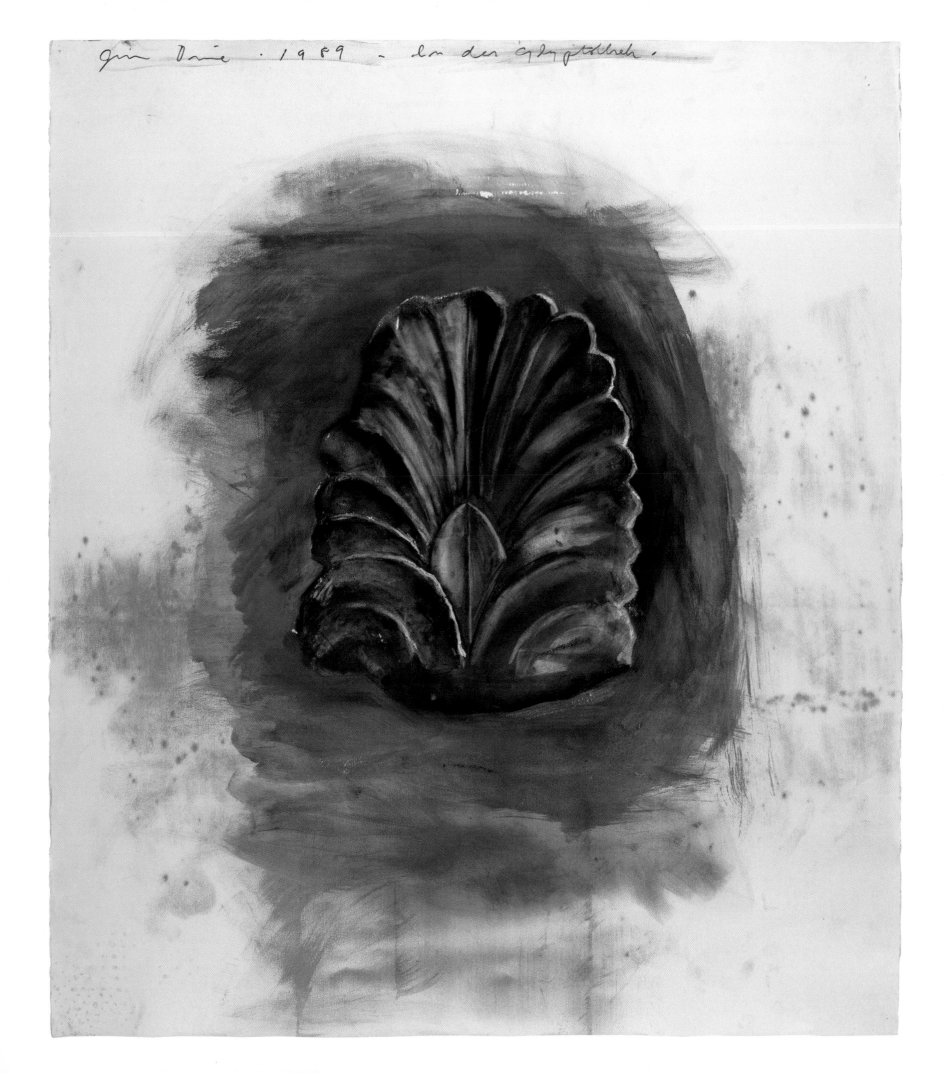

57

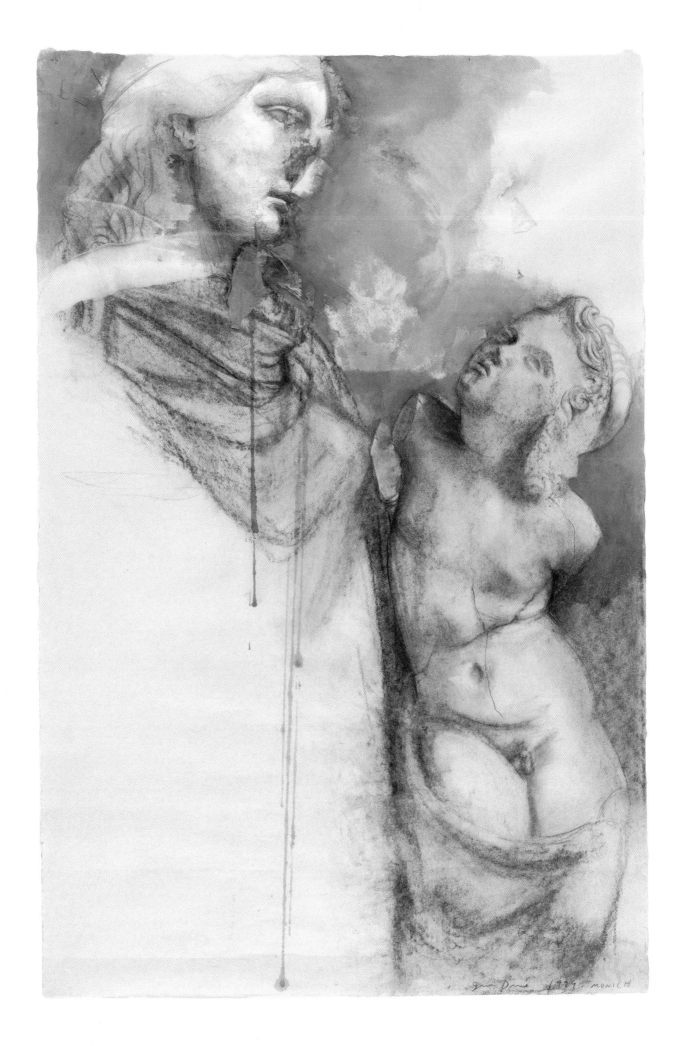

58

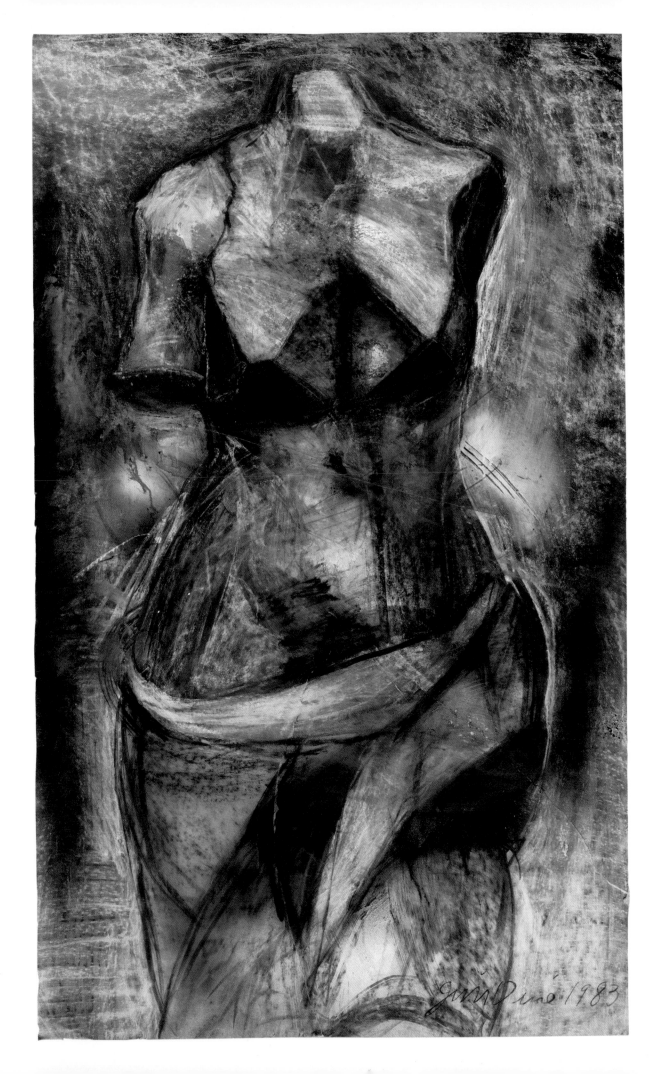

59

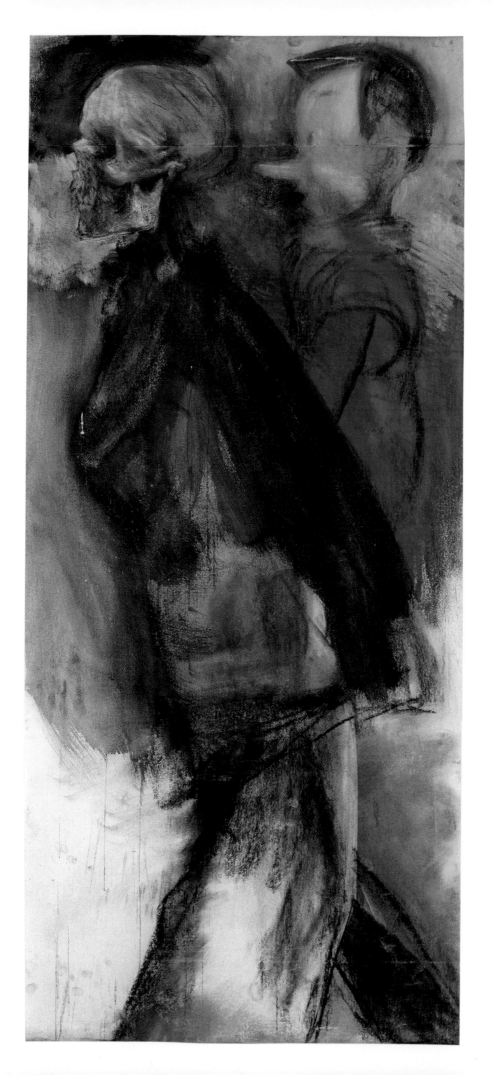

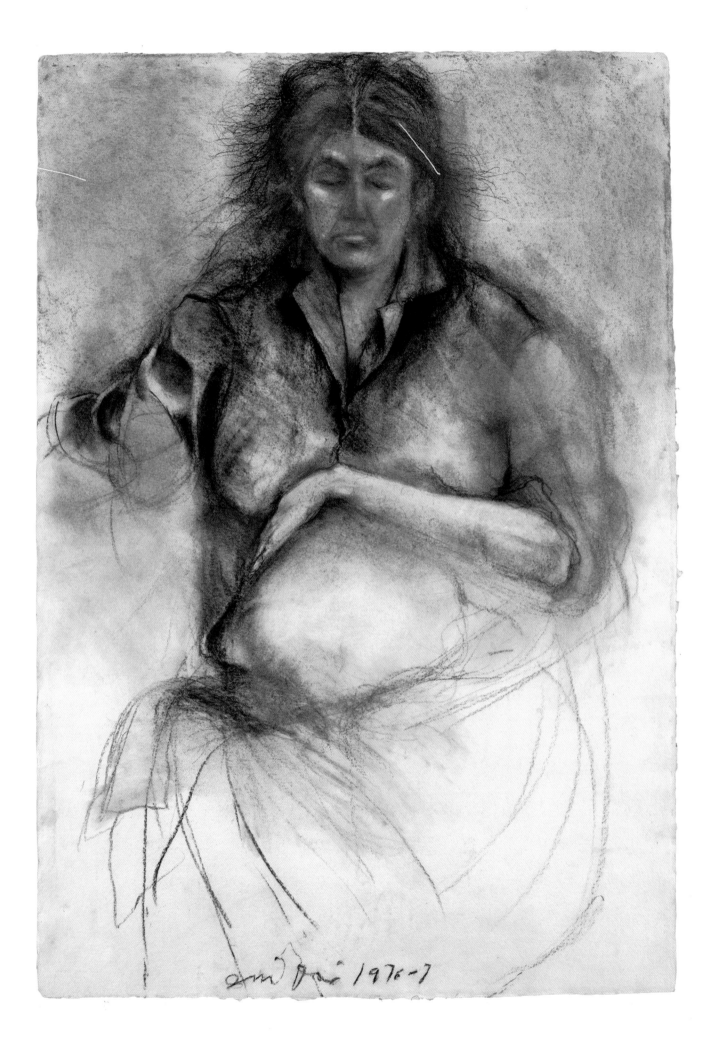

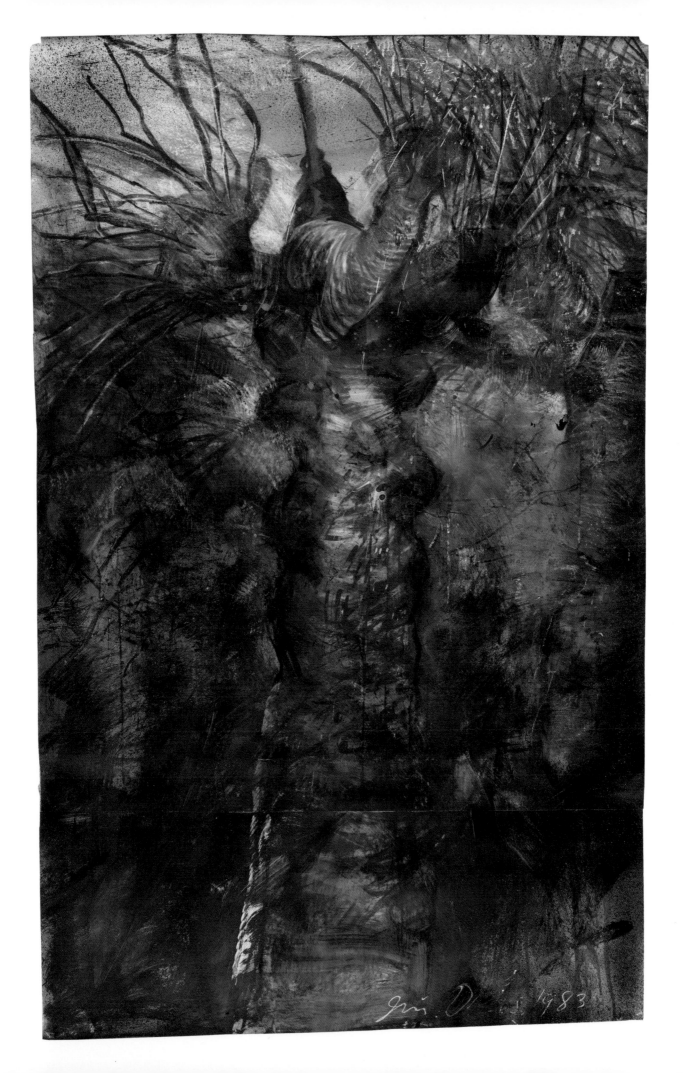

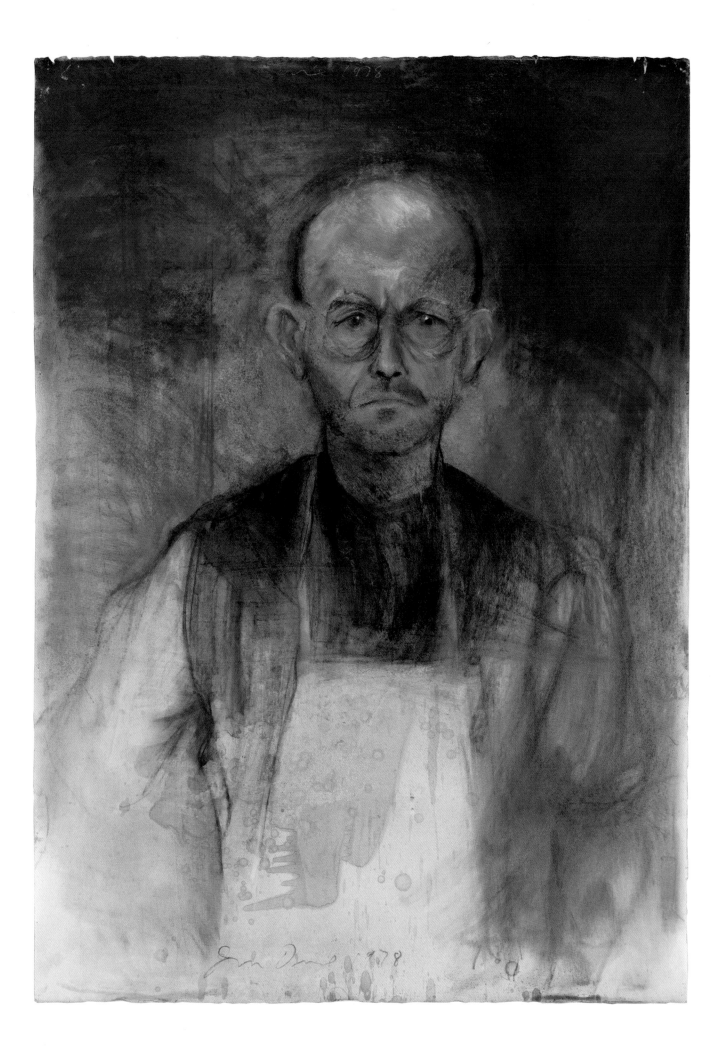

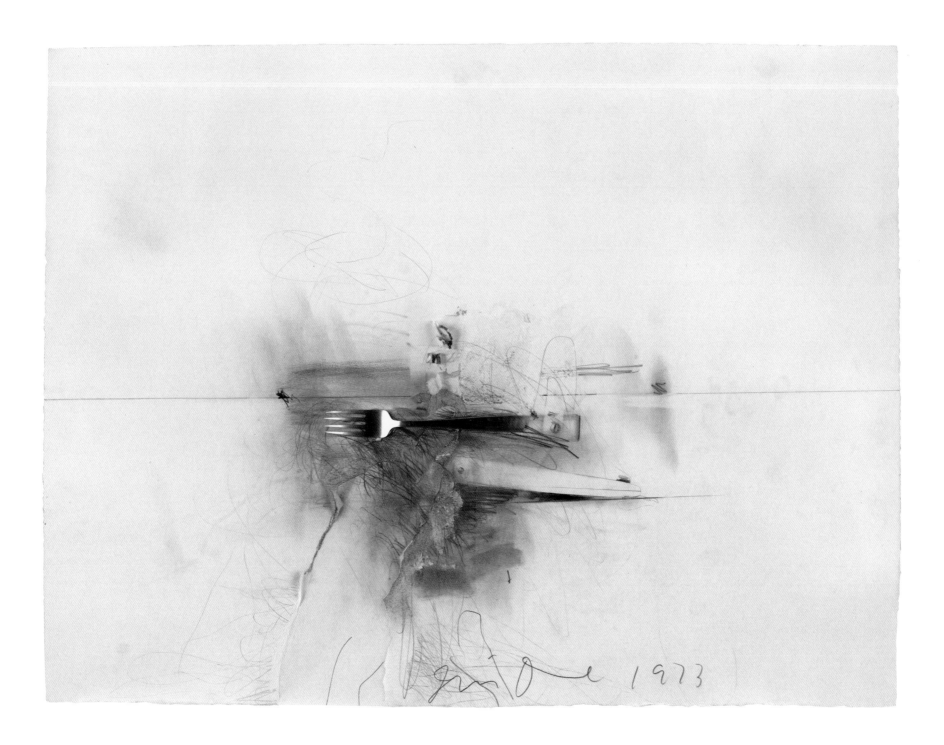

64

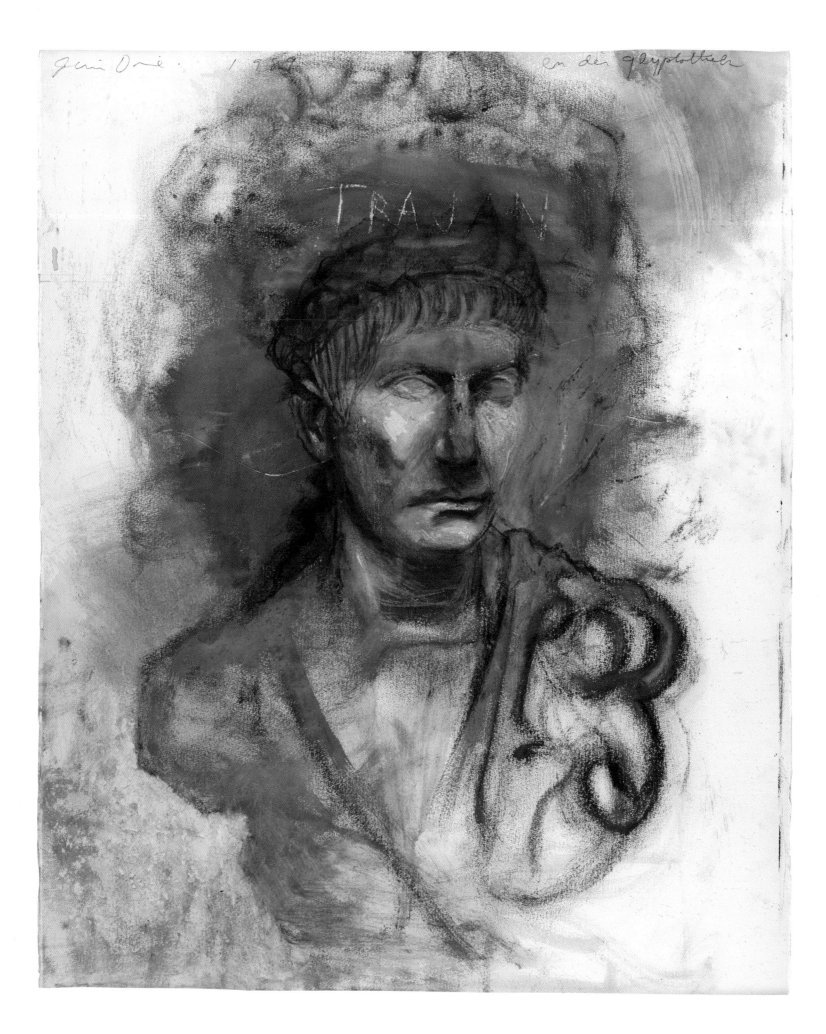

65

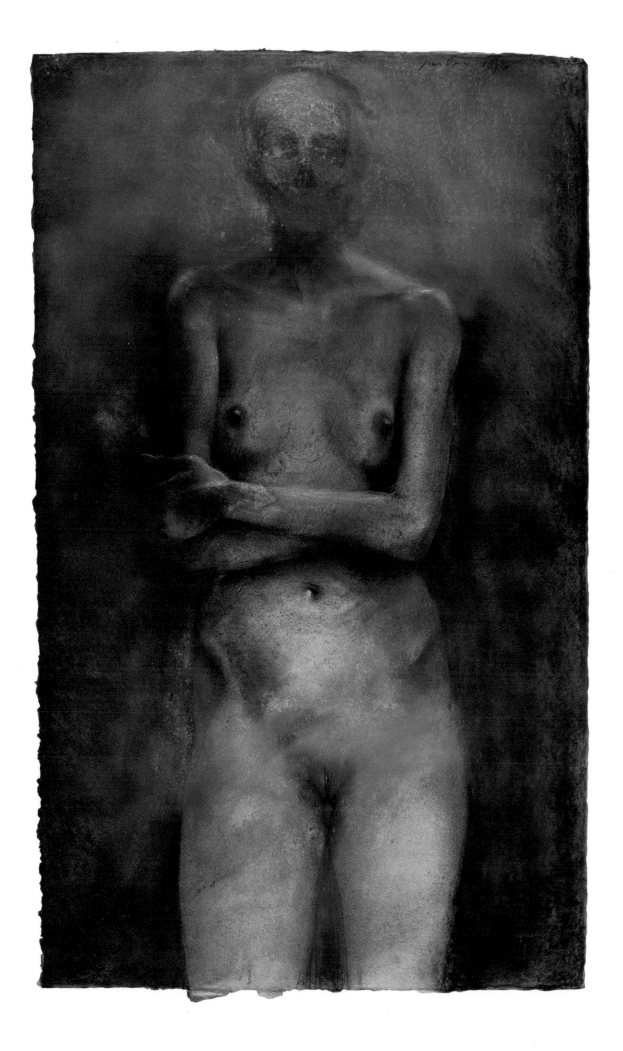

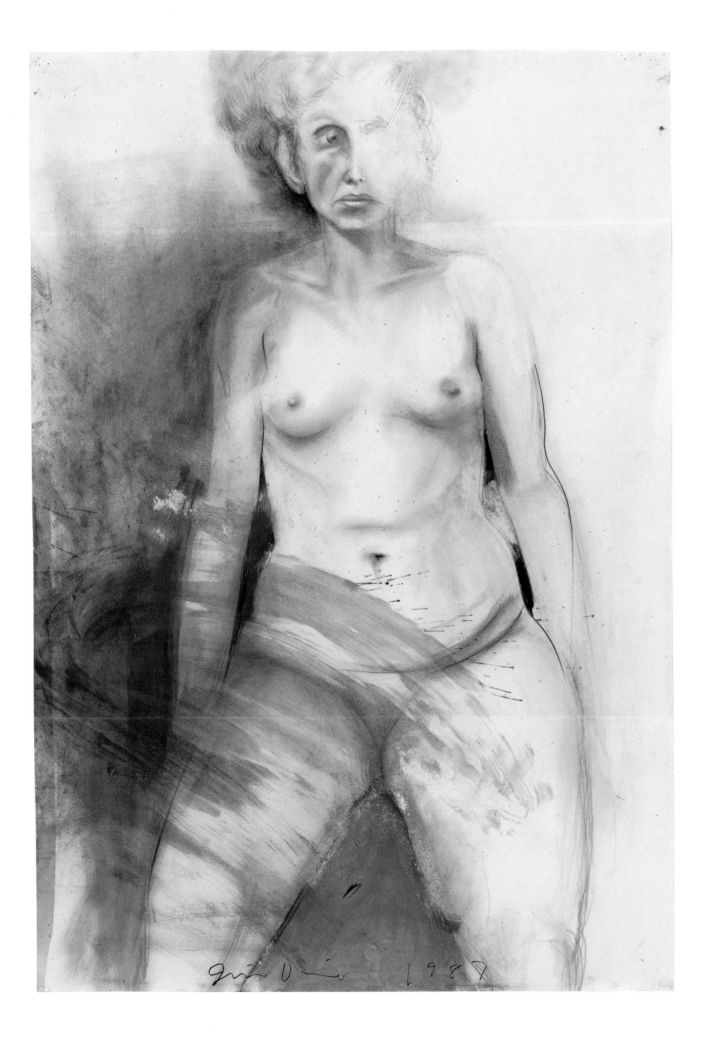

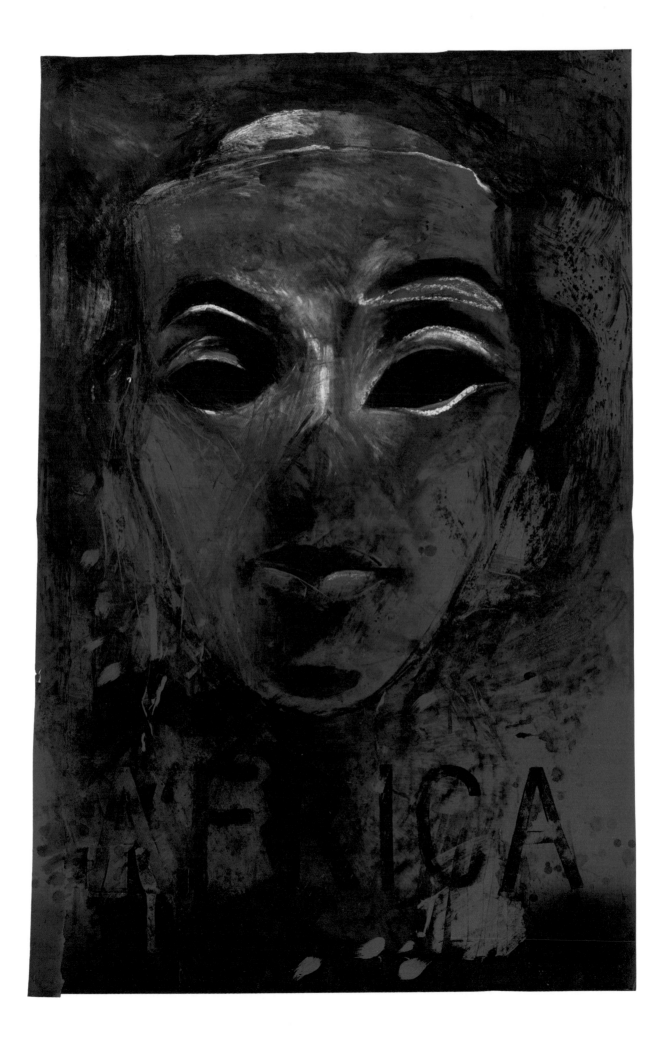

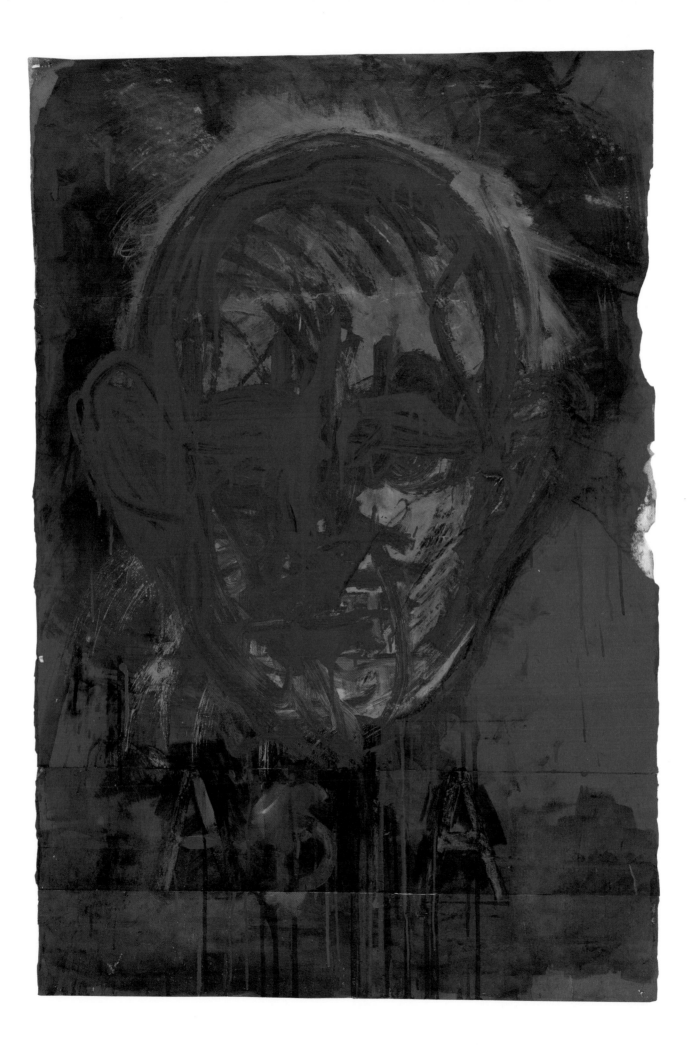

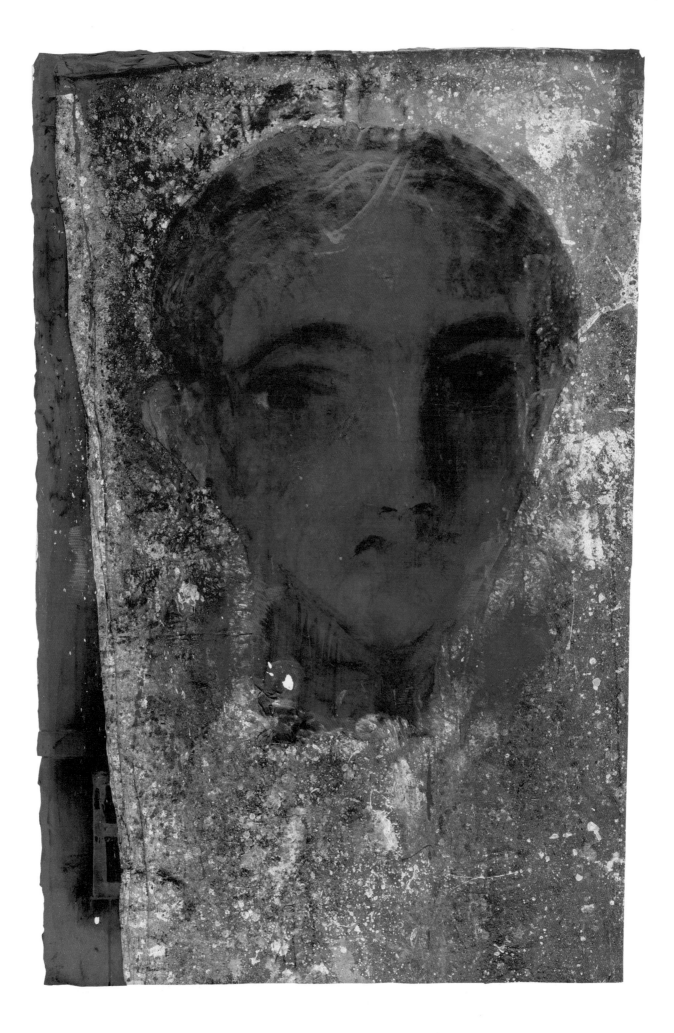

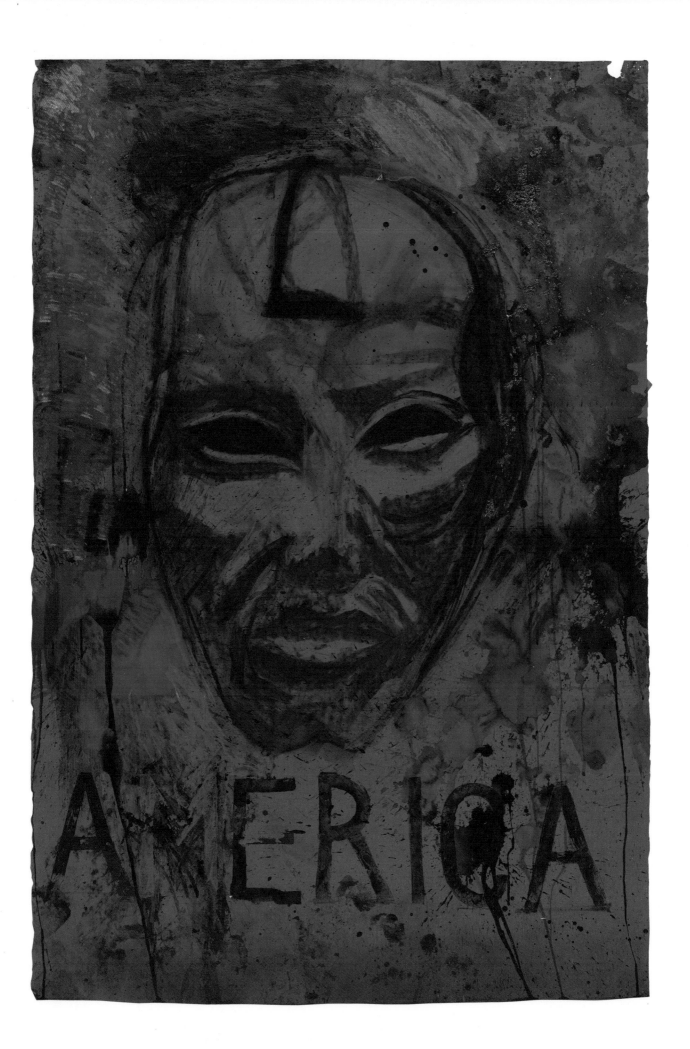

THE HENLEY COLLEGE LIBRARY
THE HENLEY COLLEGE LIBRARY

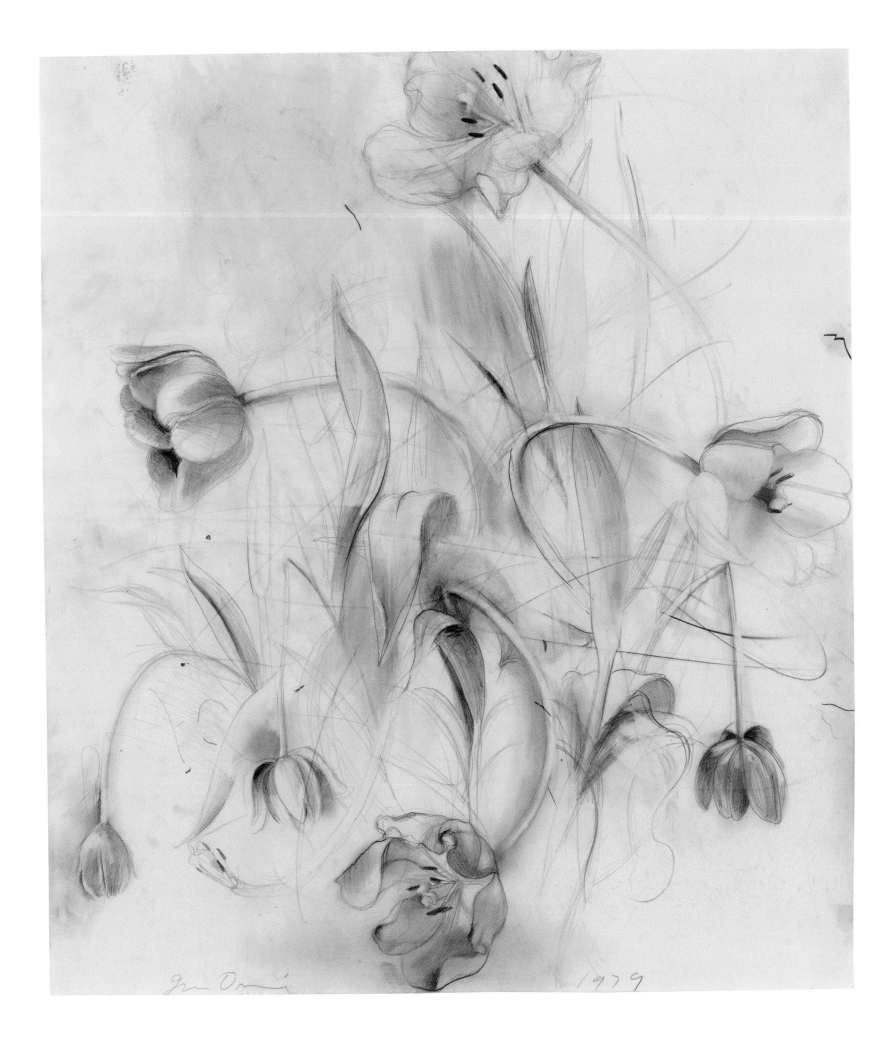

Jim Dine 1979

69

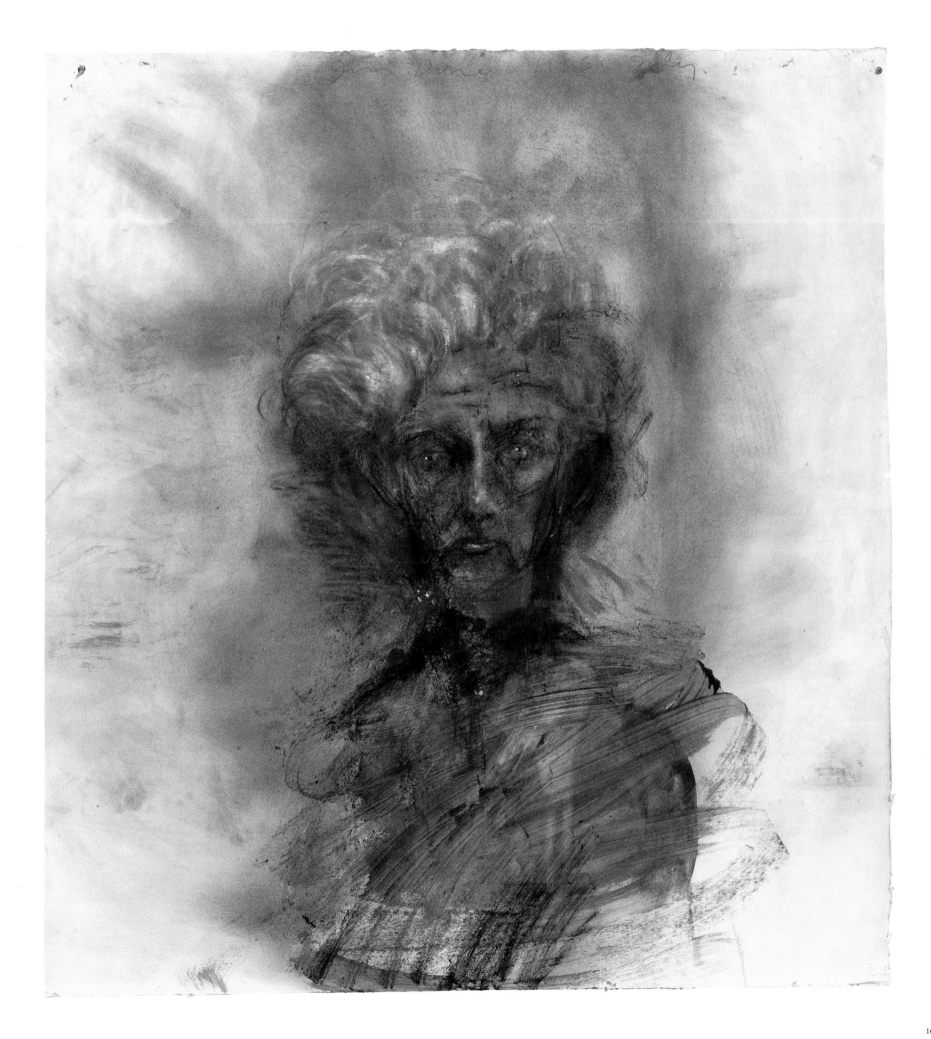

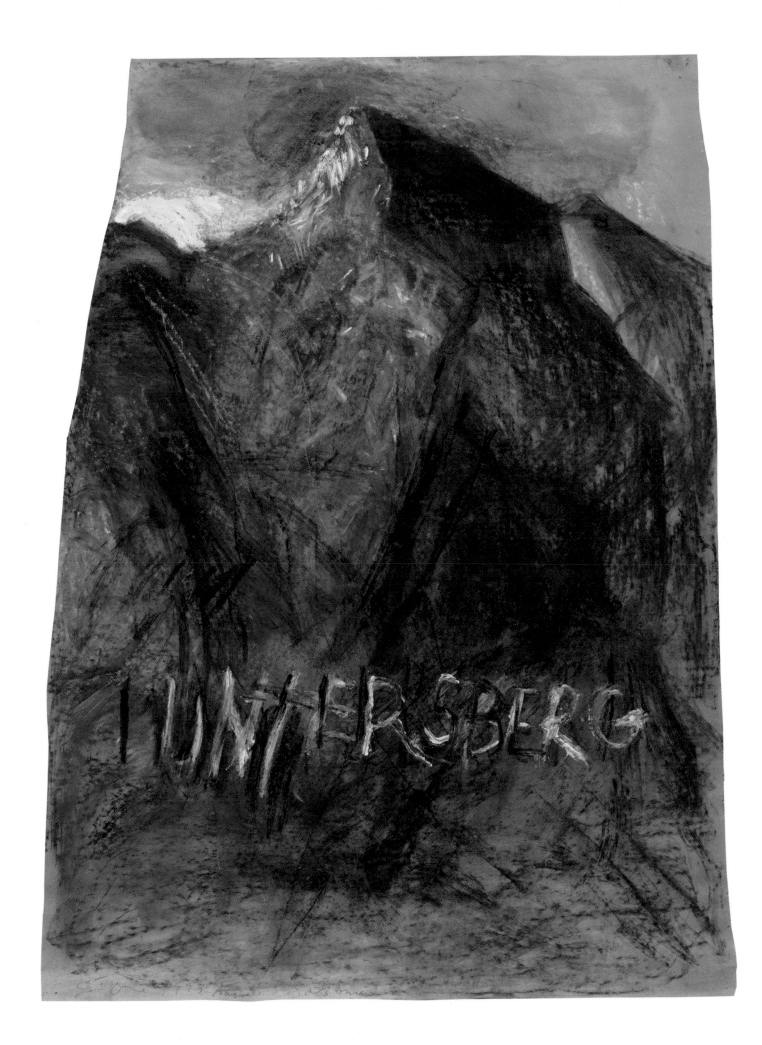

71

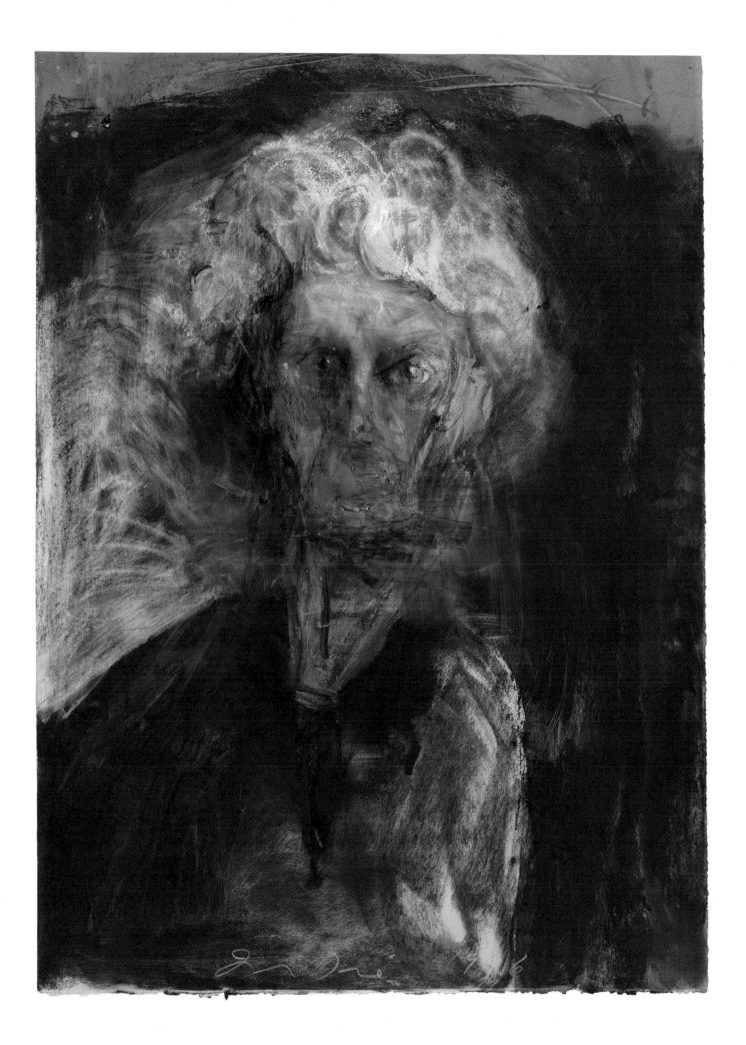

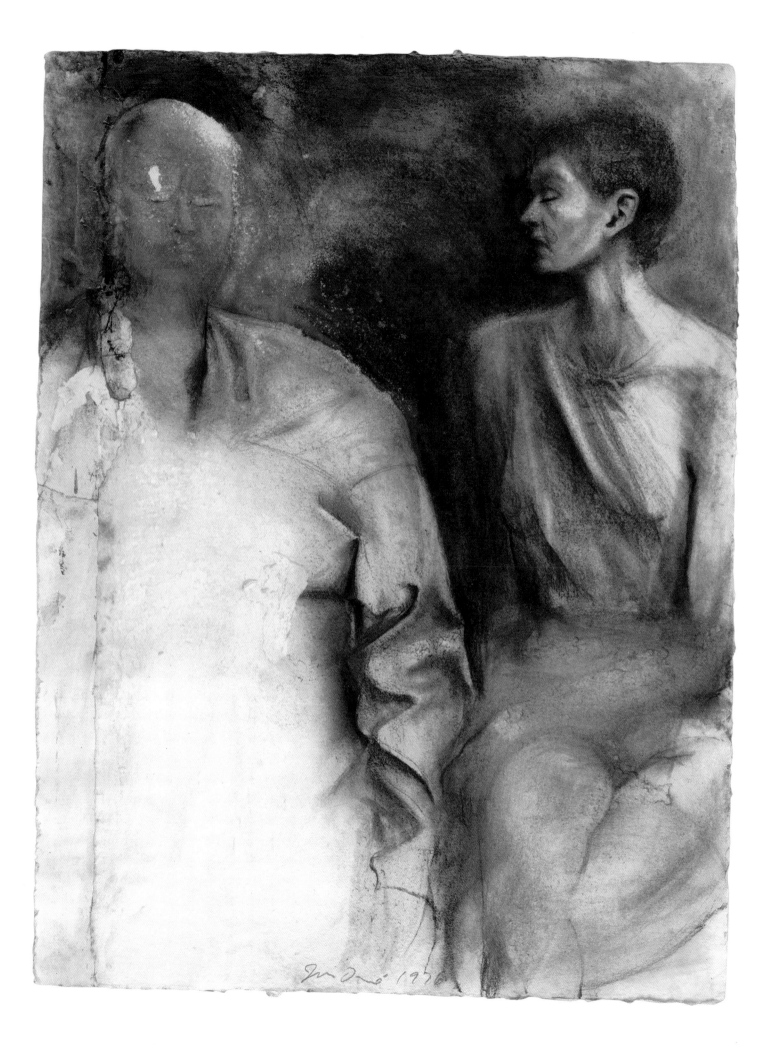

73

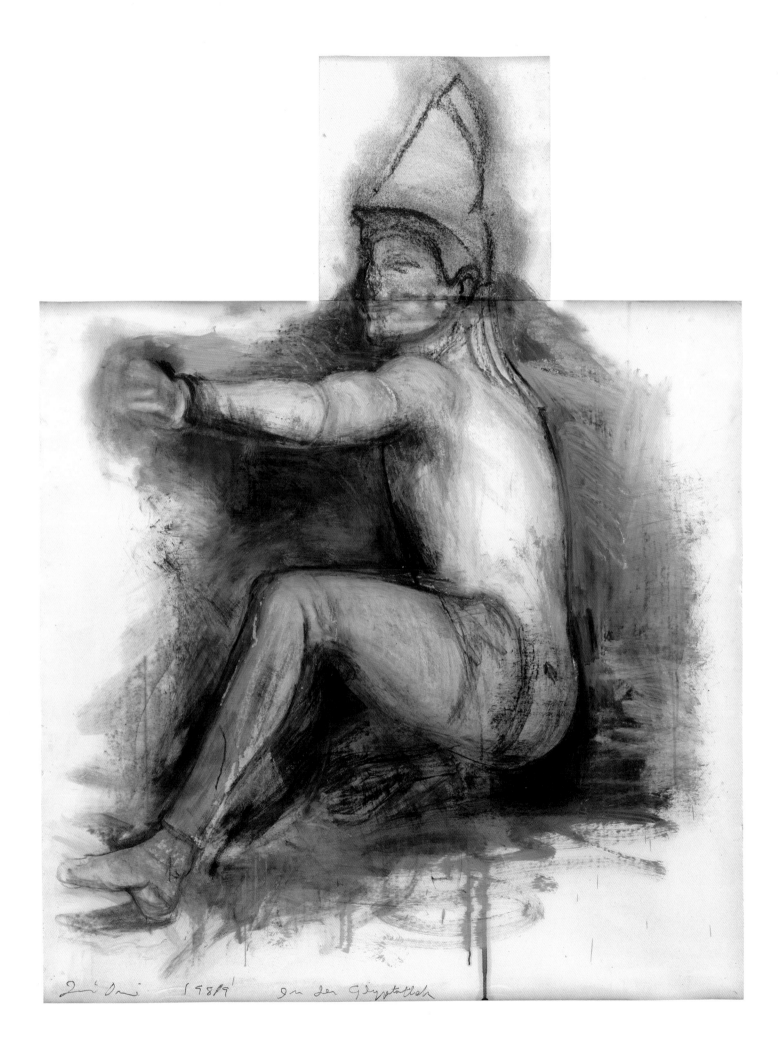

In der Glyptothek

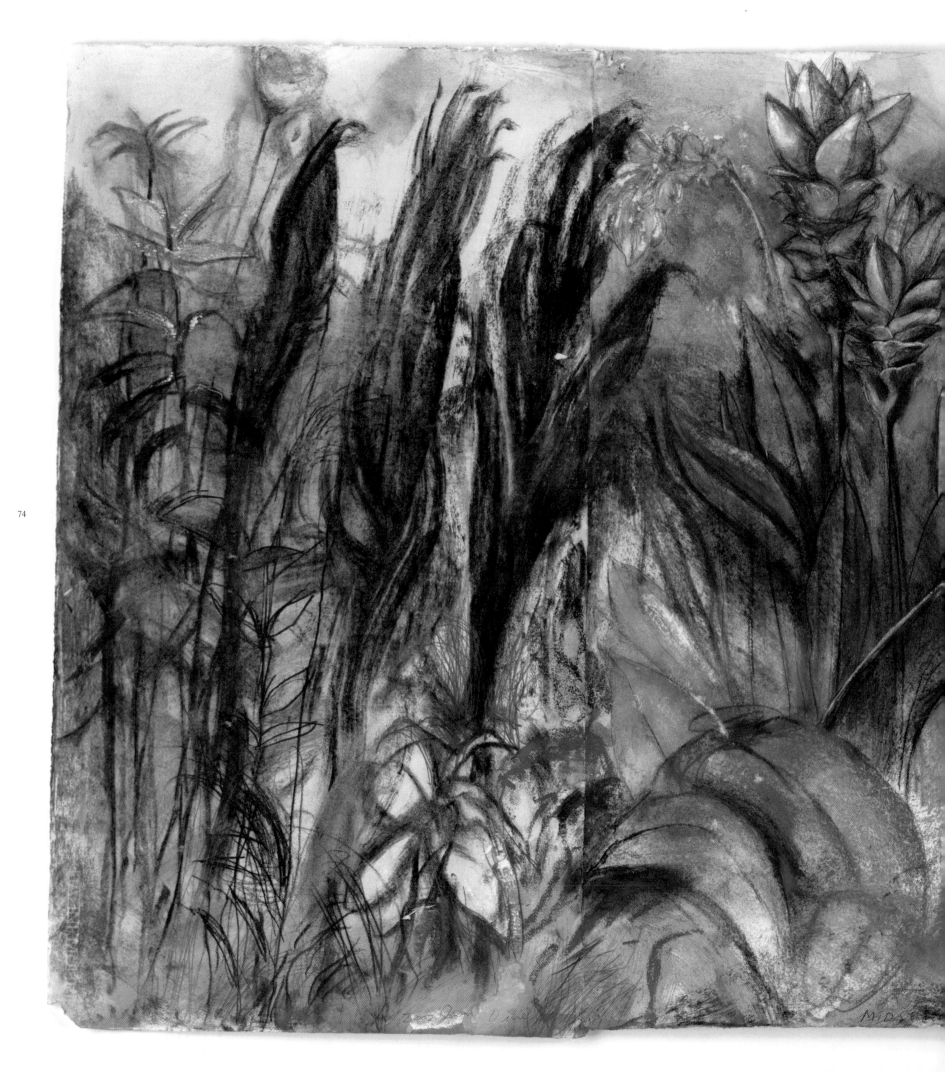

74

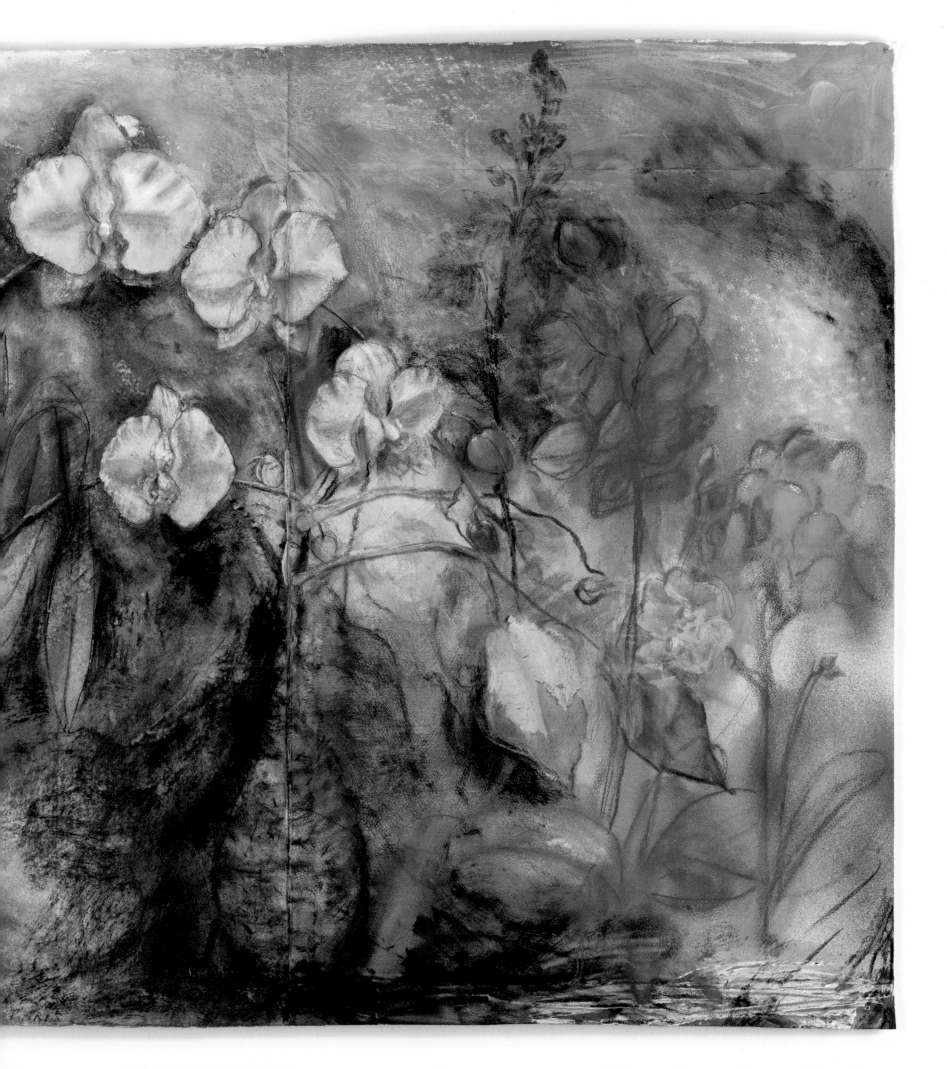

75

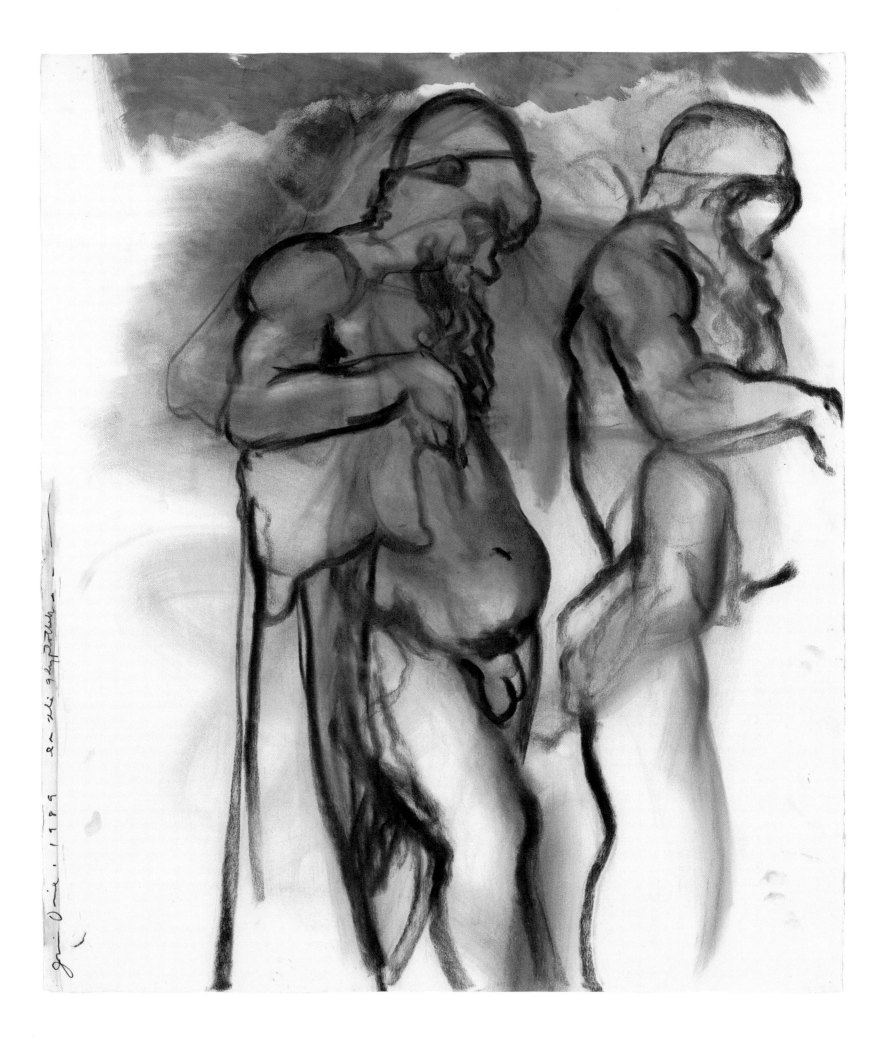

179

76

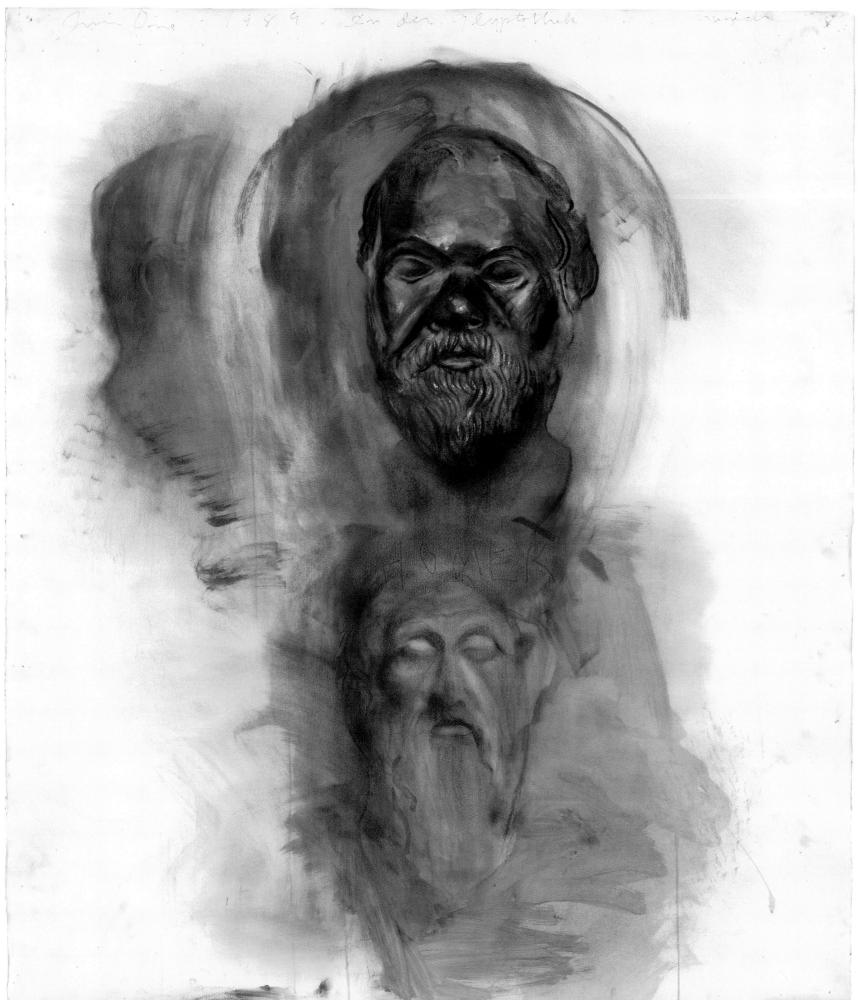

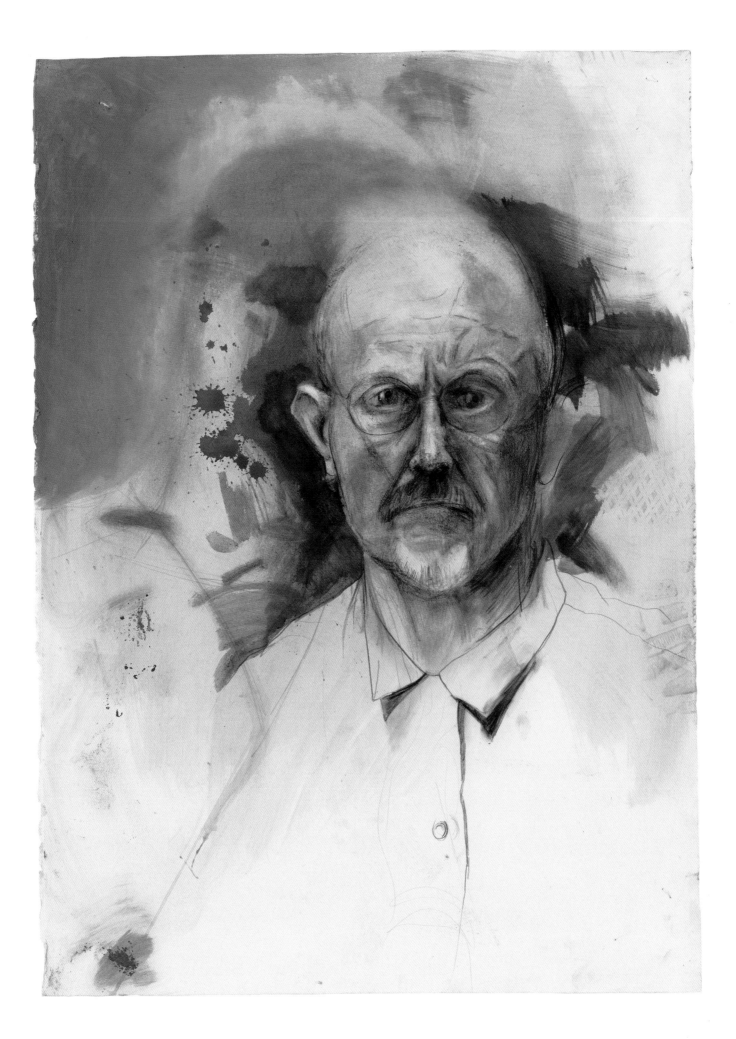

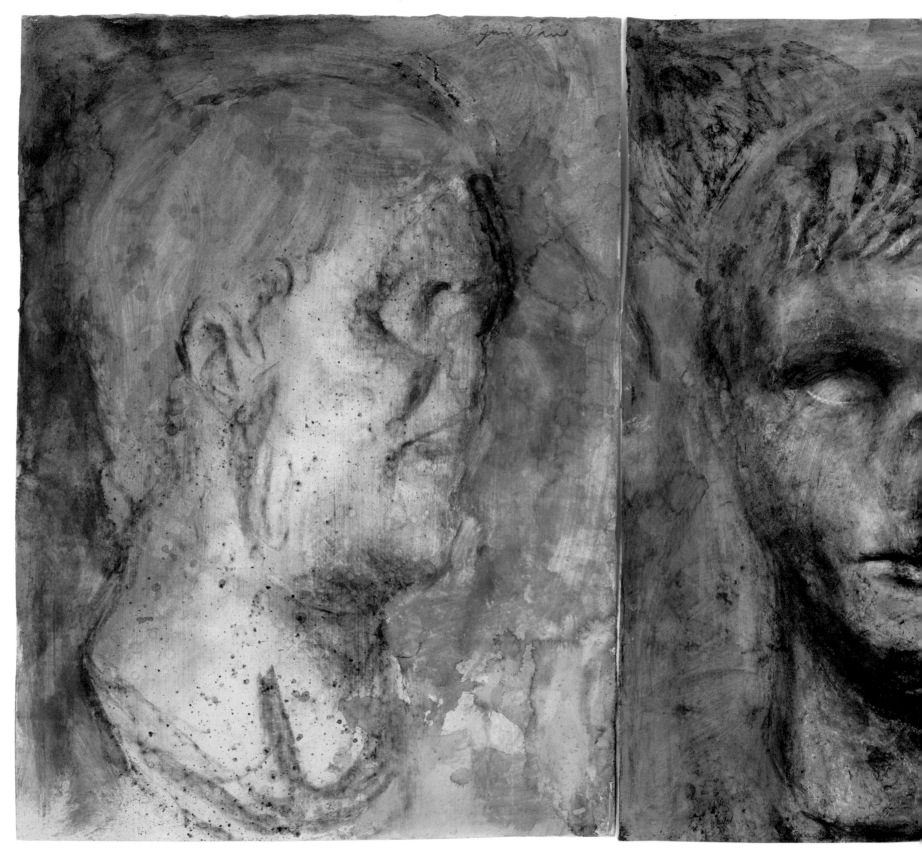

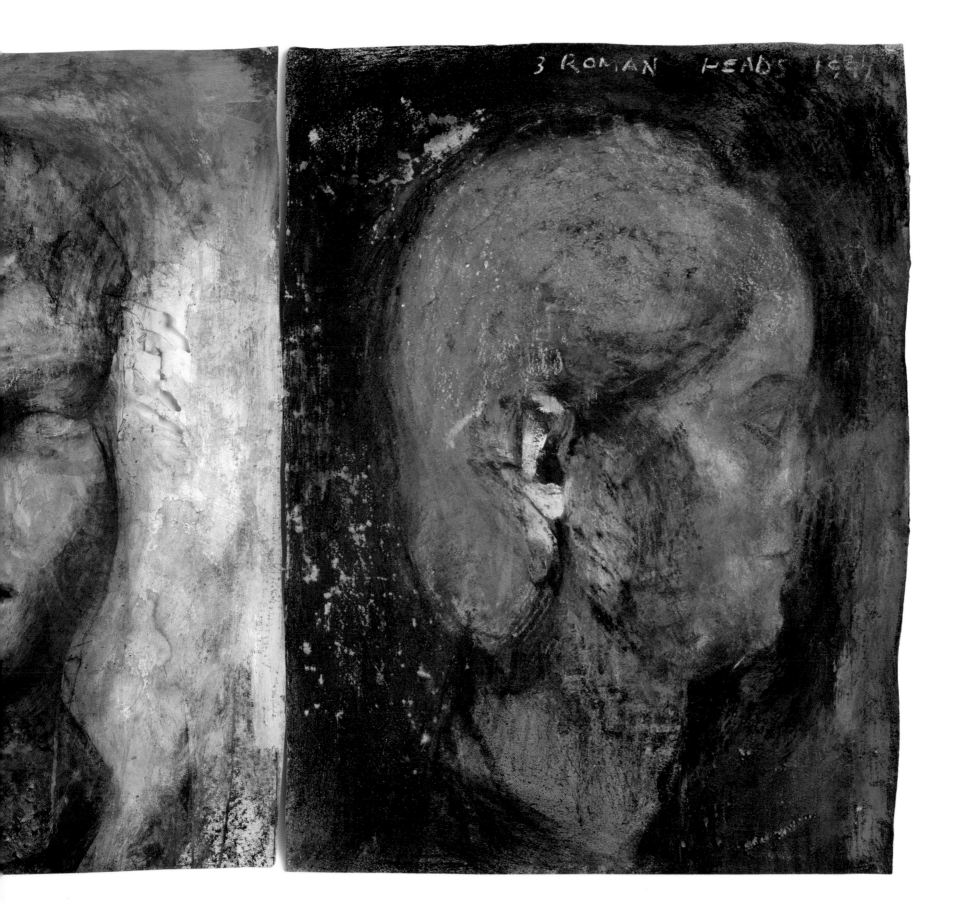

3 ROMAN HEADS 1921

79

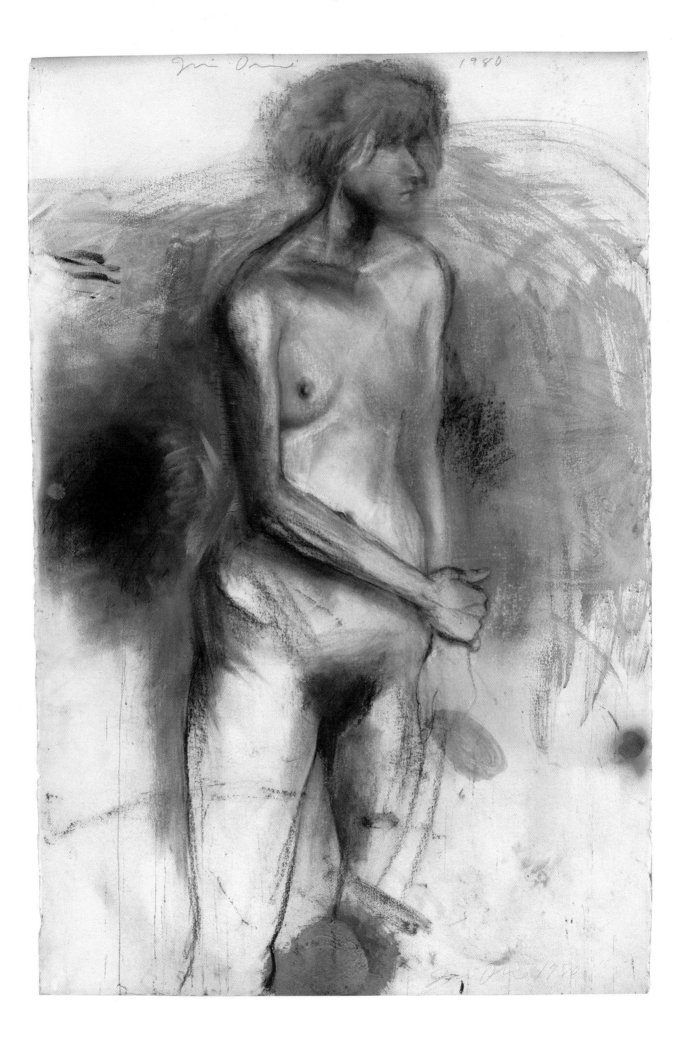

80

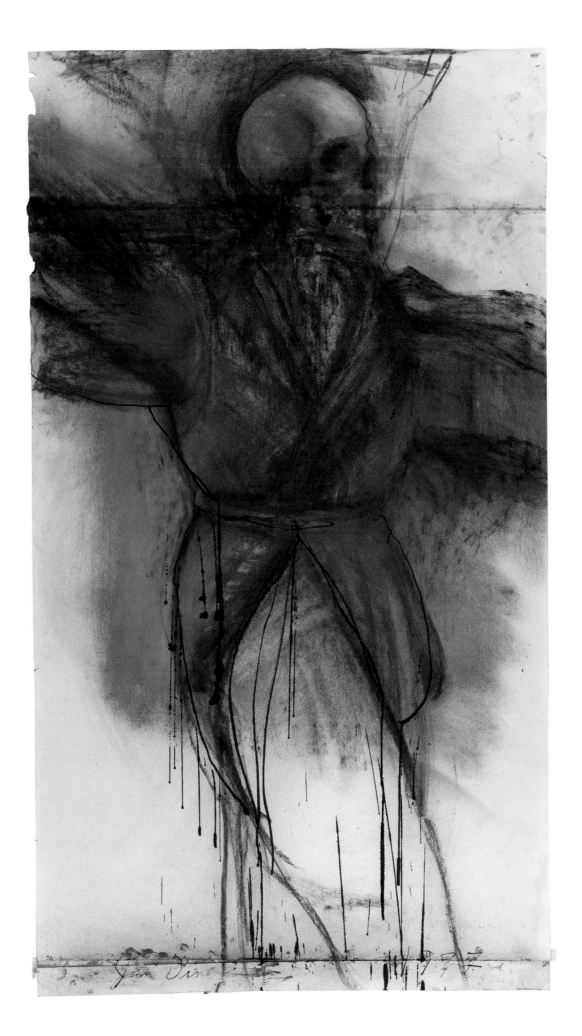

189

81

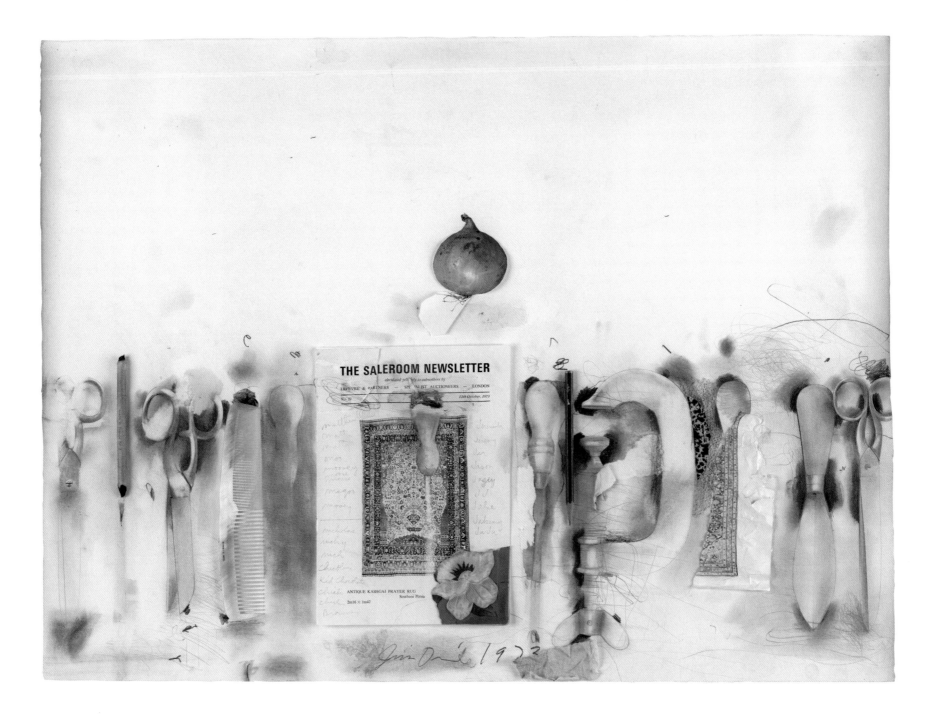

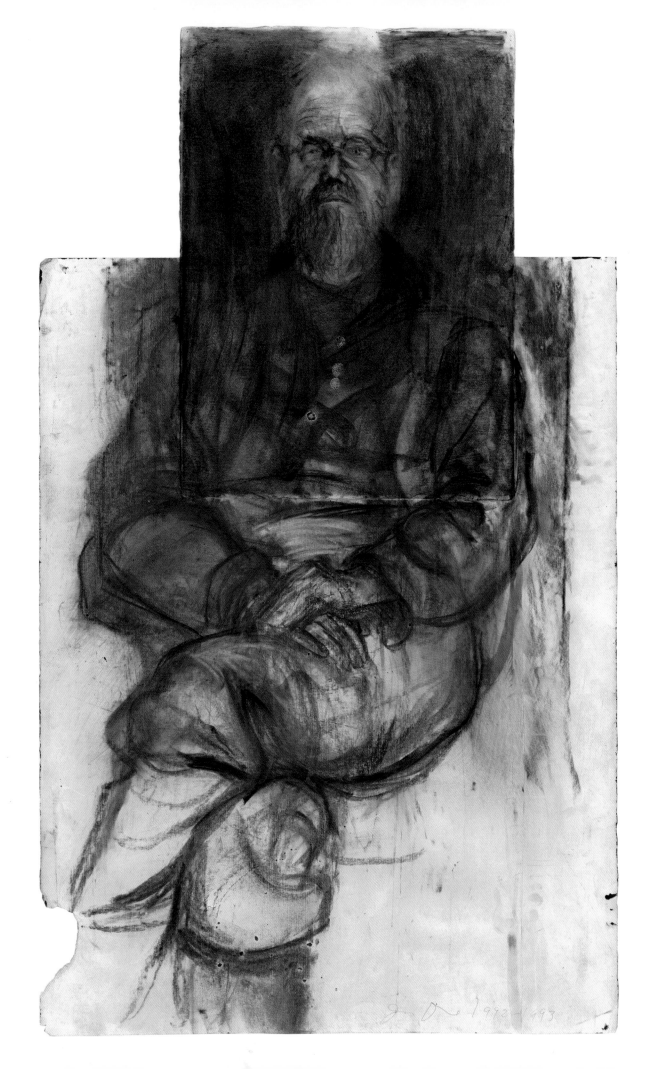

83

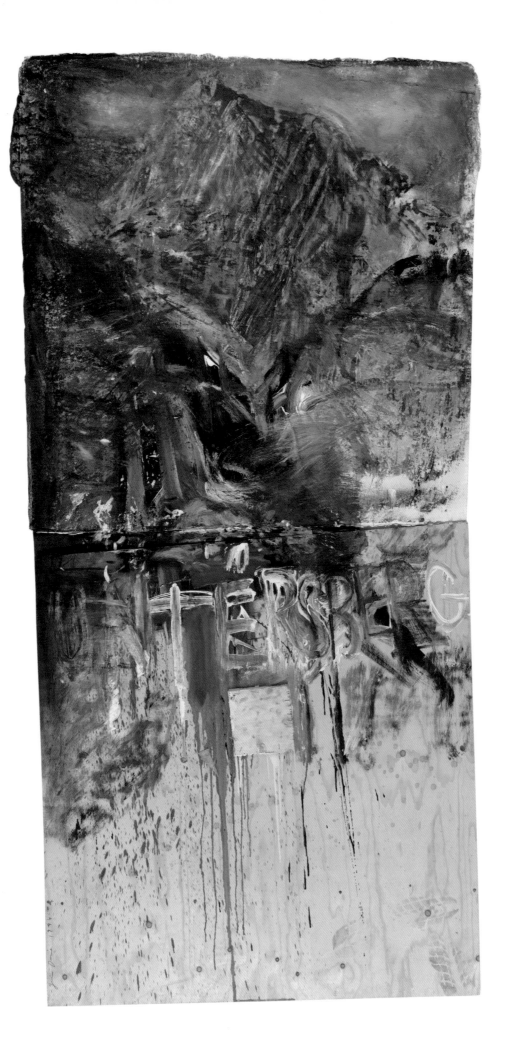

84

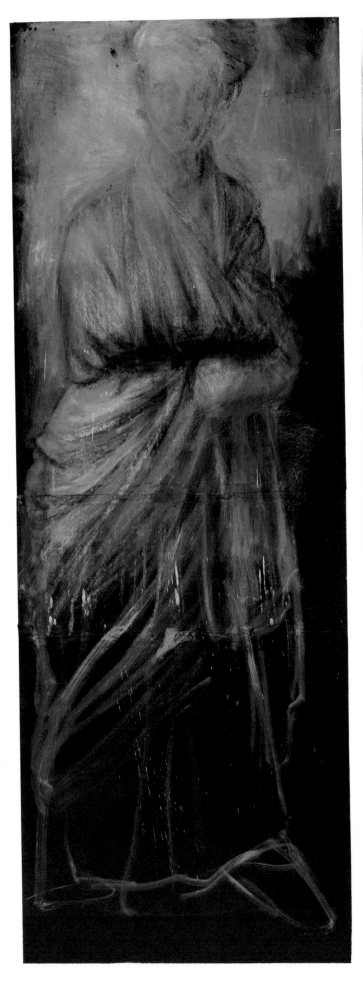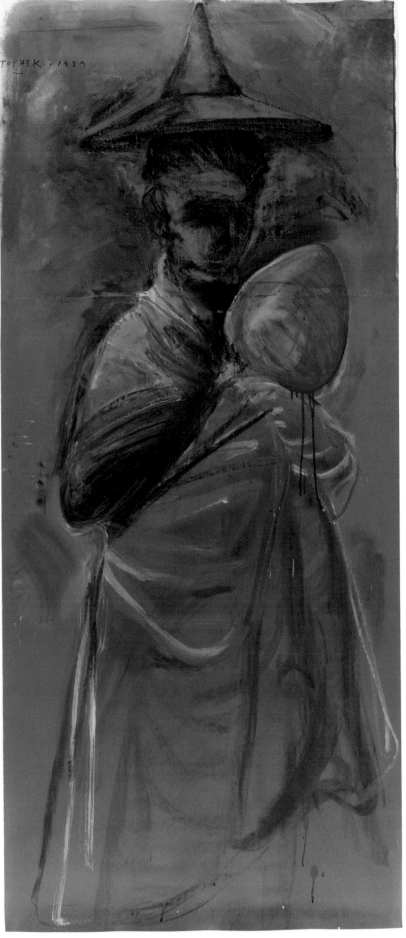

85

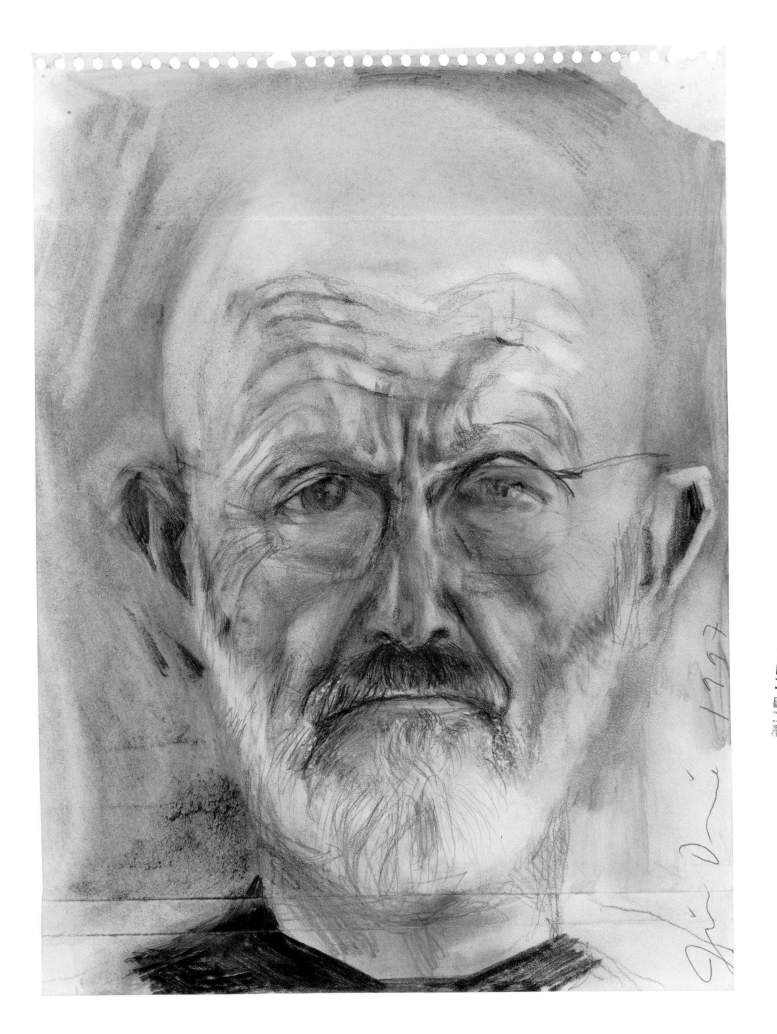

THE HENLEY COLLEGE LIBRARY

CHECKLIST OF DRAWINGS

1. *Tool Drawing II*, 1983
Mixed media
70 x 70 inches (177.8 x 177.8 cm)
JD 2008391
Collection of Arne and Milly Glimcher

2. *Tool Drawing I*, 1983
Mixed media
70 x 70 inches (177.8 x 177.8 cm)
JD 2008390
Collection of Arne and Milly Glimcher

3. *Begonia in Yemen Moishe*, 1979
Pencil
22 1/2 x 25 1/2 inches (57.2 x 64.8 cm)
JD 2007983
Private collection

4. *Jessie with the Scarf*, 1975
Graphite
31 1/2 x 23 inches (80 x 58.4 cm)
JD 2007586
Collection of the artist

5. *Drawing from Van Gogh X*, 1983
Mixed media
71 1/2 x 45 1/4 inches (181.6 x 114.9 cm)
JD 2008350
Private collection

6. *Self-Portrait*, 1986-1987
Mixed media
30 x 21 1/2 inches (76.2 x 54.6 cm)
JD 2008756
Private collection

7. *Childhood (First Version)*, 1989
Charcoal, oil stick, oil paint, acrylic,
pastel, watercolor, enamel and collage
61 3/4 x 252 inches (156.8 x 640.1 cm)
JD 2008942
Collection of the artist

8. *Self-Portrait #3*, 1997
Graphite
12 x 11 inches (30.5 x 22.9 cm)
JD 2009748
Private collection

9. *Fading Away*, 1993
Charcoal
60 x 40 1/2 inches (152.4 x 102.9 cm)
JD 2009318
Private Collection

10. Untitled, 1993
Graphite, charcoal, oil and pastel
15 1/2 x 11 1/4 inches (39.4 x 28.6 cm)
JD 20093101
Private collection

11. *Sleeping Satyr* (Barberini Faun, c. 220 B.C.), 1989
Watercolor, charcoal and colored pencil
47 3/4 x 41 3/4 inches (121.3 x 106.1 cm)
JD 2008972
Private collection

12. *Colossal Portrait of the Emperor Titus* (c. 80 A.D.), 1989
Conté crayon, charcoal and watercolor
47 3/4 x 41 7/8 inches (121.3 x 106.4 cm)
JD 2008979
Private collection

13. *Untersberg Summer 1994 No. 2*, 1994
Enamel, acrylic, charcoal and oil stick
65 x 46 inches (165.1 x 116.8 cm)
JD 2009406
Private collection

14. *Common Mullein*, 1993
Charcoal, pencil, and collage
72 1/2 x 30 1/2 inches (184.2 x 77.5 cm)
JD 2009352
Courtesy of PaceWildenstein

15. *Large Drawing of a Small Statue*, 1978
Mixed media
45 1/2 x 31 3/4 inches (115.6 x 80.6 cm)
JD 2007837
Allen Memorial Art Museum, Oberlin College

16. *Careful Pencil Drawing*, 1978
Pencil
17 1/2 x 19 3/4 inches (44.5 x 50.2 cm)
JD 2007871
Private collection

17. *Looking in the Dark #1*, 1984
Acrylic and charcoal
30 x 22 1/2 inches (76.2 x 57.2 cm)
JD 2008431
Collection of the artist

18. *Looking in the Dark #20*, 1984
Charcoal, enamel spray paint, acrylic and collage
30 1/2 x 20 7/8 inches (77.5 x 53.1 cm)
JD 2008432
Collection of the artist

19. *Looking in the Dark #21*, 1984
Charcoal and pastel
40 3/4 x 30 1/2 inches (103.5 x 77.5 cm)
JD 2008433
Collection of the artist

20. *Looking in the Dark #18*, 1984
Charcoal, pastel and acrylic
26 x 19 inches (66 x 48.3 cm)
JD 2008435
Collection of the artist

21. *"Metro 3" Cover Study*, 1962
Pencil
9 1/2 x 13 inches (24.1 x 33 cm)
JD 2006271
Private collection

22. *Himself Beside Himself*, 1995
Charcoal
52 3/8 x 48 7/8 inches (133 x 124 cm)
JD 2009503
Collection of Diana Michener

23. *Red Dancers on the Western Shore*, 1986
Charcoal on red paper; tetraptych
63 x 37 inches (160 x 94 cm), each sheet;
252 x 148 inches (640 x 375.9 cm), overall
JD 2008654
Courtesy of PaceWildenstein

24. *Jade Plant Still Life*, 1976-1977
Pencil
15 x 19 1/2 inches (38.1 x 49.5 cm)
JD 2007773
Courtesy of PaceWildenstein

25. *Nancy*, 1996
Graphite, charcoal, oil and pastel
45 1/2 x 46 3/4 inches (115.6 x 118.7 cm)
JD 2009606
Private collection

26. *"Metro 3" Cover Study*, 1962
Pencil
9 1/2 x 13 inches (24.1 x 33 cm)
JD 2006272
Private collection

27. *Douglas*, 1989
Pencil, pastel and watercolor
30 x 24 inches (76.2 x 61 cm)
JD 2008929
Collection of Douglas Baxter

28. Untitled, 1996
Pastel, charcoal and enamel
27 5/8 x 20 1/2 inches (70.2 x 52.1 cm)
JD 2009628
Private collection

29. *"Metro 3" Cover Study*, 1962-1972
Pencil
13 x 9 1/2 inches (33 x 24.1 cm)
JD 2007273
Private collection

30. *Nancy, Venice*, 1986-1987
Mixed media
31 x 27 1/2 inches (78.7 x 69.9 cm)
JD 2008753
Allen Memorial Art Museum, Oberlin College

31. *The James Kirsch Postcard*, 1986
Mixed media
59 x 42 inches (149.9 x 106.7 cm)
JD 2008651
Private collection

32. *Red Mark*, 1993
Charcoal, oil and shellac on paper with collage
60 x 55 1/2 inches (152.4 x 141 cm)
JD 20093100
Private collection

33. *Owl in Chelsea*, 2000
Charcoal, pastel, printing ink and acrylic
61 3/4 x 34 inches (156.8 x 86.4 cm)
JD 2000005
Courtesy of PaceWildenstein

34. *Atheism #13*, 1986
Mixed media
43 1/2 x 59 inches (110.5 x 149.9 cm)
JD 2008643
Courtesy of PaceWildenstein

35. *Begonia, 83rd Street*, 1978
Pencil on collaged paper
17 1/4 x 19 3/4 inches (43.8 x 50.2 cm)
JD 2007872
Private collection

36. *The Sitter Progresses from London to
Here in Three Years*, 1976-1979
Pastel, oil pastel, charcoal and acrylic gesso
45 1/2 x 31 3/4 inches (115.6 x 80.6 cm)
JD 2007955
Courtesy of PaceWildenstein

37. *Panther* (from a grave monument in Attica, c. 360
B.C.), 1989
Charcoal and watercolor
41 3/4 x 47 1/2 inches (106.1 x 120.7 cm)
JD 2008976
Courtesy of PaceWildenstein

38. *Diana in Paris*, 2002
Charcoal, pencil and pastel on
collaged paper; tetratypch
16 1/2 x 11 3/4 inches (41.9 x 29.8 cm), panel 1;
16 1/2 x 10 7/8 inches (41.9 x 27.6 cm), panel 2;
16 1/2 x 10 3/8 (41.9 x 26.4 cm), panel 3;
16 1/2 x 10 7/8 inches (41.9 x 27.6 cm), panel 4;
16 1/2 x 44 1/2 inches (41.9 x 113 cm), overall
JD 2000213
Private collection

39. *Sleeping Satyr* (Barberini Faun, c. 220 B.C.), 1989
Mixed media
47 4/5 x 41 3/4 inches (121.7 x 106.1 cm)
JD 2008971
Private collection

40. Untitled, 1973
Pencil and collage
23 x 30 inches (58.4 x 77.5 cm)
JD 2007374
Private collection

41. Untitled (Shell), 1981-1984
Mixed media
47 1/2 x 46 1/2 inches (120.7 x 118.1 cm)
JD 2008421
Collection of Diana Michener

42. *Study for Europe*, 1987
Mixed media
55 1/4 x 39 1/4 inches (140.3 x 99.7 cm)
JD 2008751
Allen Memorial Art Museum, Oberlin College

43. *Blind Owl*, 2000
Charcoal, printing ink and oil
35 3/4 x 31 1/4 inches (90.9 x 79.4 cm)
JD 2000010
Collection of the artist

44. Untitled, 1973-1974
Graphite, watercolor and collage with objects
30 x 40 inches (76.2 x 101.6 cm)
JD 2007442
Collection of the artist

45. *Twisted Torso of a Youth*
(Ilioneus, c. 300 B.C.), 1989
Oil stick, acrylic, charcoal and watercolor over
silk-screened photograph on two sheets of paper
58 x 44 1/4 inches (147.3 x 112.4 cm)
JD 2008983
Collection of the artist

46. *Hair*, 1970
Pencil on vellum; tetraptych
23 x 23 inches (58.4 x 58.4 cm) each sheet;
46 x 46 inches (116.8 x 116.8 cm) overall
JD 2007051-54
Collection of the artist

47. *Jessie with a Skull (#3)*, 1978
Pastel, charcoal, oil and turpentine wash
45 1/2 x 31 3/4 inches (115.6 x 80.6 cm)
JD 2007843
Courtesy of PaceWildenstein

48. Untitled, 1996
Charcoal, pastel and pencil
37 5/8 x 20 1/4 inches (95.6 x 51.4 cm)
JD 2009626
Private collection

49. *Nancy*, 1996
Charcoal, color crayon and pastel on paper
with abrasion and collage on verso
29 1/2 x 31 inches (74.9 x 78.7 cm)
JD 2009614
Private collection

50. *Easter Lily in New York*, 1980-1982
Charcoal
53 x 30 1/4 inches (134.6 x 76.8 cm)
JD 2008272
Courtesy of PaceWildenstein

51. Untitled, 1996
Charcoal and pastel on collaged paper
17 3/4 x 12 3/8 inches (45.1 x 31.4 cm)
JD 2009650
Private collection

52. Untitled, 1974
Charcoal, pastel and colored pencil
54 x 42 inches (137.2 x 106.7 cm)
JD 2007450
Private collection

53. *Self-Portrait #1*, 1997
Graphite

17 x 14 inches (43.2 x 35.6 cm)
JD 2009745
Private collection

54. *San Marco (The White Heart)*, 1989
Watercolor, oil stick, pastel, charcoal, ink,
pencil and oil paint
85 1/2 x 121 inches (217.2 x 307.4 cm)
JD 2008943
Courtesy of PaceWildenstein

55. *Diana*, 2004
Charcoal on collaged paper
53 3/8 x 46 7/8 inches (135.5 x 121.6 mm)
JD 2000406
Collection of the artist

56. *Palmette from the Parthenon*
(c. 440-430 B.C.), 1989
Charcoal and watercolor
47 3/4 x 41 7/8 inches (121.3 x 106.4 cm)
JD 2008982
Private collection

57. Untitled, 1994
Watercolor and charcoal
38 1/4 x 25 1/4 inches (97.2 x 64.1 cm)
JD 2009263
Private collection

58. *Study for the Venus in Black and Gray*, 1983
Charcoal
63 x 38 1/2 inches (160 x 97.8 cm)
JD 2008332
Private collection

59. *Walking with Me*, 1997
Charcoal, shellac, oil and pastel
67 1/2 x 30 1/8 inches (134.6 x 76.5 cm)
JD 2009732
Courtesy of PaceWildenstein

60. *Patsy Orlofsky, Pregnant*, 1976-1977
Charcoal, pastel and pencil
46 x 32 inches (116.8 x 81.3 cm)
JD 2007741
Collection of Sam Orlofsky

61. *Drawing from Van Gogh II*, 1983
Mixed media
77 3/4 x 48 3/4 inches (197.5 x 123.8 cm)
JD 2008342
Private collection

62. *Self-Portrait*, 1978
Charcoal and pastel
41 1/2 x 29 1/2 inches (105.4 x 74.9 cm)
JD 2007801
Collection of Diana Michener

63. Untitled, 1973
Graphite, collage on paper with real fork
23 x 30 inches (58.4 x 76.2 cm)
JD 2007345
Private collection

64. *Portrait Bust of the Emperor Trajan*
(c. 100 A.D.), 1989
Charcoal, watercolor, acrylic and enamel paint
48 3/8 x 39 7/8 inches (122.9 x 101.3 cm)
JD 2008977
Collection of the artist

65. *A Study from Blake*, 1976
Charcoal, pastel and mixed media
45 1/2 x 28 inches (115.6 x 71.1 cm)
JD 2007652
Private collection

66. *Portrait of Nancy (Nude)*, 1987
Gouache and pastel
39 1/2 x 27 1/2 inches (69.9 x 100.3 cm)
JD 2008708
Courtesy of PaceWildenstein

67. *The Continents*, 1989
Charcoal, watercolor, acrylic, shellac,
pastel, enamel and collage; tetratypch
59 x 155 1/2 inches (149.9 x 395 cm)
JD 2008900
Courtesy of PaceWildenstein

68. *Tulips*, 1979
Pencil
20 x 17 1/2 inches (50.8 x 44.5 cm)
JD 2007985
Private collection

69. *Untitled Nancy with Shellac*, 1996
Charcoal, color crayon and shellac
47 1/4 x 43 7/8 inches (120 x 111.5 cm)
JD 2009617
Private collection

70. *Untersberg No. 6*, 1993
Acrylic, charcoal, chalk and pastel
47 x 35 1/2 inches (119.4 x 90.2 cm)
JD 2009329
Allen Memorial Art Museum, Oberlin College

71. Untitled (Nancy), 1996
Charcoal, pastel and chalk
40 x 30 inches (101.6 x 76.2 cm)
JD 2009636
Private collection

72. *A Variation of Jessie Learning Things from a Man,*
1976
Charcoal, pastel and mixed media
45 1/2 x 34 1/2 inches (115.6 x 87.6 cm)
JD 2007660
Courtesy of PaceWildenstein

73. *Trojan Archer* (Paris, from the pediment of the
Temple of Aphaia at Aegina, c. 500 B.C.), 1989
Charcoal, oil stick, watercolor, acrylic and turpentine
wash on two sheets of paper
67 5/8 x 51 5/8 (172 x 131.1 cm)
JD 2008973
Collection of the artist

74. *Mid-Summer, Paris,* 2002
Charcoal, pastel, pencil and flasche on collaged paper
31 x 59 1/2 inches (78.7 x 151.1 cm)
JD 2000211
Collection of Diana Michener

75. *Aged Silenus with Wineskin* (Roman sculpture
after a Hellenistic original), 1989
Charcoal and watercolor
47 3/4 x 41 3/4 inches (121.3 x 106.1 cm)
JD 2008975
Private collection

76. *Homer and Socrates*
(Homer, Roman copy of a bronze sculpture,
c. 460 B.C.; Socrates, c. 380 B.C.), 1989
Charcoal and watercolor
47 3/4 x 41 3/4 inches (121.3 x 106.1 cm)
JD 2008974
Private collection

77. *Self-Portrait,* 1989
Watercolor, pencil and pastel
30 1/2 x 22 (77.5 x 55.9 cm)
JD 2008919
Davison Art Center, Wesleyan University
Gift of the artist in honor of Ellen D'Oench

78. *Three Roman Heads,* 1991
Charcoal, oil stick, acrylic, shellac and ferric chloride;
triptych
38 1/2 x 29 inches (97.8 x 73.7 cm) each sheet; 115 1/2 x
87 inches (293.4 x 261 cm) overall
JD 2009103
Private collection

79. *Jessie Among the Marks,* 1980
Charcoal, pastel and enamel
60 x 40 3/4 inches (152.4 x 103.5 cm)
JD 2008031
Courtesy of PaceWildenstein

80. *Dancer,* 1997
Charcoal and pastel
53 x 30 1/8 inches (134.6 x 75.3 cm)
JD 2009739
Private collection

81. Untitled, 1973
Pencil and collage
23 x 30 1/2 inches (58.4 x 77.5 cm)
JD 2007351
Private collection

82. *Portrait of Chuck Close,* 1993
Charcoal, pencil, acrylic and shellac with collage
64 3/4 x 38 1/4 inches (164.5 x 97.2 cm)
JD 2009301
Collection of the artist

83. *Untersberg Summer 1994 No. 4,* 1994
Enamel, acrylic, charcoal and oil stick
79 3/4 x 39 3/4 inches (202.6 x 101 cm)
JD 2009408
Private collection

84. *Tanagra Figures (c. 300 B.C.),* 1989
Charcoal, oil stick and enamel paint
82 1/4 x 29 1/2 inches (208.9 x 74.9 cm), left side;
79 1/8 x 35 inches (201 x 88.9 cm), right side
JD 2008985
Private collection

85. *Self-Portrait #4,* 1997
Watercolor, pencil and graphite on collaged paper
12 x 9 inches (30.5 x 22.9 cm)
JD 2009746
Collection of Gerhard Steidl

BIOGRAPHY OF JIM DINE

1935	Born June 16 in Cincinnati, Ohio
1953–55	Studies at the University of Cincinnati and the Boston Museum School
1957	Receives B.F.A. from Ohio University, Athens
1958	Pursues graduate work at Ohio University
	Moves to New York City
	Teaches at the Rhodes School, New York City
1959–65	Participates in "Happenings," primarily at the Judson and Reuben Galleries, New York
1960	First solo exhibition at the Reuben Gallery, New York
1961–62	Solo exhibition at the Martha Jackson Gallery, New York
1962	Meets Ileana Sonnabend and begins 14-year association with the Sonnabend Gallery, New York
1964	Participates in the Venice Biennale
	First solo exhibition at the Sidney Janis Gallery, New York
1965	Guest lecturer, Yale University, New Haven, Connecticut
	Artist-in-residence, Oberlin College, Oberlin, Ohio; first solo museum show at the Allen Memorial Art Museum
	Set and costume design for *A Midsummer Night's Dream* commissioned by Actor's Workshop, San Francisco, California
1966	Travels to London to work on prints with Editions Alecto
	Visiting critic, College of Architecture, Cornell University, Ithaca, New York
1967	Moves to London
1970	Retrospective at the Whitney Museum of American Art, New York
1971	Returns to the United States, settles in Putney, Vermont and begins to draw intensively
1975	Visiting printmaker, Dartmouth College, Hanover, New Hampshire
	Designs interior of Los Angeles Biltmore Hotel
1976	Artist-in-residence, Williams College, Williamstown, Massachusetts, at the invitation of Thomas Krens
	Begins association with The Pace Gallery, New York
1977	First solo exhibition, *Jim Dine: Paintings, Drawings, Etchings, 1976,* at The Pace Gallery, New York
1977–80	Serves on Solomon R. Guggenheim Museum selection committee
1980	Elected to American Academy and Institute of Arts and Letters, New York
1982	*Lessons in Nuclear Peace,* commissioned for the library of the Louisiana Museum of Modern Art, Humlebaek, Denmark
1984	*2 Big Black Hearts,* commissioned for Pappas Companies' building, White Plains, New York
1984–85	Retrospective, *Jim Dine: Five Themes,* Walker Art Center, Minneapolis. Traveled to Phoenix, Arizona; Saint Louis, Missouri; Akron, Ohio; Buffalo, New York; and Washington, D.C.
1985	Moves from Vermont to New York
	The Nuveen Painting, commissioned for John Nuveen & Co., Chicago, Illinois
	Howard Street Venus, commissioned for the San Francisco Redevelopment Agency and installed at Convention Plaza, San Francisco, California
1986	Designs sets and costumes for Houston Grand Opera's 1986–1987 season presentation of Richard Strauss's *Salome*
1987	*Double Boston Venus,* commissioned by Graham Gund/Schoolhouse Condominiums and installed at Bulfinch Triangle, Boston, Massachusetts
1988	*Jim Dine: Paintings, Sculpture, Drawings, Prints, 1959–1987* at Galleria d'Arte Moderna Ca'Pesaro, Venice
	Cincinnati Venus, commissioned by Tipton Associates and installed at Centennial Plaza, Cincinnati, Ohio
1988–90	*Drawings, Jim Dine, 1973–1987* at The Contemporary Arts Center, Cincinnati, Ohio. Traveled to Fort Lauderdale, Florida; Santa Barbara, California; Seattle, Washington; Fort Worth, Texas; Minneapolis, Minnesota; Chicago, Illinois; Omaha, Nebraska; and San Francisco, California
1989	*Looking Toward the Avenue,* commissioned by Tishman Speyer Trammell Crow Limited Partnership and installed outside 1301 Avenue of the Americas, New York
	East End Venus, commissioned by Rosehaugh Stanhope Developments for Broadgate, London, England
	At the Wedding, commissioned for Seibu Department Store, Tokyo, Japan
1990	Traveling exhibition of drawings, *In der Glyptotek,* Staatliche Antikensammlungen und Glyptotek, Munich
1990–91	Retrospective exhibition at the Isetan Museum of Art, Tokyo and the Museum of Art, Osaka
1992	Receives the Pyramid Atlantic Award of Distinction, Washington, D.C.
	Jim Dine Childhood Stories, a thirty-minute film about the artist's early years, is produced by Outside in July
	The Second Nuveen Painting, commissioned by John Nuveen & Co., Chicago, Illinois

1993	*Black Venus* exhibited in *Copier créer de Turner à Picasso, 300 oeuvres inspirées par les maîtres du Louvre,* Musée du Louvre, Paris
1993–97	Teaches at the Internationale Sommerakademie für Bildende Kunst, Salzburg, Austria
1993–94	*Jim Dine: Drawing from the Glyptothek* organized by the Madison Art Center, Madison, Wisconsin. Traveled to Salzburg, Cincinnati, Honolulu, Montreal, and Miami
	Jim Dine: Paintings, Drawings and Sculpture 1973–1993, Borås Konstmuseum, Borås, Sweden. Traveled to Budapest and Nice
1995	*Jim Dine: A Self-Portrait on the Walls,* a thirty-minute film documenting the artist's exhibition of temporary wall drawings, Kunstverein Ludwigsburg, Germany, produced by Outside in July
	Visiting artist, Hochschule der Künste, Berlin
1996	*Ape & Cat,* commissioned by the Battery Park City Authority for Robert Wagner Park in Battery Park, New York
	All About Looking: Jim Dine Teaches at the International Sommerakademie Salzburg, a thirty-minute film about the artist's methods for teaching life drawing, filmed in Salzburg, Austria in 1994 and produced by Outside in July
1997	Receives honorary doctorate from California College of Arts and Crafts
	Works at Sèvres on first porcelain sculptures
	Three Red Spanish Venuses commissioned by the Guggenheim Museum Bilbao, Bilbao, Germany
1998	Elected to the Akademie der Künste, Berlin
	Jerusalem Heart, commissioned by Andrea and Charles Bronfman to commemorate Charles Bronfman's chairmanship of the general assembly of the council of the UJA/UJF/UIA, Jerusalem
1999	*Jim Dine: Walking Memory 1959–1969,* exhibition at the Solomon R. Guggenheim Museum, New York
2000	Invited by the Mayor of Siena, Italy to design banner for the Palio, July 2, 2000
2002	*Cleveland Venus,* commissioned by the Art in Architecture Program of the U.S. General Services Administration and installed outside the Carl B. Stokes U.S. Court House, Cleveland, Ohio
2003	Named Commandeur de l'ordre des Arts et des Lettres, June 25, 2003, Paris, France (awarded for artistic or literary contributions in France and around the world)
	Traveling exhibition, *Jim Dine, the Photographs, so far,* organized by the Davison Art Center, Wesleyan University, Middletown, Connecticut and the Maison Européenne de la Photographie, Paris. Traveled to Sweden and Germany
2004	Retrospective exhibition, *Jim Dine Drawings,* organized by the National Gallery of Art, Washington, D.C.

Selected Bibliography

Further Reading

For a complete bibliography, see Marco Livingstone, *Jim Dine, The Alchemy of Images.* New York: The Monacelli Press, 1998.

Beal, Graham W.J. *Jim Dine: Five Themes.* New York: Abbeville Press, and Walker Art Center, Minneapolis, 1984. Contributions by Robert Creeley, Jim Dine, and Martin Friedman.

Brodie, Judith. *Jim Dine Drawings.* Steidl Verlag, with the National Gallery of Art, Washington, D.C., 2004.

Celant, Germano, and Clare Bell. *Jim Dine: Walking Memory, 1959–1969.* New York: Guggenheim Museum, 1999.

Dine, Jim, Fine, Ruth E., and Fleischman, Stephen. *Jim Dine: Drawing from the Glyptothek.* New York: Hudson Hills Press, in association with Madison Art Center, Madison, Wisconsin, 1993.

Feinberg, Jean E. *Jim Dine.* New York: Abbeville Press, 1995.

Glenn, Constance W. *Jim Dine Figure Drawings 1975–1979.* New York: Harper & Row, with the Art Museum and Galleries, California State University, Long Beach, 1979.

Glenn, Constance W. *Jim Dine Drawings.* New York: Harry N. Abrams, 1985.

Jim Dine, Tekeningen. Amsterdam, Stedelijk Museum, 1966. Essay by Alan R. Solomon.

Jim Dine, Complete Graphics. Berlin, Galerie Mikro, 1970. Essays by John Russell, Tony Towle, and Wieland Schmied.

Jim Dine. Whitney Museum of American Art, New York, 1970. Text by John Gordon and statement by the artist.

Jim Dine: Paintings, Drawings, Etchings 1976. New York, Pace Gallery, 1977.

Jim Dine, An Exhibition of Recent Figure Drawings, 1978–1980. Chicago, Richard Gray Gallery, 1981. Text by David Shapiro.

Jim Dine, New Paintings and Figure Drawings. Chicago, Richard Gray Gallery, 1983. Statement by Jim Dine.

Jim Dine: Sculpture and Drawings. Pace Gallery, New York, 1984. Essay by Michael E. Shapiro.

Jim Dine: Paintings Drawings Sculpture. Pace Gallery, New York, 1986.

Jim Dine: Drawings 1973–1987. Contemporary Arts Center, Cincinnati, and elsewhere, 1988. Essay by Sarah Rogers-Lafferty.

Jim Dine in der Glyptothek. Munich, Glyptothek am Königsplatz and Copenhagen, Ny Carlsberg Glyptotek, 1990. Essay by Wieland Schmied, statement by the artist and preface by Klaus Vierneisel.

Jim Dine: Drawings. Pace Gallery, New York, 1990.

Jim Dine: The Four Continents. New York: Pace Prints, 1993. Essay by Marco Livingstone.

Jim Dine: Untersberg 1993–1994. Residenzgalerie, Salzburg, 1994. Statement by the artist, preface by Roswitha Juffinger and essays by Barbara Wally and Wieland Schmied.

Jim Dine: Walldrawing. Kunstverein Ludwigsburg, Ludwigsburg, Germany, 1994. Statement by the artist, interview with the artist by Peter Iden and essay by Ingrid Mössinger.

Jim Dine: Youth and the Maiden. London: Waddington Graphics, 1988. Text by Konrad Oberhuber and Donald Saff.

Livingstone, Marco. *Jim Dine: Flowers and Plants.* New York: Harry N. Abrams, 1994.

Paris, Galerie Claude Bernard and Lausanne, Galerie Alice Pauli. *Oeuvres sur papier 1978–1979.* Statement by Jim Dine.

Shapiro, David. *Jim Dine: Painting What One Is.* New York: Harry N. Abrams, 1981.

Some Greeks, Some Romans: A Drawing by Jim Dine. Pace Gallery, New York, 1996.

ACKNOWLEDGMENTS I would like to express my gratitude to Jim Dine and Diana Michener whose enthusiastic collaboration made it possible to organize the present exhibition. I would also like to thank Arne Glimcher and Douglas Baxter of PaceWildenstein; the writer and poet Vincent Katz; the artist Edy Ferguson; and Gerhard Steidl and his colleagues, Detlef Otten, Claas Möller, and Julia Braun, at Steidl Verlag.

At Oberlin College, many people helped to make this exhibition become a reality. I am grateful to the College's Provost, Clayton Koppes, for his early support of the exhibition, and to the Art Department for their enthusiasm for having Jim Dine return to Oberlin. I would also like to thank my colleagues at the Allen Memorial Art Museum, Stephen Fixx, Michael Holubar, Lucille Stiger and Laura Winters, for their willingness to help at every turn.

Stephanie Wiles

Copublished by the Allen Memorial Art Museum, Oberlin College,
Oberlin, Ohio and Steidl Publishers Germany

First edition 2005

Copyright © Jim Dine for all images
Copyright © for the texts by authors
Copyright © for the photo on page 6 by Diana Michener
Copyright © 2005 Steidl Publishers for this edition

Book design: Jim Dine, Diana Michener,
Gerhard Steidl and Claas Möller
Digital copying technique by Steidl
Production: Gerhard Steidl

Steidl, Düstere Strasse 4, D-37073 Göttingen
Phone +49 551 49 60 60, Fax +49 551 49 60 649
E-mail mail@steidl.de, www.steidl.de
Orders can be placed directly at our publishing house or via e-mail

All rights reserved. No part of this book may be reproduced in any manner,
in whole or in part (except for reviews in the public press), in any media,
electronic or mechanical, including photocopy, recording, or any information
storage and retrieval system, without prior written permission from the publisher.

ISBN 3-86521-119-4
Printed in Germany